Painting People in Watercolor

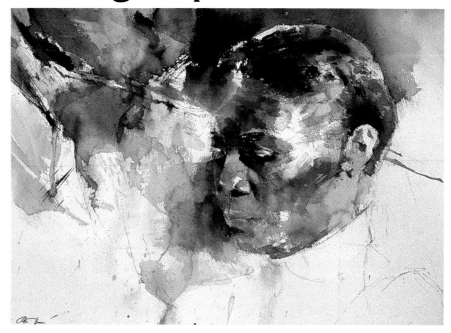

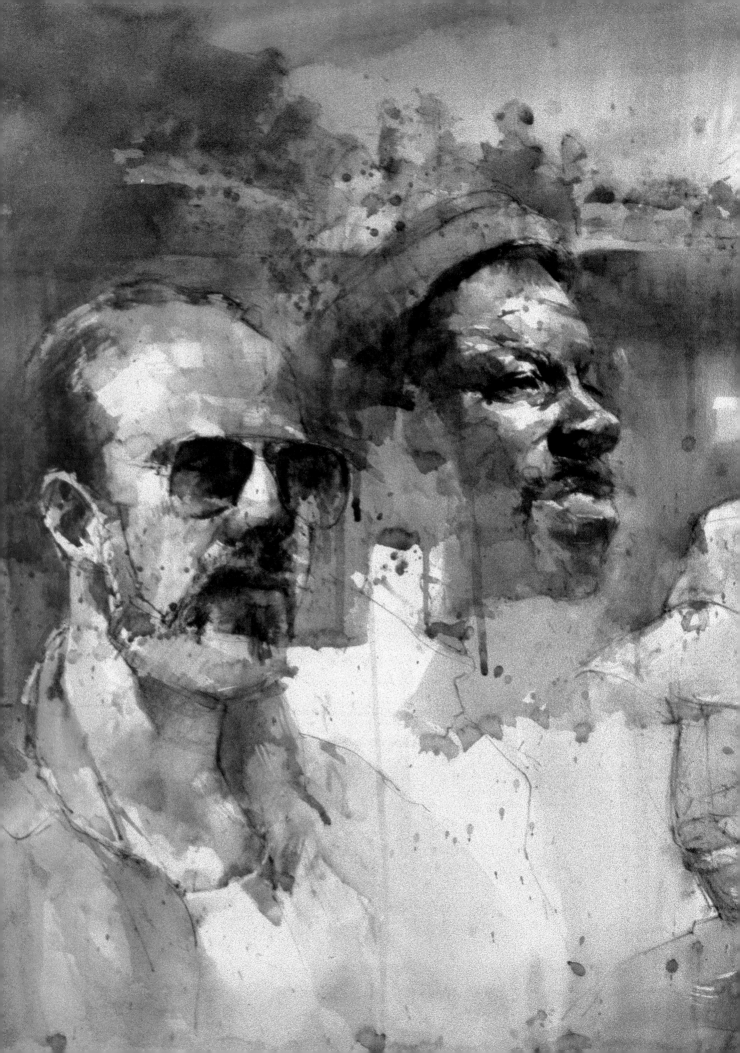

Painting People in Watercolor
A Design Approach

Alex Powers

Watson-Guptill Publications/New York

PAINTING INFORMATION

Frontispiece:
ALICE, *watercolor, 18″ × 24″ (45.72 × 60.96 cm), 1982. Collection of Lucie Dulin, Charlotte, NC.*

Title page:
TRANSITION PORTRAITS, *watercolor, 26″ × 40″ (66.04 × 101.60 cm), 1984. Collection of Annie Massie, Lynchburg, VA.*

Page 10:
POCONOS REPOSE, *watercolor and charcoal, 13″ × 16″ (33.02 × 40.64 cm), 1987. Collection of Jane Walter, Warren, NJ.*

Page 34:
VICTORIAN DANCE II, *watercolor and enamel spray paint, 22″ × 30″ (55.88 × 76.20 cm), 1978. Collection of Rodney B. Lewis, Surfside, SC.*

Page 100:
LARRY HERNDON, *watercolor, charcoal, and gouache, 23″ × 29″ (58.42 × 73.66 cm), 1985. Collection of the artist.*

Page 120:
TWO JAMAICAN WOMEN, *watercolor, 18″ × 24″ (45.72 × 60.96 cm), 1987. Collection of the artist.*

Page 138:
DONNA'S BACK II, *watercolor on toned paper, 22″ × 30″ (55.88 × 76.20 cm), 1984. Collection of Betty Edwards, Macon, GA.*

Copyright © 1989 by Alex Powers
First published in 1989 by Watson-Guptill Publications,
a division of Billboard Publications, Inc.,
1515 Broadway, New York, N.Y. 10036

Library of Congress Cataloging-in-Publication Data
Powers, Alex.
 Painting people in watercolor : a design approach / by Alex Powers.
 p. cm.
 Bibliography: p.
 Includes index.
 1. Human figure in art. 2. Humans in art. 3. Watercolor painting—Technique. I. Title.
 ND2190.P69 1989 751.42′242—dc19 88-31426
 ISBN 0-8230-3816-5

Distributed in the United Kingdom by Phaidon Press Ltd., Musterlin House, Jordan Hill Road, Oxford OX2 8DP

Manufactured in Singapore

2 3 4 5 6 7 8 9 10 / 92

Edited by Grace McVeigh
Graphic production by Ellen Greene

Grateful acknowledgment is made for permission to reprint excerpts from the following sources:

The Natural Way to Draw by Kimon Nicolaïdes. Copyright 1941 by Anne Nicolaïdes. Copyright © renewed 1969 by Anne Nicolaïdes. Reprinted by permission of Houghton Mifflin Company.

Watercolor Energies by Frank Webb. Copyright © 1983 by Frank Webb. Used by permission of North Light Books.

The Art of Color and Design by Maitland Graves. Copyright © 1951 by Maitland Graves. Used with permission.

Russ Warren, Clara Couch, Norbert Irvine, Herb Jackson, and Gary Cook, quoted in *Understanding Abstract Art*, a pamphlet compiled by the Rowan Art Gallery Guild. Used with permission of the artist.

From a story paraphrased by William Pachner in *Art Voices*/South, July/August, 1979.

From the preface to *The Nigger of The Narcissus* by Joseph Conrad.

The Art Spirit by Robert Henri. Copyright 1923 by Harper & Row, Publishers, Inc. Reprinted by permission of the publisher.

Portrait of An Artist: A Biography of Georgia O'Keeffe by Laurie Lisle. Copyright © 1986, 1980 by Laurie Lisle. Reprinted by permission of Washington Square Press, a division of Simon & Schuster, Inc.

Two Worlds of Andrew Wyeth: Kuerners and Olsons. Copyright © 1976 by Metropolitan Museum of Art. Used with permission.

*This book is dedicated to the memory of
my mother and father, Elsie and W. C. Powers*

Thanks to Pat Braun for showing my work to Watson-Guptill Publications. Thanks to my friend, Professor Claudia Cleary, who made my written words comprehensible. And to the Watson-Guptill staff, Mary Suffudy, Bonnie Silverstein, Candace Raney, and Grace McVeigh for their thorough and thoughtful help—especially to Grace McVeigh for shaping my manuscript into book form. And to Marie Lovero and her word processor.

A special thanks to artist Janet Powers for her steady support.

In addition, I would like to pay tribute to all those art students with whom I have worked. I appreciated their patience and understanding as the ideas used in this book developed over the years. Finally, a note of appreciation to the people of Myrtle Beach, South Carolina, who have supported my efforts as a self-employed artist for twenty years.

Contents

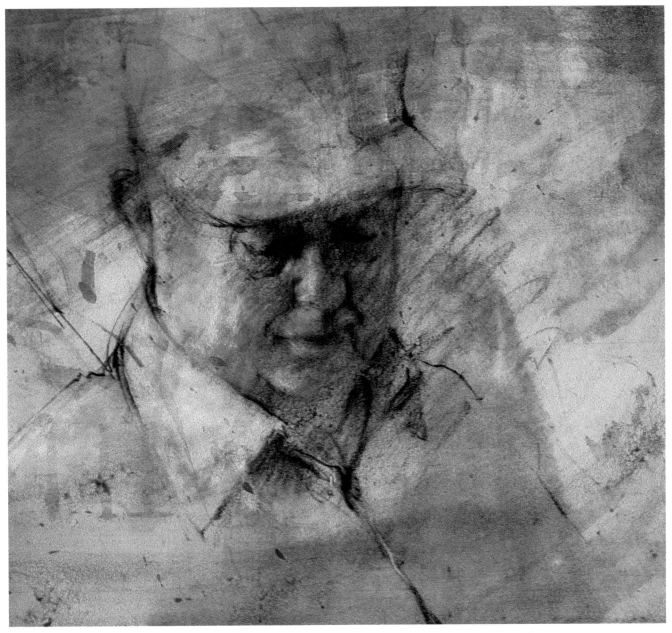

POP, *charcoal and pastel on watercolor-toned paper, 13" × 13" (33.02 × 33.02 cm), 1988. Collection of Betty Anglin Smith, Mt. Pleasant, SC.*

Introduction

Observing beginning artists and their work reminds me of my own beginnings. My paintings were very busy. They were filled with too many shapes, and the excessive sharp edges of these shapes all yelled for visual attention. My use of detail was not selective. Both minor and major areas of the painting were equally described.

Also, I had not come to grips with the distinction between reality/truth and painting as illusion. Seeing painted shapes, no matter how realistic or abstract, as symbols and thinking in terms of two- and three-dimensional space to present these symbols was not, as I feel it should have been, an early consideration for me. Since I identified neither a dominance in the painting nor a focal area, transitional change between differing shapes was not possible. The lack of transition created visual monotony.

These problems are common when one is learning one's craft. Artists learn to solve them through experience. This text has approached the painting of portraits and figures from the standpoint of establishing design priorities that will lead to the flowering of an individual style founded on conscious aesthetic considerations.

When I was a computer programmer at Cape Kennedy, Florida, I found myself experiencing a metamorphosis on the drive home from work each day. I would begin the drive as Powers the Programmer and evolve into Alex the Artist by the time I arrived home. Later, even with the obvious awkwardness of starting a new career in painting at the age of twenty-seven, I began to feel a greater continuity between my work and my life. I knew that the choice of art was right for me. Soon, there was no separation between work and life at all.

I have heard it said that if a person has truly chosen the right work for himself or herself, even the most menial tasks contain some joy. Art is that way for me.

There is more to art than mastering subject matter and technique. I believe that you are enriched by an understanding of design and aesthetics and better prepared by it for the adventure into the world of your own individual imagery . . . and into the even greater world where art and life merge.

I have divided this book into five basic sections, each building upon the other to lead you to develop your own way.

1. Drawing the head and figure. This section deals with basic drawing from a direction that is probably different from the usual approach. It focuses on specific problem areas that I have identified during my years of painting and teaching. It also presents the portrait and figure in such a way that the ensuing design section may build upon this section.

2. Designing the head and figure in the rectangle: Design elements and principles. My specific design approach, which is presented here in detail, is the major theme of this section. Although your approach to design will naturally be different from mine, exploring and understanding the components of a specific painting style will enable you to prioritize and determine your own needs.

It is my belief that when you gain an understanding of such terms as shape, value, space, color, texture, line, dominance, movement, variety, and unity, which are fully discussed in this section, you can make more fulfilling painting decisions in your own work . . . decisions that can lead to maturing as an artist.

3. Pragmatic considerations. Materials, techniques, the practical side of art, and demonstrations. Any able-minded person, with reasonable art instruction, can become technically competent as a painter. Reproducing nature in paint is documentation, not art. Thus, I discuss materials and technique here as an extension of the artist's personal response to his environment.

The practical side of art is another important part of the artist's survival. How much painting time and money have you seen artists lose by not dealing effectively with practical necessities? This section of the book discusses these practical necessities and gives specific, workable solutions.

Just as demonstration paintings by the instructor are useful in art workshops, step-by-step visuals are included here so that the reader can see how the final paintings were made.

4. Looking at paintings. Individual paintings are discussed here with adjacent diagrams and text. I look at the paintings from the initial inspiration through the painting process to the completed image. Intuitive and analytical considerations are included.

5. Aesthetic considerations. Art concerns beauty, emotions, and the senses. The study of aesthetic thought is critical to the development of the complete artist. I discuss aesthetics here in relation to creativity, inspiration, art education and growth, art criticism, and art and the public. Selected quotations from artists and thinkers about art are included.

There is also a list of suggested reading, with comments that will be of interest to those who would like to pursue their studies further.

Part I

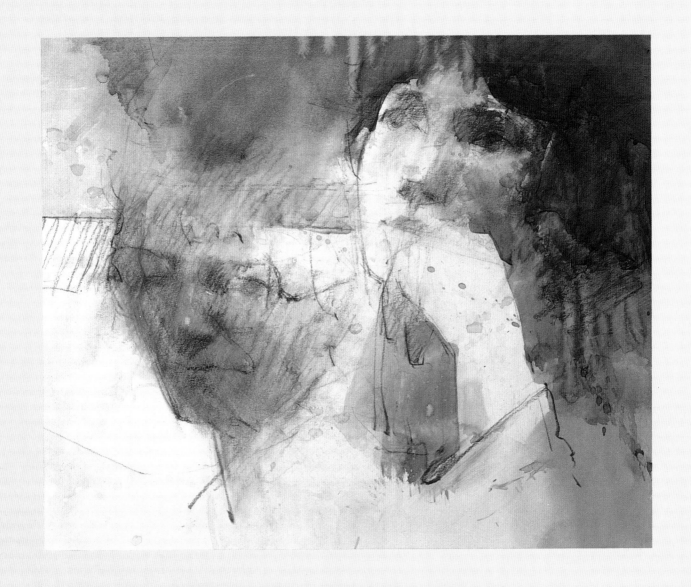

Drawing the Head and Figure

Drawing the Head

There is more to drawing the head than drawing a circle with eyes, nose, and mouth. In fact, to me, the most fascinating aspect of drawing the head is drawing it without the features. Once the head is competently constructed, it is a relatively easy matter to include the features. If you approach drawing the head in this way, it is possible to avoid two common problems in portrait painting: (1) drawing the features too distinctly in relation to the rest of the head so that they stand out too much from the remainder of the drawing, and (2) drawing the features too symmetrically, as when the eye on the shadow side of the face is drawn exactly like the eye on the light side of the face. (This mistake can also be made with the corners of the mouth, the ears, etc.)

A head with the features placed on the head but not individually indicated.

The same head with the features more clearly indicated.

The Tilt and Turn of the Head

Usually a good way to begin to draw the head is by sketching an oval shape. This will help you to place the head properly in the rectangle and to ensure the appropriate size of the head before you add confusing details. In the design chapter on shape, more will be said about the placement and size of the head.

The next consideration is the tilt of the head on its axis, which is the imaginary line running through the north and south poles of the oval. The north pole is the imaginary line coming out of the top of the head. The south pole emerges from the bottom of the skull near the front of the neck. Running down the middle of the face and up the back of the head is the *vertical oval*. This vertical oval determines to what degree the head is turned to the left or the right and whether it is a front view, a three-quarter view, a profile, or some other angle. A front view of a head that is not tilted to either side has the same line for the vertical oval as the north/south line running through the center of the face.

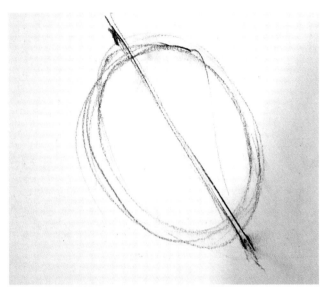

The tilt of the head, showing the north- and south-pole axis.

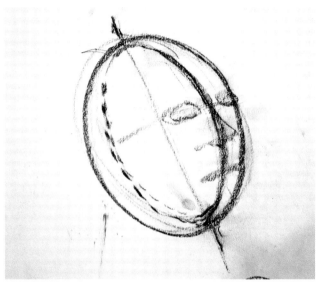

The vertical oval, which runs along the outside surface of the spherical head down the middle of the face, clarifies the model's pose as to view: front, three-quarter, etc.

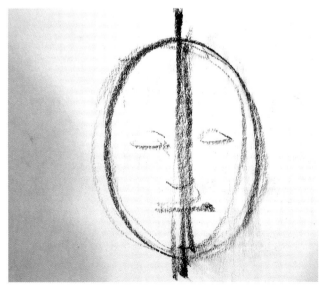

The vertical axis and the vertical oval down the middle of the face are the same line only when the head is a front view and is not tilted to either side.

Locating the Features on the Head

Locating the features on the oval head is more important than being able to draw individual features. The eyes are generally located halfway from the chin to the top of the skull. This is often surprising to the beginning portrait painter. When we look at a person, we look at the features and not at the upper half of the head. This makes us think that the half of the head from the eyes down is larger than its actual size. Children often place eyes high on the head for this reason.

The bottom of the nose is located halfway between the eyes and the bottom of the chin. The mouth is slightly above halfway from the bottom of the nose to the chin. The ears are located between the lines of the eyes and the nose. Of course, these are standardizations. The artist's real interest is in the many ways in which models are different from this standard.

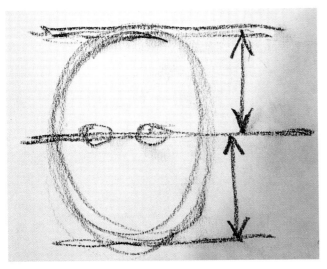

The eyes are located halfway between the chin and the top of the skull.

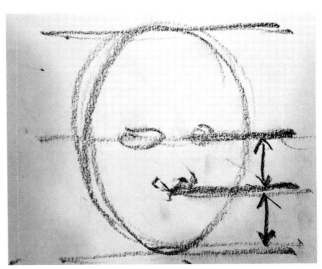

The bottom of the nose is located halfway between the bottom of the chin and the eyes.

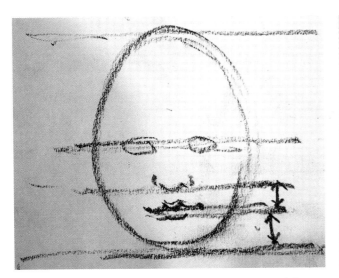

The mouth is located slightly closer to the bottom of the nose than it is to the bottom of the chin.

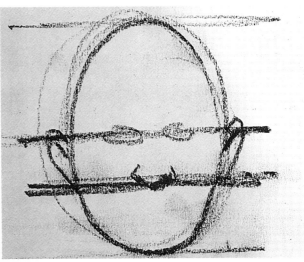

The top of the ears is on line with the eyes. The bottom of the ears is on line with the bottom of the nose.

The Angles of the Head

I consciously try not to choose a level front view of the head because the features are too symmetrically repetitive and the face tends to appear flat. There are eight other possible angles of the head. In my opinion, the ability to locate the features on heads turned and tilted in these nine positions is the *single most important* aspect of drawing the head. Often neglected, this ability makes the features a part of the spherical head and adds subtle and sophisticated three-dimensionality to the rendering.

Study the nine photographs of artist Janet Powers and the nine sketches made from the photographs. Notice in each sketch the use of: (a) the axis, (b) the vertical oval line through the middle of the face, (c) the placement of the eyes, (d) nose, (e) mouth, and (f) ears. Similarly, study the nine heads painted with watercolor, which were cropped from larger paintings. As an exercise, you might make a sketch from each of the nine paintings, as I did from the nine photographs.

When sketching a pose other than a level front view, you have to make a preliminary adjustment to the vertical oval line running through the center of the face. You can see from looking at the sketches of the skull on page 16 that the shaded area of the chin juts out of the oval of the head, making a change necessary to the vertical oval through the center of the face.

The illustrations on page 16 show examples of the adjustment to the vertical oval through the lower portion of the face. The adjustment needs to be made to all drawings of heads that are not front views. This means that, in the illustration at the top of page 15, heads 1, 4, and 7 (turned to the left) and 3, 6, and 9 (turned to the right) need the adjustment made to them.

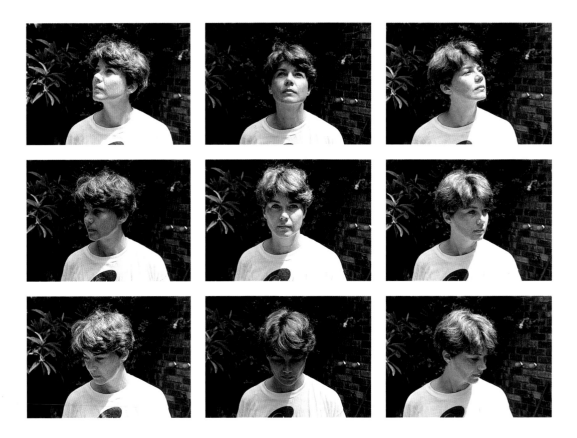

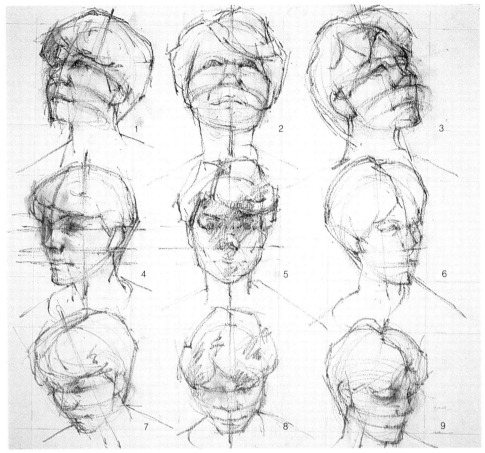

There are basically nine possible tilts and angles of the head. Understanding these positions may be the most important part of portrait drawing and painting. As you study these heads, keep in mind: (1) the vertical axis (north–south poles), (2) the vertical oval running through the center of the face, and (3) the location of the features on the head.

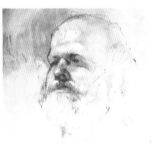 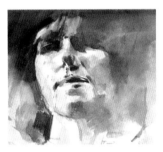

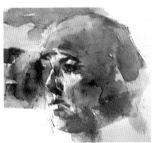 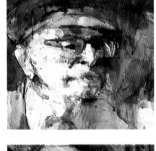 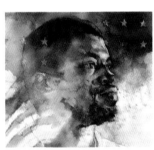

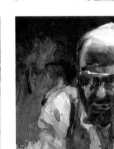 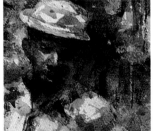

The nine heads here are cropped from nine larger paintings. They are painted examples of the nine photographs and the nine sketches of the photographs.

An adjustment to the vertical oval running through the center of the face. Since the chin protrudes out of the egglike shape of the head, it is necessary to make a slight change in the vertical oval through the center of the face.

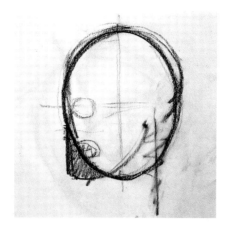

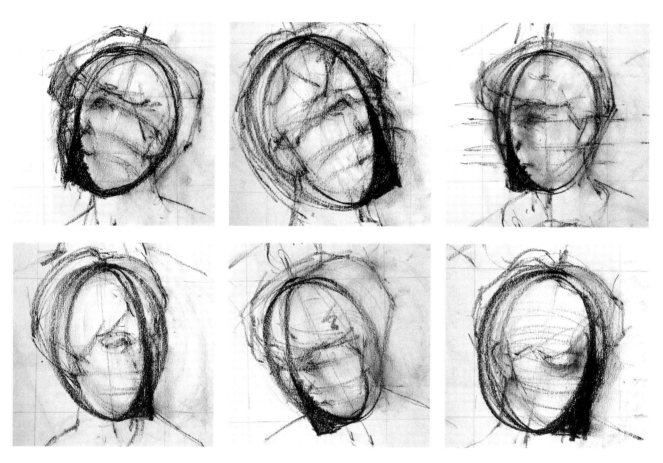

The shaded areas in the lower portion of the head show the adjustments made necessary by the chin jutting out of the egg-shaped head.

Finding the Features with Horizontal Ovals

If the head is not tilted up or down, the horizontal lines drawn through the eyes, bottom of the nose, and mouth are straight lines. However, when the head is tilted up or down, the horizontal straight lines become ovals through the eyes, bottom of the nose and mouth. At the top of page 15, heads 1, 2, and 3 (tilted up) and 7, 8, and 9 (tilted down) have horizontal ovals drawn through the features, not horizontal straight lines.

The sketch at right shows a head tilted up and to our left. The line through the eyes is no longer halfway up the head. It is above halfway from the chin to the top of the skull. And since the head is tilted, the line through the eyes is no longer a horizontal straight line but a tilted horizontal oval. The same is true of the line through the bottom of the nose and through the mouth. Be sure to complete the ovals around the back of the head for the feeling of three dimensions.

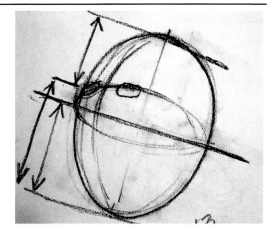

With the head turned up and to our left, the eyes are no longer halfway up the head. They are above the halfway line. Also, the line through the eyes is now seen as an oval going all the way around the back of the head.

The Shape of the Back of the Head

A common error in drawing the head is the way the back of the head is drawn. The reason is obvious. We do not often study the back of the head. Let's look again at the shape of the human skull. We have already seen that we needed to make an adjustment to the vertical oval through the middle of the face because the chin juts out of the oval of the head. We also need to make an adjustment to the back of the head.

Hold your head level with the floor as you read these sentences. Place one of your fingers on the bottom of the occipital bone at the back of your head. Then run your finger around the side of your face toward your eye. Isn't the bone at the back of the head just below the level of the eye? This bone locates the bottom of the back of the skull. If that seems awfully high for the bottom of the skull, remember that the vertebrae of the back and neck connect to the skull at this point. Note in the illustration at right the consequent adjustment to the shape of the back of the head. Also study where the bone at the back of the head is located on all nine heads in the illustration at the top of page 15.

An adjustment to the shape of the back of the head. The shading shows the adjustment needed at the occipital bone.

Drawing the Features of the Head

The features of the head are much easier to draw when the horizontal ovals through the eyes, the bottom of the nose, and the mouth are already located on the head. We will now discuss drawing all of the features of the face in their standard front-view appearance. Then, more importantly, we will study the changes to each feature in a few paintings where the head is tilted and turned to other positions that are shown in the illustration on page 15.

The Eyes

The distance between the eyes is generally the same as the width of each eye. Students often draw this distance too small. Sufficient space needs to be left for the side wedges of the nose to make the connection with the inner portion of the eye socket before the inside corners of the eye are drawn.

In drawing the shape of the eye, the line above the eye is much more important than the line below it, because the folds of the eyelid make the upper line darker. In fact, being in shadow, the line above the eye is as dark as the pupil of the eye and, thus, can actually be connected to the pupil. The highest point of this upper line of the eye is not the center of the eye. The illustration at right shows that the highest point of the upper line of the eye is nearer the inside, or tear-duct side, of the eye. This makes the line A portion of the upper eyelid a much steeper angle than the longer line, B. Note the changes to the shape of the eyes when the head is at an angle other than a front view. Line A of the left eye becomes shorter and its angle becomes nearer a vertical.

The illustration below, right, is a head looking down and to our right, the same as head number 9 in the illustration on page 15. The eyes are placed on the horizontal oval, which is scooping downward. Notice that the highest point of the upper eyelid of the eye on our right is closer to the midline. Line A is steeper on the eye on the left.

Study and do sketches of eyes for the other heads in the illustration on page 15. Find and study newspaper and magazine photographs of heads in these positions. Also, of course, observe and sketch this as you "people watch." Look in the mirror and observe the changes in your own eyes as the tilt and turn of your head changes.

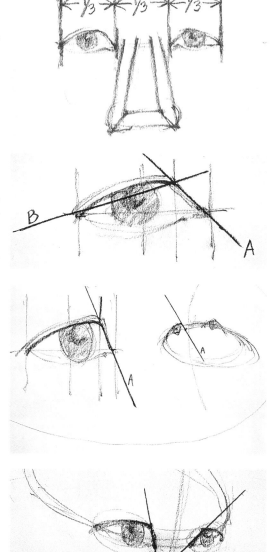

Leave enough space between the eyes so that you can draw the inside portion of the eye socket before drawing the tear duct of the eye.

The angle of the upper eyelid is steeper at the tear-duct side and becomes a more gentle angle toward the outside of each eye.

Line A of the eye at left is a steeper angle, with the apex of the upper lid close to the inside of the eye. In the eye at right, the apex moves toward the center.

The highest points of the upper eyelid in both eyes moves to the left for these eyes. Line A becomes a steeper angle and the angle in the other eye is a gentler angle.

The Nose

Children often have trouble drawing noses. An understanding of the illusion of depth on a flat surface, which young children do not generally have, is necessary because the nose juts forward from the face.

Dividing the nose into four planes simplifies this illusion of depth. The four planes point in different directions, catching the light differently. However, since the light source is almost always from above rather than from below the nose, the bottom wedge is almost always in shadow. The lack of a shadow value on the bottom wedge allows the nostrils to get too much attention and gives a "pig nose" look. When the head is tilted down, the wedges of the nose look as they do in the middle illustration below, with the bottom wedge of the nose no longer visible. With a backward tilt of the head much more of the bottom wedge of the nose is exposed, and the top wedge of the nose appears foreshortened as it moves away from the tip of the nose toward the eyes.

The illusion of the nose coming forward and away from the face is easily represented using the four wedges and the lights and shadows from a strong light source.

The bottom wedge of the nose is not visible when the head is tilted downward.

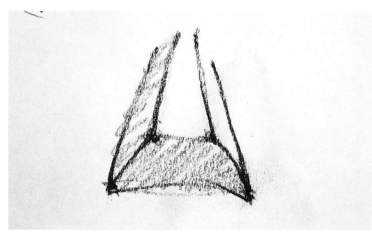

When the nose is tilted backward, the angle of the lines is very different.

The Mouth

The mouth is simplified by thinking of it as having five muscles, three in the upper lip and two in the lower lip. This explains the placement of the key dark lines of the mouth, for they are the intersections of these muscles. The upper lip is almost always in shadow because the light sources are invariably from above.

The five muscles of the mouth.

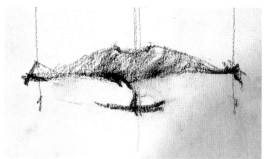

The key dark lines of the mouth are at the intersections of the five muscles of the mouth.

The Ears

The ear is shaped like a question mark and is tilted on the side of the head. The top of the ear is located on the horizontal oval line that goes through the eyes or just slightly higher. The horizontal oval line through the bottom of the nose locates the bottom of the ear.

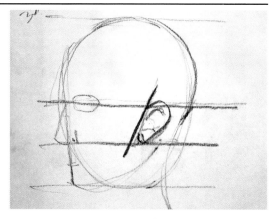

The ear is tilted on the head, and it is located more toward the back of the head than the front.

Relating Drawing the Head to Finished Work

The considerations that we have just discussed may not seem too obvious, or even too important, when looking at completed drawings and paintings. However, they are critical, for they are what make heads look correctly drawn. Let's study some completed drawings and paintings in relation to the essential considerations that we have discussed: axis of the head, tilt and turn of the head, vertical oval through the center of the face, horizontal ovals locating the features on the head, adjustment to the shape of the head because of the chin, adjustment to the shape of the head because of the back of the head.

The diagram (see the illustration below) of *Tuesday Night Poker II—Pro* shows that the axis of the oval of the head is slightly tilted—north pole tilted to the right. In relating this head to the nine heads in the illustration on page 15, we find that it is similar to head number 4, with the head level but turned to the left. The vertical oval through the center of the face shows that it is a three-quarter view. The forward tilt of the neck gives a stooped gesture that makes the line of the top of the shoulders connect to the head at about the level of the mouth or the bottom of the nose.

The detail of the drawing *The Singer* has an extremely tilted axis—north pole to the left. The tilt of the head is similar to head number 3 in the illustration on page 15, turned to the right and looking up. The vertical line through the center of the face shows that the head is turned to a three-quarter view to our right. The "unfinished" left side of the head reveals guidelines relating precisely to matters that we are currently discussing.

The head in the detail of *Red Heads* has its axis tilted and turned in a way similar to that of *The Singer*, but the head is turned slightly more to our right. The ear is located between the horizontal ovals of the eyes and the bottom of the nose.

Janie VI is similar to head number 1 in the illustration on page 15 with the north pole of its axis tilted to our left. As I was painting Janie, the steep upward angle of my view gave a feeling similar to that of her head being tilted back. Note the almost overlapping position of the tip of the nose and the left eye, which shows the extreme upward viewing angle that I had.

The backward tilt of the head in *Sun* is more exaggerated yet similar to that of *Janie VI*. The difference in the two heads is that the north pole of the axis in *Sun* is tilted to our right and to our left in *Janie VI*. We know where the ears are located in *Sun*, even though the drawing of them is incomplete, because the line of the sunglasses connects to the top of the ear. Notice the extreme horizontal oval through the mouth: It is almost circular. The more the head is tilted backward, the more the horizontal ovals through the features approach being circles.

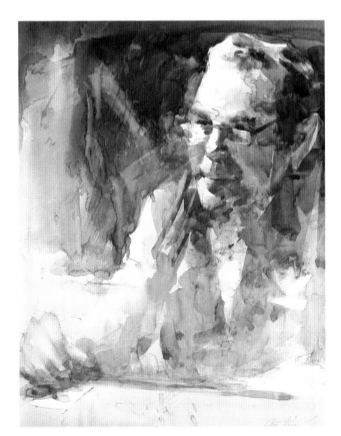

This head is turned the same as head number 4 in the illustration at the top of page 15.

TUESDAY NIGHT POKER II—PRO
watercolor, 14" × 11" (35.56 × 27.94 cm), 1983.
Collection of Rose Metz, Sumter, SC.

Compare the tilt and turn of this head to head number 3 in the illustration at the top of page 15.

THE SINGER (detail),
charcoal, 18" × 24" (45.72 × 60.96 cm), 1987. Collection of the artist.

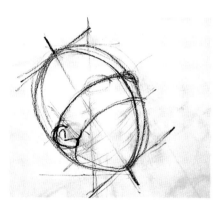

Notice how the horizontal ovals through the eyes and the bottom of the nose connect to the top and bottom of the ear, respectively.

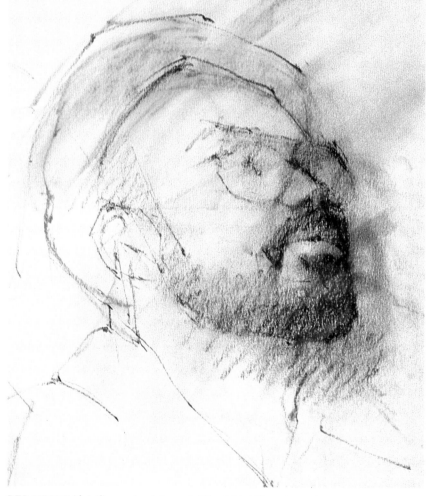

RED HEADS (detail), *pastel and charcoal, 18" × 24" (45.72 × 60.96 cm), 1986. Collection of the artist.*

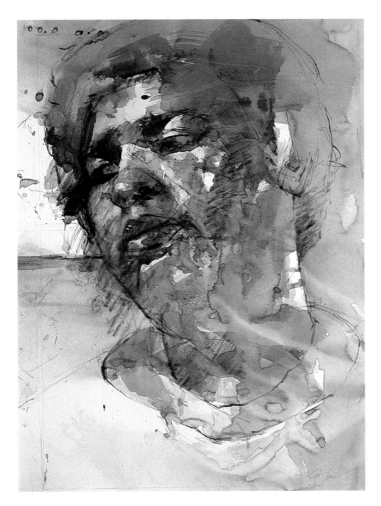

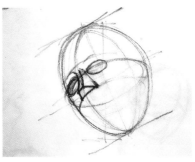

The steep angle created by looking up at Janie as I painted her made the wedge-shaped tip of the nose almost overlap the eye.

JANIE VI, *watercolor and charcoal, 16″ × 12″ (40.64 × 30.48 cm), 1985. Collection of the artist.*

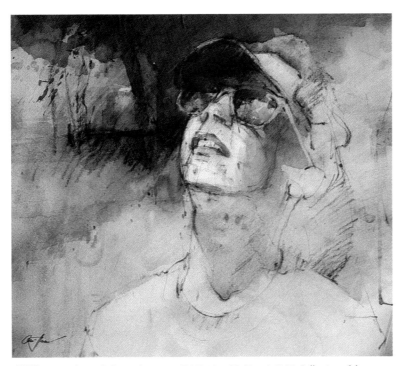

As the head is tilted farther back, the horizontal ovals through the features become almost circular. The horizontal oval connecting the bottom of the nose and the bottom of the ear is at a steep angle. The bottom of the ear is positioned straight across from the bottom of the chin.

SUN, *watercolor and charcoal, 16″ × 12″ (40.64 × 30.48 cm), 1985. Collection of the artist.*

Drawing the Features of the Head 23

Drawing the Figure

Drawing the figure and the head are simultaneously similar and different. They are similar in that the big shapes need to be dealt with first. They are different in that the head is a small part of the figure and must not be given too much detail or focus in relation to the remainder of the figure. Detail in figure painting should be detail of the figure, not the head.

In all of our considerations in this section, keep this approach in mind. We begin with the gesture drawing, which forces us to treat the figure as one unit. Having accomplished this, we break the figure down into its major moving parts; these are the large gestural parts of the figure. The one-value silhouette uses value instead of line to treat the figure as one unified shape. The two- and three-value silhouettes allow breaking up the figure but within the structure of the one-value silhouette underpainting.

A simple procedure, which may help here, is to position your easel farther away from the model when doing figure painting than when doing a portrait head. This will force you to look at the entire figure rather than focus on just its parts.

Gesture Drawing

I did not specifically mention gesture drawing in the previous section on drawing the head, but depicting gestures of the head is the result of being able to draw heads tilted and turned at different angles. Gesture is even more important in figure drawing. Since the figure is a much more flexible form than the head and the shoulders, gesture and motion are critical characteristics.

Study the gesture drawings on this page. Notice that I have tried to capture the essential movements of each pose. I concentrated on *what* the model was doing, not on who the model was. It was not a documentation of character, clothing, and detail that I wanted to achieve but a study of the major moving parts of the pose.

Since the torso is always the primary part of the figure, I completely omitted some parts of the body to further simplify the major movement of the next pose. You might include one or both arms and legs and the head if they are part of the continuous flow of the movement of the torso. If they are not, leave them out completely. *Quick Figure Sketch* is a gesture study in watercolor rather than charcoal or pencil. Practice these exercises in both watercolor and charcoal or pencil. However, do not make an abrupt switch from charcoal to watercolor when it is time for sustained "finished" paintings. Completed paintings *are* gesture studies, among other things.

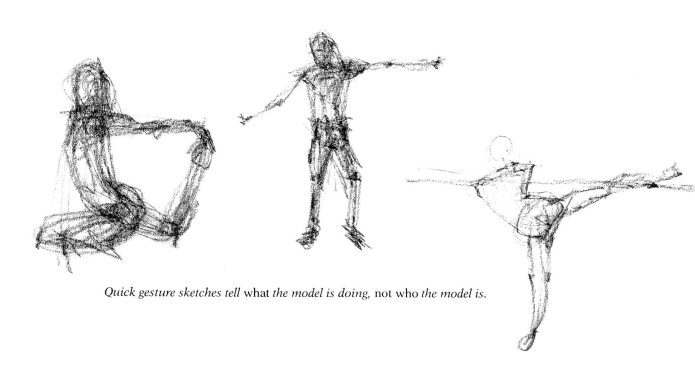

Quick gesture sketches tell what *the model is doing,* not who *the model is.*

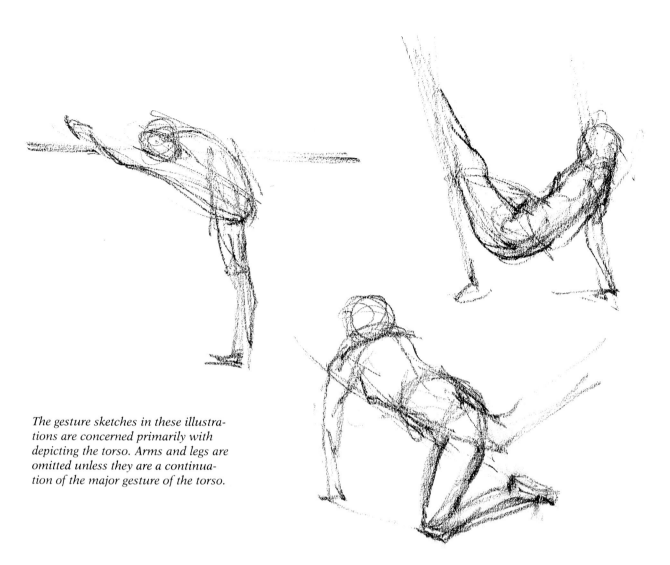

*The gesture sketches in these illustra-
tions are concerned primarily with
depicting the torso. Arms and legs are
omitted unless they are a continua-
tion of the major gesture of the torso.*

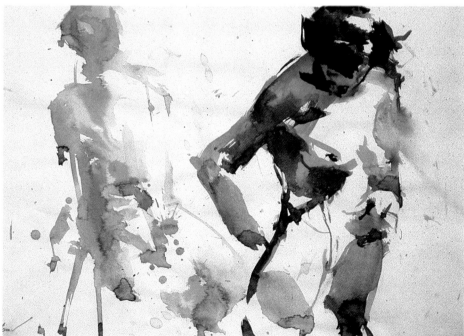

QUICK FIGURE SKETCH, *watercolor, 10″ × 14″ (25.40 × 35.56 cm), 1984. Collection of Sandra
and John Durrell, Myrtle Beach, SC.*

Major Moving Parts of the Figure

The primary benefit of gesture drawing is the simultaneous rendering of the entire figure. Never forget the gesture as your drawings and paintings become more exact. Although the figure is complex, it may be simplified by dividing it into its major moving parts: head, torso, upper arms, forearms, hands, thighs, lower legs, feet. Practice drawing figures using these fourteen major moving parts, but do not get too caught up in dealing with the individual parts. Remember that the gesture is the thing. Use gesture to represent *what* the model is doing.

To ensure that you achieve the goal of expressing the gesture of the pose when using the fourteen major moving parts of the figure, capture the essential movement of the pose and simply sketch the fourteen major moving parts of the figure over this gesture sketch. You can see how this is done in the example below. When approached in this way, even the dreaded foreshortened drawing of a form receding in space becomes simple.

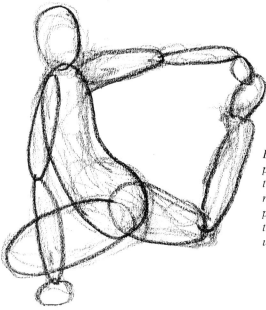

The fourteen major moving parts of the body permit us to draw individual parts of the body, but their simplification keeps our focus on the gesture of the whole figure.

By overlaying the body parts onto the simple torso sketch, we can retain the gesture of the pose even as we draw the form with individual body parts.

Drawing the Figure with Line

Students in my art classes have observed that I draw by establishing dots and connecting them. These dots are placed at intersections of shapes or at points of major change in the contour of the figure or any form. The lines connecting these darker, wider lines or dots are not too important and can be lightly drawn. This variety of line is more interesting visually than drawing all the lines the same. The upper right arm seen in *Lenore* is an example of this technique. This line exercise can and should be done with a wide watercolor brush in addition to charcoal.

The darkness and width of a line played against light lines or no lines at all emphasize or de-emphasize these contour lines.

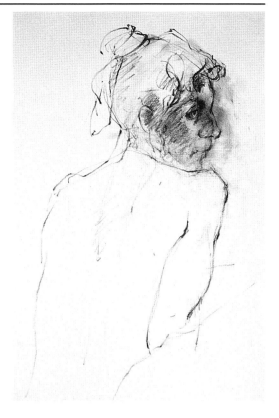

LENORE, *charcoal, 23" × 14" (58.42 × 35.56 cm), 1985. Collection of the artist.*

The Silhouetted Figure

A silhouette is a solid dark or middle-value tone occurring in a foreground figure or other form, created by a very light background or strong backlighting. Because it is a simple solid form, not an outline, the silhouette is an excellent way to study the figure and its gesture. Do the following exercises in watercolor with a wide brush rather than in pencil or charcoal.

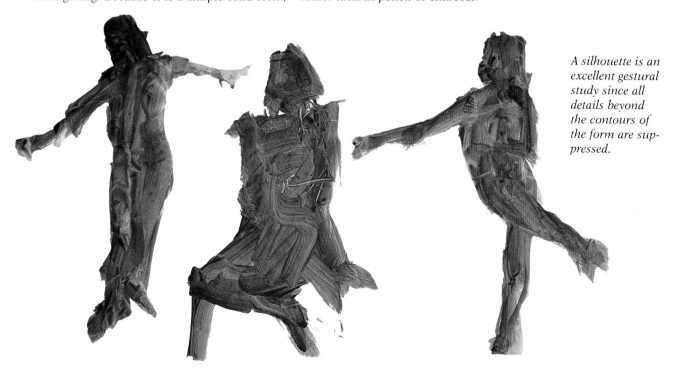

A silhouette is an excellent gestural study since all details beyond the contours of the form are suppressed.

The Two-Value Silhouette

Make sure that the middle value in this three-value scale is halfway from light to dark.

Control of the lightness or darkness of the one dark color of watercolor that you are using now becomes important. Study the value (tone, light and dark) scale in the illustration at left. Paint another silhouette as in the illustrations at the bottom of page 27, but this time take care to paint it with a solid middle tone. After you have completed the one-value silhouette, study the pose and determine the parts of the figure that are important and separated the farthest in space. Now paint a dark tone over the portion of the middle-tone silhouette that separates these forms that are separated the farthest in space. In the illustration below, left, the dark tone is painted over the right hip area to separate it in space from the middle tone of the knee and leg, which is coming forward in space. On a flat sheet of paper, the sharp edge between the two tones helps to create the illusion of depth.

The dark shape (forearm and knee) in the illustration below, right, gives the illusion of a shape coming forward in space. The separation of form in space is the same as in the illustration below, left, except that the dark is placed as a shape coming forward in space rather than as a shape receding in space.

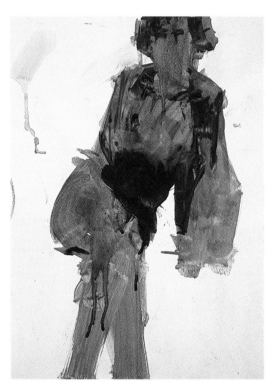

The edge between the leg and hip is sharp to draw attention to the separation of form in space. The top edge of this dark area, near the waist, is blurred because there is little separation of form in space at the waist area. The dark shape in this illustration recedes into space behind the leg.

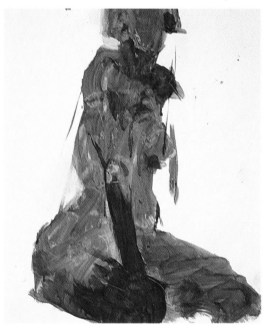

Here the dark shape of the forearm and knee have sharp edges and come forward in space in front of the rest of the body. Notice the blending of the dark edge at the thigh to make a gradual connection of the thigh to the hip area. The forearm and knee have to be the same dark value regardless of the actual local values of these two forms in order to represent the three-dimensional separation of form in space.

The Three-Value Silhouette

It is important to retain the integrity of the simple middle-tone silhouette as we deal with more specific portions of the figure. Even though we now want to add a light value to the figure, in addition to the middle and dark values, let's continue to begin painting the gesture with a solid middle-value silhouette. To get our light shape on the figure, simply wipe out the damp watercolor with a paper towel or damp sponge. If the middle-value silhouette has already dried and will not wipe up, wet the area again with clear water, and then wipe or scrub the paint off the paper with a paper towel or damp sponge.

The illustration below, left, was painted as a solid middle-value silhouette. The light areas were wiped out. The shapes painted darker were done as they were in the illustration on page 28. Remember that changes of value are used to represent the illusion of depth, not to indicate the lightness or darkness of hair or clothing or anything else. The illustration below, right, is another example of a three-value figure, with the lightest value wiped out. I added dark shapes to enhance the light shape. Resist the temptation to wipe out small lights or to paint small darks. Make fairly large shapes of all the values.

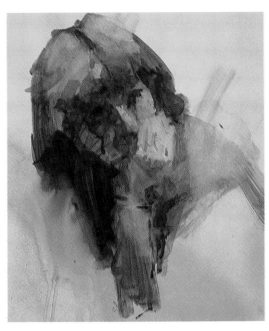

The light areas of the shoulder, fingers, face, and hair were wiped out with a paper towel. Although this technique can be used on any paper, it is easier on a relatively smooth paper, such as the Strathmore 400-8 drawing paper that I used.

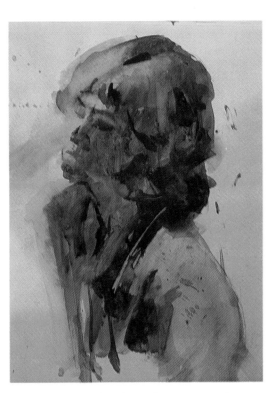

The shoulder is the closest form in space here. Since I wiped it out as a light shape, I placed dark shapes next to it at the bottom edge of the hair, the neckline, and the armpit area.

Relating Figure Studies to Completed Figure Drawings and Paintings

To ensure that the preceding ideas are not just exercises to keep art students busy, let's relate them to finished drawings and paintings. The first sequence on the left in *Seve's Mid Iron* is a one-value silhouette, which gives the entire emphasis to the gesture of the golfer. The other sequences do show some separation of value between golf glove, arm, and shirtsleeves, but the overall gesture and separation of body parts in space are maintained.

The gesture of the figure in *Plantation Lady* is what caused me to make this painting. To keep the unity of the figure, I made a very dark background since the figure was wearing light-valued clothing. Look at the face and the feet. Because this is a figure painting and not a portrait, I grouped the dark face with the dark background to de-emphasize the face. The background changes to a light value behind the feet. Notice that I made the feet a blurred middle value instead of a dark value so that they would not draw too much attention.

The Worker (page 32) is primarily a line drawing of the worker's arm. There are some dark lines of the arm, some light lines, and some disappearing lines. The white chalk and dark charcoal toning are further variations.

A Good Walk Spoiled (page 33) is also a line drawing. Because watercolor shapes tend to dominate line, I kept the watercolor areas to a minimum so that line could be used to explore the gesture of the golf swing.

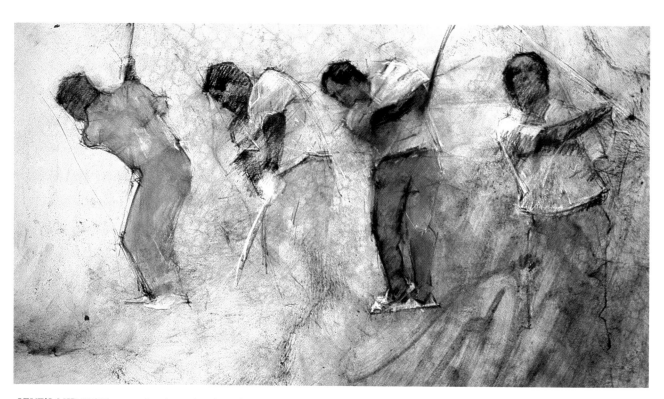

SEVE'S MID IRON, *watercolor, charcoal, and pastel on watercolor-toned paper, 16″ × 28″ (40.64 × 71.12 cm), 1988. Collection of the artist.*

The figure is professional golfer Severiano Ballesteros in four sequences of a golf swing. The four figures are centered in the page—which should have been a negative visually. To keep the four figures from being repetitive, I made several adjustments. First of all, their gestures vary from the backswing to the follow-through. Their colors also vary. The red of the pants is brighter in the third sequence from the left, and the legs are more complete than in the second and fourth sequences. The figures in the second and fourth sequences are larger than the other two. The pants, shirt, and head of the figure on the left run together creating a silhouette, warranted by the whiteness in the upper left.

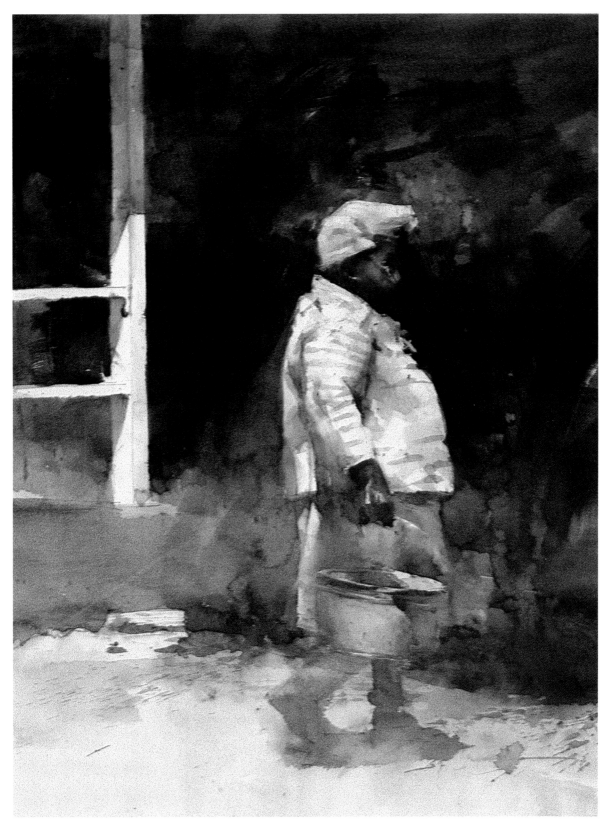

PLANTATION LADY, *watercolor, 15" × 11" (38.10 × 27.94 cm), 1982. Private collection.*

The white shapes of the coat, hat, and porch post were so strong that I did not want to pop out anything else. I kept the feet area as a middle-value silhouette. The face is close in value to the dark background, which shifts the painting's focus from the face to the interesting gesture of the figure.

I loved the lines from the hand up the arm to the shoulder. The hand and forearm are dark with charcoal, while white chalk makes the shoulder lighter than the watercolor-toned paper. Here, I was more interested in the shoulder than the front of the face.

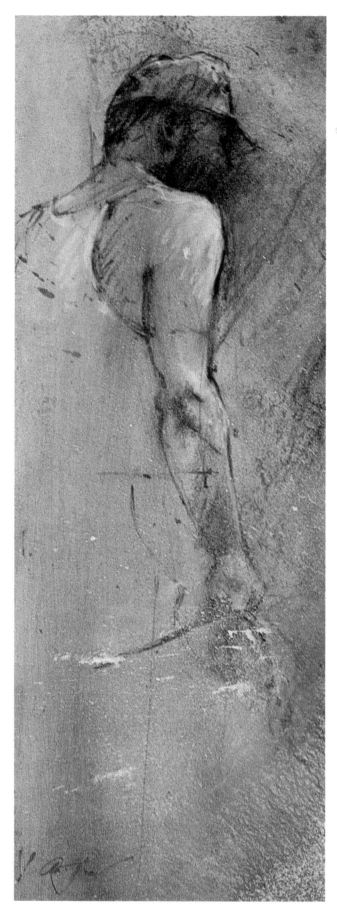

THE WORKER
charcoal, white pastel, and gesso on watercolor-toned paper, 18" × 6" (45.72 × 15.24 cm), 1986. Collection of Beverly Grantham, Greenville, SC.

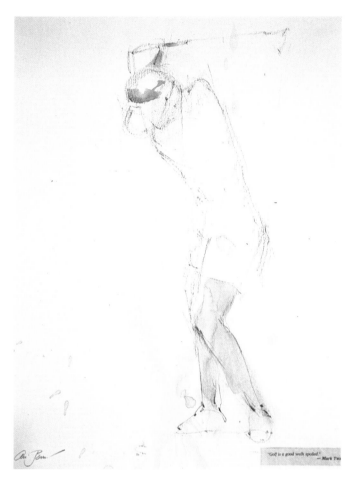

A GOOD WALK SPOILED, *charcoal and watercolor, 15" × 11" (38.10 × 27.94 cm), 1986. Collection of Mary and Joe Reeves, Myrtle Beach, SC.*

If they are well done, I like abbreviated sketches like this. As you can imagine, it was difficult for me to limit my use of watercolor to the legs and a touch of the hair above the sun visor. It takes some courage to deviate from the norm—our own and other people's—but when we do, our individual expression can come into its own. (The title of this painting came from a quote from Mark Twain: "Golf is a good walk spoiled.")

Toward an Individual Style of Drawing

The reply attributed to Edgar Degas when he was asked by an art student "How should I go about learning to draw?" was "Draw, draw, draw!" Degas's advice is invaluable.

Go to airports, bus stations, or other public waiting areas, and you'll discover a world of great models. Sketch people in their everyday environment. At home, don't sit in front of the television but, rather, beside it. Family members make wonderful models as they peer transfixed at the television screen. Or hire a model, and share the model and model fee with other artists. To keep costs down, work from photographs at times, but always *your* photographs not those of others. And always do more work from life than from photographs.

Practice figure drawing and painting exercises as often as possible. Draw more heads without features than you draw with eyes, nose, and mouth included. Exaggerate any deviations from the standard shape and size of the head and features that I have outlined here. Do some actual caricatures with the unusual features and shapes flagrantly emphasized. Do other drawings as semicaricatures.

Beware of drawing things. Draw shapes of different values representing figures in space. Draw and paint across edges of forms if the shapes are in a similar place. Do not color up to the edge of things.

Drawing can be learned in two or three years of full-time study and practice. Although we never learn to draw as well as we would like, there comes a time when we are comfortable with our drawing skills. I have observed that at this point the artist reaches an important crossroads. Should he continue to perfect the ability to duplicate the model's likeness, or should the artist now begin working and thinking in a more personal, abstract, and individual style? I believe the more personal approach is the desirable one. The most fascinating art trip of all is the voyage toward a personal aesthetic, with your work documenting each step of the way. I am still on that trip, and I relish it more with each new painting. I hope you too have begun this voyage of self-exploration.

The exercises in this book may be a somewhat different way of seeing for you. Practice them so much that they become a natural, albeit a new way of seeing. New visions and good habits are important. They will stand you in good stead as we build upon them in the succeeding sections on realistic and abstract design.

Part II

Designing the
Head and Figure
in the Rectangle

Design Elements
and Principles

Growth and expertise in any field of endeavor are best realized by delving deeper into the basics than by continually moving in new directions from an already all-encompassing foundation. This is the nature of advanced study. Successful paintings are most often simple and sure and give the impression that they were painted with ease.

The design elements are the tools of the artist's trade. They are

1. shape (pattern, form, mass, object, subject matter)

2. value (light and dark, tone, tint)

3. space (the illusion of three-dimensional depth and two-dimensional flatness)

4. edges (blurred and sharp, lost and found)

5. color temperature (warm and cool)

6. texture (surface variation)

7. line (drawing)

8. color hue (spectrum classifications: red, yellow, blue, etc.; local and arbitrary hues)

9. color intensity (brightness)

The design principles are the organizing aesthetic ideas that guide your use of elements in a painting. They are

1. dominance (emphasis, focal point)

2. movement (rhythm, direction, gesture, transition)

3. variety (contrast, conflict, tension)

4. unity (harmony, balance)

The artist deals directly with the elements on the painting's surface. The principles govern the elements. The first design principle, dominance, may be carried out by any of the elements, value, for example. Similarly, movement, the second design principle, may also be achieved by any of the elements, light-valued shapes, for example.

General design instruction presents these elements and principles in their broadest terms to the art student for understanding and use. How-ever, I will further request that preferences and priorities be made from the list of elements. For instance, eventually a choice of a dominant design element should be made and a choice of an element should also be made to move the eye through the painting (movement), etc. These choices create a built-in unity that will hold the design together and give continuity to all of your paintings.

In this section, we will discuss the elements and principles one at a time, studying each from two points of view: its most general use and my individual approach to using it. We will clearly indicate whether each element or principle is to be emphasized or de-emphasized, and how each fits into a specific design style and relates to the overall design.

This approach is broad enough to allow any artistic style to develop and specific enough to give each style direction. Even if you have studied design thoroughly, I think you will find this information useful, since it is written from a personal approach.

Throughout my years of painting, it was not my conscious intention to develop a design structure that could be put into words. But as I began to study and analyze the characteristics of the paintings I was doing, I gradually realized what was dominant and what was least important and how each element and principle corresponded to the whole. It has been very satisfying for me to be able to articulate the design structure in which I work. It has helped me with both my painting and my teaching. I find that having this framework in mind is an invaluable aid in critiquing student's work and in evaluating my own work—one of the most difficult things for an artist to do.

When presented in their most general terms, design elements and principles can be a dry and nebulous subject. My goal here is to present design in a personal way, showing in a step-by-step fashion through the inclusion of many sketches, diagrams, and paintings how to interact more knowledgeably with the ever-changing pattern of brushstrokes one uses to make a painting.

Shape
Grouping and Arranging the Model and Background in the Rectangle

The artist is the shape maker, completely in charge of creating shapes and arranging them in the rectangle. It is not the creative artist's job to reproduce exactly what he sees, for that would be documentation, not art. Similarly, it is not for the artist to give in to current styles of arranging shapes in the rectangle. The artist needs to explore a more unique personal vision. This development will occur naturally through intelligent hard work.

Think about what you are doing as you design your painting. Visualize the paintings you have seen that fail to meet your standards. How many fail because they are too complicated? How many fail because they are too simple? Don't you find that using too many shape arrangements is more often the cause of failure than using too few?

Be aware that the artist's arrangement of patterned shapes in the rectangle profoundly affects all subsequent design decisions. Seize the opportunity to be a creative shape-maker and put yourself into the rectangle. Distinguish yourself as shape maker and artist.

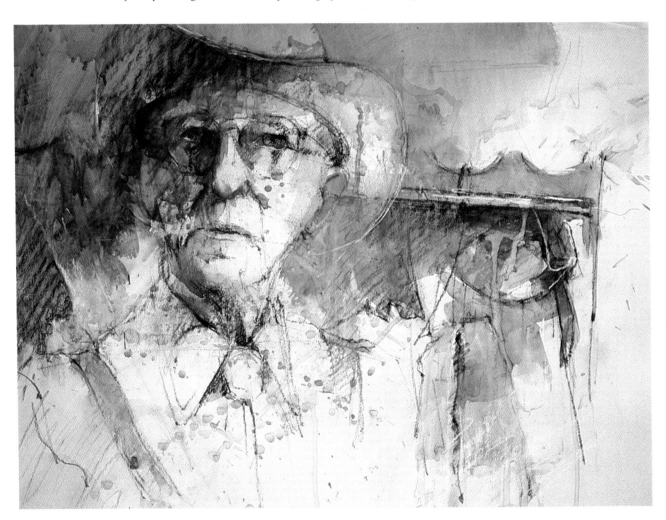

BILL, *watercolor, charcoal, and pastel, 18" × 24" (45.72 × 60.96 cm), 1987. Collection of Mary Whitehill, Newburgh, NY.*

Background shapes are much more difficult to paint for me than the portrait head or the figure. This painting is a rare one in that I like the background shapes on the right more than the portrait head.

Simplifying Shapes

There are two basic ways of simplifying representational subject matter—grouping and zooming in. I use a combination of both ways with an emphasis on zooming in. I respond to large interesting shapes in a close-up rectangle. Most artists do not choose to zoom in as closely as I do, so the need for grouping becomes critical to the unity of the painting.

It takes a lot of visual training to simplify a subject that contains sixty shapes, for example, into a subject that contains ten to fifteen shapes.

Most realistic subjects have at least sixty shapes, and the popular landscape is the most complicated of all. Copying those sixty shapes is often a goal for the beginning art student, and this can be a useful project. But what happens after the art student learns to copy those sixty shapes in paint? He must then realize that there is more to art than duplicating reality. Grouping and simplifying shapes places the artist in a creative position, poised on the verge of discovering his own personal aesthetic philosophy.

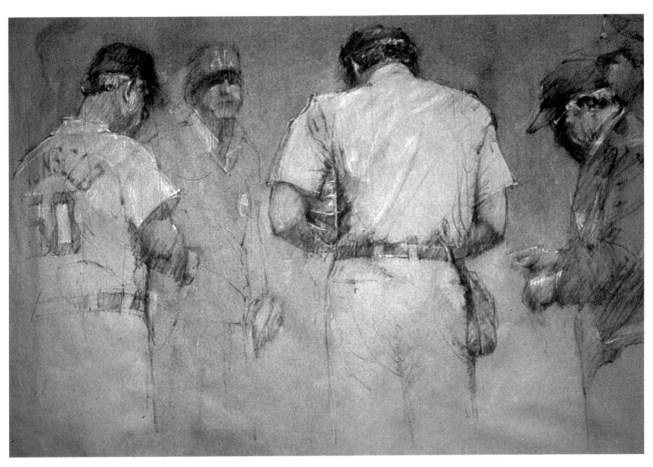

EXCHANGING LINE-UP CARDS, watercolor, charcoal, and pastel on brown Kraft paper, 26" × 40" (66.04 × 101.6 cm), 1983. Collection of Barbara Cogan, Spartanburg, SC.

When I started this painting, I did not realize that I was going to work so simply. With five figures filling the rectangle, no further background shapes were wanted. The umpire's back, being such a large shape, needed no further contrast. The only watercolor used in this large painting was painted in one continuous wash without a change of color or value. The blue was painted around the three foreground figures except for the jacket of the baseball manager at the right and the two umpires in the background. Charcoal and chalk completed the work.

Size of Shapes

I have a stack of throwaway watercolor paintings in my studio—as do many watercolorists. Recently, I went through them and found that the single biggest reason for their failure was that the shapes were too small for the rectangle. At the risk of seeming academic, let us devise a scheme to guarantee that our shapes are not too small for the space they are in.

In order to competently paint shapes in relationship to one another, we have to limit their number. Let us consider making an entire painting of, say, only twelve shapes. That may sound like too few, but remember that we must paint the relationship of each shape to *every* other shape. Since we have to keep in mind not just the relationship of adjacent shapes but shape relationships from one side of the rectangle to the other, the choice of twelve shapes seems sufficiently complicated. (The idea is to use between ten and fifteen shapes.)

This grid is a reminder not to begin with shapes that are too small. Twelve shapes for a painting may seem to be too few shapes, but remember that we are painting shape relationships, not shapes in a vacuum.

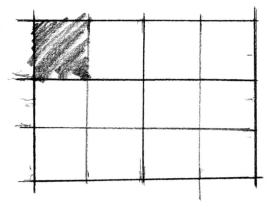

Once we have agreed upon the idea that twelve shapes are enough with which to deal, we then need to determine the size of an individual shape. The grid shown here may be beneficial in determining the size of a single shape. Using the formula $4 \times 3 = 12$, divide the long side of the rectangle into fourths and the short side into thirds. The size of any one section of the grid is our general reference for the size of one shape. When you paint a full-sheet watercolor—$22'' \times 30''$—both of your hands side by side are equal to about the size of a single shape. For a half-sheet watercolor—$15'' \times 22''$—one hand is equal to approximately one-twelfth of the rectangle. For a quarter-sheet painting—$11'' \times 15''$—one hand balled up as a fist is an appropriate size. Although we know that any painting needs small, medium, and large shapes, this is merely a guide to remind us to be wary when we begin painting shapes smaller than one-twelfth the size of the rectangle.

Even though the many blurred edges found in my paintings make it difficult to determine the number of shapes, you can see the twelve major shapes in *Jazz Bass—Tom* in the accompanying diagram. If you look at the reference grid, you'll see that the average size of a single shape in *Jazz Bass—Tom* is very similar. The focal-point relationship of two shapes involves the head and the adjacent hand. The size of each of these two shapes is enlarged to a size that is nearly one-twelfth of the rectangle by a combination of grouping and zooming in.

The hand (shape 1) is made larger in relationship to the rectangle by zooming in on the bass player in the photograph on page 39 and eliminating the left side of the photograph. The shapes of the head of the bass player (shape 2), which are enlarged in the same way, are further enlarged by grouping. Not only is the large shadow plane of the head grouped as a single shape, but it is combined with a dark background, which is not in the photograph.

I often hear it said that painting portraits and figures in watercolor is the most difficult of all painting problems. I can also recall saying the same thing myself several years ago. And yet, compared to their ability to group and arrange shapes in the rectangle, art students are generally quite successful in drawing the head and figure and in handling the watercolor medium with this subject. My critiques of students' portrait and figure paintings are, by far, more involved with design than they are with drawing the model and handling the watercolor medium!

Choose any subject to paint, such as the photograph on page 39. If you agree that translating the photograph into a watercolor painting is not art, then consider a personal response to the shapes as the job of the artist. Sketch the subject in the usual way. Then use the grid that we have discussed to determine the general size of a single shape. If there are more than twelve shapes, decide upon the grouping of small shapes into larger ones, totaling no more than ten to fifteen shapes. Of course, variety in the size of the individual shapes is required. Make sure there are enough shapes that are larger than one-twelfth of the rectangle, as well as some smaller. Use your pencil to redraw the contours of these grouped shapes. Confine detail to the edge of a shape or to transitions between adjacent shapes. This transition area from one shape to another is the appropriate place for detail.

The color, value, edge, etc., relationship of one shape to its adjacent shape is near the top of my list of important design considerations. As you paint in this way, you will automatically feel the abstract relationships of shapes. For the beginning art student as well as the on-dead-center realist, this feeling of painting a representational subject with an abstract structure may be a unique experience.

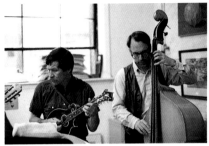

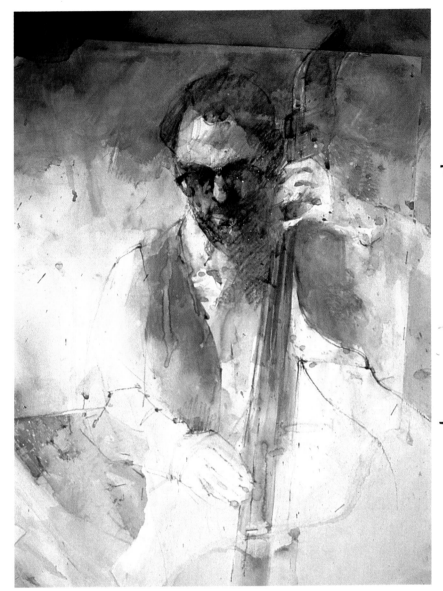

JAZZ BASS—TOM, *watercolor, collage, gouache, and charcoal, 25" × 19" (63.50 × 48.26 cm), 1985. Collection of Oklahoma Christian College, Oklahoma City, OK.*

Simplification is achieved by eliminating the mandolin player and zooming in on the bass player. The shapes of the bass player and his environment are then further simplified by grouping small shapes into larger ones.

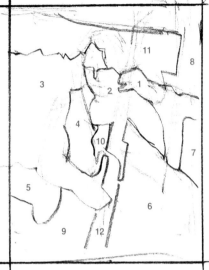

As you can see from the photograph, there are frequently more than twelve shapes in a subject chosen for a painting. The sketch shows my simplification of the photograph. I have grouped and numbered the shapes in the rectangle to show you the twelve I've limited myself to and their sizes— roughly the size suggested for this size rectangle if you use the reference grid.

This photograph has more than twelve shapes.

Here is the sketch of that photograph before I simplified the shapes.

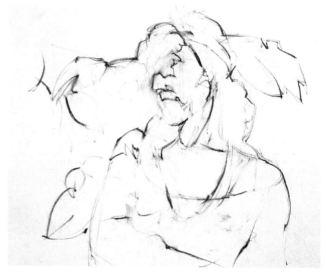

In this sketch small details at the center of shapes have been erased so that the interest moves from shape to shape rather than lingering within one shape only. This is a way of simplifying the number of shapes.

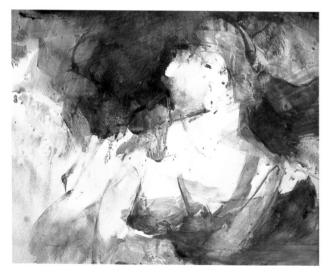

An abstract simplification of the shapes in the photograph above.

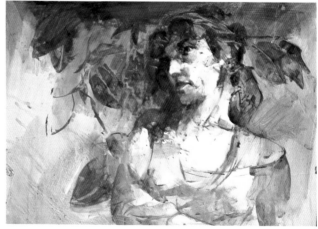

A more realistic treatment of the same photograph. Notice that most of the detail is at the edges of shapes.

Arranging Shapes in the Rectangle

Consider various possibilities for the arrangement of shapes in the completed painting. If the artist is so inclined, the painting may be developed as a complete abstraction. An abstract painting is based on nature, although the images depicted may or may not be recognizable as shapes from nature.

Through the years I have come to realize that *drawing is grouping* and that *painting is primarily a personal patterned arrangement of shapes in the rectangle.* It is not enough to place the shapes in the rectangle as the model and background are posed. Kimon Nicolaïdes, author of *The Natural Way to Draw,* reminds us that "It is necessary to rid ourselves of the tyranny of the object as it appears." Painting shapes just because they are there, which I refer to as the Mount Everest theory of painting, is too automatic a response to reality. One needs to be selective.

In arranging shapes in the rectangle, we'll begin with the focal point. The focal point of a painting is where the viewer first looks when viewing a painting. It should be seen as the relationship between two shapes, not as just a single shape. A single shape exists in a vacuum, whereas a painting is made up of many interrelated shapes. The edge between the two shapes is the center of the focal point. Generally, this edge should be placed in one of the so-called sweet spots. These "sweet spots" are not centered horizontally or vertically, and they are not placed around the edges of the rectangle. When you place the important shape relationships in the "sweet spots," remember to make the shapes the appropriate size in relation to the size of the rectangle.

Place the remainder of the simplified shapes in the rectangle in a visually interesting way. Do not neglect background shapes. Too often we *choose* an interesting model but merely *take* whatever background shapes are there. Yet the background (negative space) is as important as the foreground (positive space).

Practice painting backgrounds only. Although you will not be able to paint shape relationships with regard to the foreground shapes, in this way you can gain increased awareness of the importance of background shapes. Also, do some paintings placing the model in the background. A heightened consciousness of the model's environment will make you more comfortable when you are painting foreground-to-background shape relationships.

Even with simplified shapes, it is important to design rest areas in paintings. Think of them, in one sense, as the sky in a landscape painting. The often-present, small, busy shapes benefit from the juxtaposition of these rest areas.

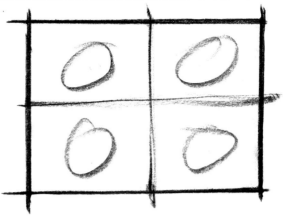

The focal point in a painting is generally placed in one of the four "sweet spots" shown above. By observing this suggestion, you can avoid two common problems: (1) If you place the focal point in the center of the painting vertically or horizontally, movement through the painting can be awkward because there is not a long side of the rectangle to move toward. (2) If you place the focal point near the edges of the painting, you might lead the viewer's eye out of the painting rather than into it.

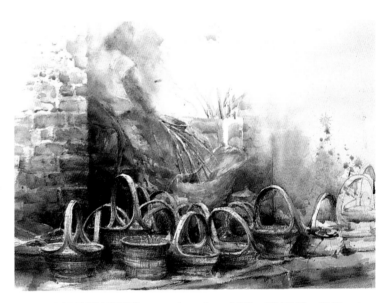

CHARLESTON BASKETS, *watercolor and pastel, 22" × 30" (55.88 × 76.20 cm), 1979. Collection of Gaye and Jesse Fisher, Myrtle Beach, SC.*

The figure is a background shape in relation to the group of baskets, which is the focal point. Painting and photographing people in their environment adds variety and a naturalness that posed-in-the-studio paintings do not have.

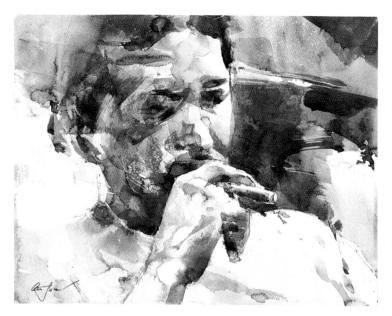

KEG, *watercolor and pastel, 11" × 15" (27.94 × 38.10 cm), 1981. Collection of Jane Wall, Laurel, MD.*

Running shapes off two or three sides of the painting creates movement and rhythm in the painting, whereas placing shapes in the center of the rectangle often results in a static, object-oriented rendering.

Use one dark color to paint sheets of inexpensive paper to correspond to values 2, 3, and 4—one tone for each sheet. Use an unpainted sheet for value 1 above. After sketching a subject with pencil, tear and glue these value shapes over the sketch in a patterned arrangement. Working with these value and shape relationships is a critical design consideration.

You might also design an arrangement of shapes so that the shapes run off two or three sides of the rectangle. The piled-up-in-the-center look is usually an undesirable arrangement. The racetrack shape running around the outside edges of the rectangle is markedly uninteresting. This tendency may have been initiated by teachers, myself included, who asked beginning students to make sure all their shapes were placed safely within the rectangle. Running shapes off two or three sides of the page suggests to the viewer that there is life beyond the edges of the painting. Furthermore, the completed image will appear to be a patterned arrangement rather than a rendering of an object placed in the center of the rectangle.

The arrangement of shapes in the rectangle is a critical design consideration. One of the best ways to treat this problem is to visualize the shapes as being two-dimensional. If you leave the individual shapes flat, instead of rounded or detailed, the eye is more inclined to focus on their relationship to each other rather than on their individual shapes.

To understand the importance of this two-dimensional arrangement of shapes, do the following exercise with both different realistic subject matter and as a complete abstraction. Using three small sheets of inexpensive drawing paper and one dark color, paint each of the three sheets to correspond to values 2, 3, and 4 in the illustration at left. Use a white sheet for value 1. Sketch a subject on inexpensive paper. Remembering the previous discussion of the size and simplification of shapes, cut or tear the four sheets and glue or tape them over the sketch. When you are viewing the completed watercolor collage of two-dimensional shapes in four values, what your eye will see and enjoy is the arrangement of those shapes. Embellishing those shapes, realistically or abstractly, is almost decorative as compared to the importance of a simplified, visually interesting arrangement of shapes in the rectangle.

As we shall see, a seemingly simple matter of sketching the subject on the paper can be decidedly difficult and can have a profound effect on all other design considerations.

Value

Assigning and Arranging Light and Dark Shapes

Value is my choice of a dominant design element. I get excited about mysterious darks, transparent middle values, and contrasting whites. My persistent interest in drawing and my preference for graphic images on paper reinforces my fascination with lights and darks.

Value is the core of my vision. Leaving light shapes white and being bold enough to paint rich darks maximizes the boundaries of contrast. Traditional realists, colorists, and abstract artists all generally agree that value is the primary visual shape-maker. Humans identify objects in nature primarily by whether they are light, middle, or dark values. Color, texture, and most of the other design elements are characteristics usually seen secondarily.

This value-oriented vision does not have to be the case. Shapes can also be distinguished by color, for example. However, most art students are trained to see shapes in relation to values. I recommend this method also. Master value before emphasizing color. Use color to enrich shapes defined by value. From the light and dark poles of the color sphere, travel the equator of color's perimeter, never forgetting the value of value.

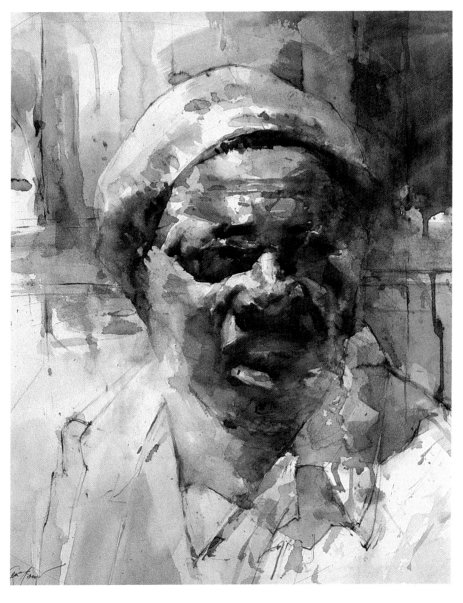

Most of us paint in watercolor because we love the transparency of the medium. We tend to worry when we lose the white of the paper. Dark areas of watercolor can be painted that retain their transparency, but those areas are often not dark enough for the value painter. Be willing to paint opaque darks as you see here. They will contrast nicely with the transparent middle and light values. Be sure to repeat them in other places in the rectangle as well as set them up with strong middle values.

PLANTATION MAN VIII
watercolor, 22" × 17" (55.88 × 43.18 cm), 1982. Collection of Nancy and Max Rogers, New Bern, NC.

The Paper-Doll Relationship

The paper-doll relationship has the white shape coming forward in space as the dark shape recedes. The only way to make a light shape come forward in space in a painting is to surround it on three or four sides with dark.

Cutting out white paper dolls with scissors and gluing them on a black paper background is a common activity for many children. The white paper-doll shapes stand out from the black background. The paper-doll value relationship is the core of the vision of all watercolorists. An interesting light shape, or the possibility of one, is often the single inspiration needed for painting. Beginning watercolorists quickly learn to give special visual attention to the light shapes that come forward in space. Creating the paper-doll relationship is one of the ways of handling these areas of light.

Most of my paintings were initiated upon seeing an exciting foreground light shape. *Jacksonville Demo* is an example. In this painting, the light on the side of the face is the "paper doll" coming forward in space in front of the dark background.

It is often critical to resist the local color, in this case the light flesh tones. Sufficient value contrast can be achieved only by leaving this light shape very light. Often it is necessary to paint around it, leaving the white of the paper. Value contrast, being the dominant element and, thus, the focal point of the entire painting, must be kept far from a middle-value range. If the pure white of the paper-doll relationship seems too stark after the painting is otherwise completed, it might be appropriate to use a very pale wash over certain portions of it.

I love this foreground light focal-point so much that I will often change a middle or dark value in my subject to a white paper-doll value relationship. The light plane of the black man's face in *Ned* is an example. The characteristics of the black man's face are not lost when using a paper-doll value relationship, for these characteristics are portrayed in the shadowy shapes of the face and in the contours of the white value against the background. This ability to change any middle or dark value to a white value gives the painter great latitude in handling subject matter.

JACKSONVILLE DEMO
watercolor, 15" × 22" (38.10 × 55.88 cm), 1985. Collection of the artist.

The paper-doll light value that comes forward in space in this painting is the light on the side of the face. It is surrounded on three sides (left, top, and right) by darker areas to make it come forward. The background dark on the left is the most contrasting value relationship with the light face, ensuring a foreground-to-background relationship.

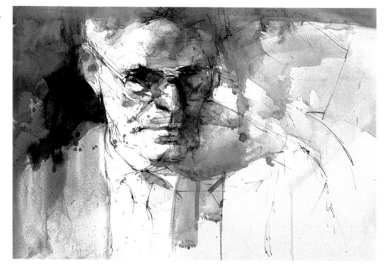

NED, *watercolor, 17" × 23" (43.18 × 58.42 cm), 1984. Collection of Bobbie Cheetum, Aiken, SC.*

The right side of this black man's face remained white without changing the character of the black face. It may be necessary to change middle or dark values to light values in order to express your unique vision. I love to paint black skin. When I see black people, I see the person and a painting. Artistically, for the value painter, black faces range from rich darks to shimmering lights.

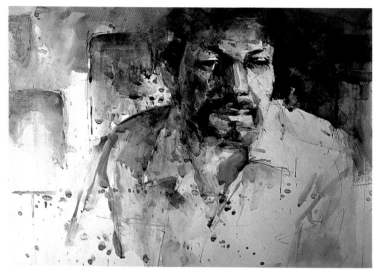

The Silhouette Relationship

In the silhouette, the spatial positions of the light and dark shapes are reversed from those of the paper-doll relationship. The dark shape comes forward and the light shape recedes. You can visualize the silhouette as a figure in front of a window or as any shape made shadowy by backlighting. *Classic Golf* is a painting that has a complete silhouette, a silhouette with no secondary paper-doll relationship. It is rare that I find an image that works as a continuous silhouette without being monotonous. In *The Market— Charleston V* (page 46), the silhouette is the vague figure in the upper left, a shadowy dark form with backlighting. In *Jeanne Cummings* (page 46), the semiabstract shapes (A) in the upper right are silhouettes. In both paintings, notice that the silhouettes are shape relationships secondary to the paper dolls. Since the silhouette's value range is closer in value, it does not compete with the paper doll as the focal point.

However, the silhouette can be the focal point and the paper doll the secondary relationship. In this case, the foreground shape of the silhouette (A) in *Junior Leaguer* (page 47) should be a rich dark and the background very light. Because the paper doll (B) in the same painting is not the focal point, it should be closer in value to the background shape.

Try to gain facility in painting the silhouette in a flexible range of values, deepening middle-value shapes to darks and changing light shapes to dark silhouettes. The photograph on page 47 shows the upper portion of the figure to be a light shape and the lower portion darker. When transformed with paint, the figure became a dark silhouette at the top and a secondary paper doll at the bottom.

The key to creating a silhouette is not the silhouette itself but the light background portion of the silhouette relationship. Hold out one of your hands. The lamp by which you are reading makes your hand light. Now move the same hand in front of the reading lamp or in front of the daylight from a window. Squinting your eyes will help you see that your hand has become silhouetted.

The silhouette is the opposite of the paper-doll relationship of values in space. The dark is in front, and the light is behind.

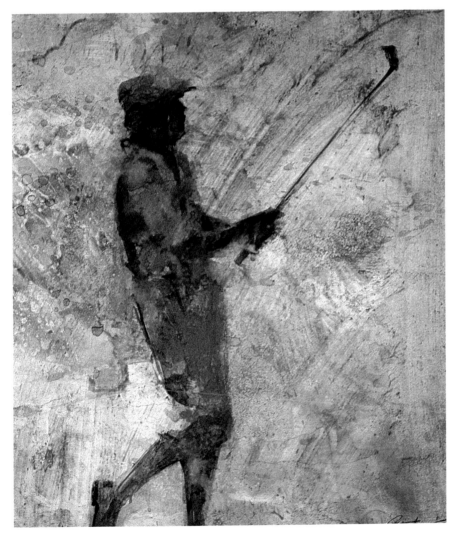

A major point of emphasis in this text is to use both the silhouette (dark foreground shape against a light background) and the paper-doll relationship (light foreground shape in front of a dark background). I think that in most value paintings, it is necessary to use both. However, this painting uses only the silhouette. Nowhere in this painting does a light shape come forward in front of a dark shape. The monotony of the continuous silhouette is alleviated by the interesting textures in the dark figure and the light background.

CLASSIC GOLF, *watercolor on watercolor-toned paper, 19" × 17" (48.26 × 43.18 cm), 1988. Collection of the artist.*

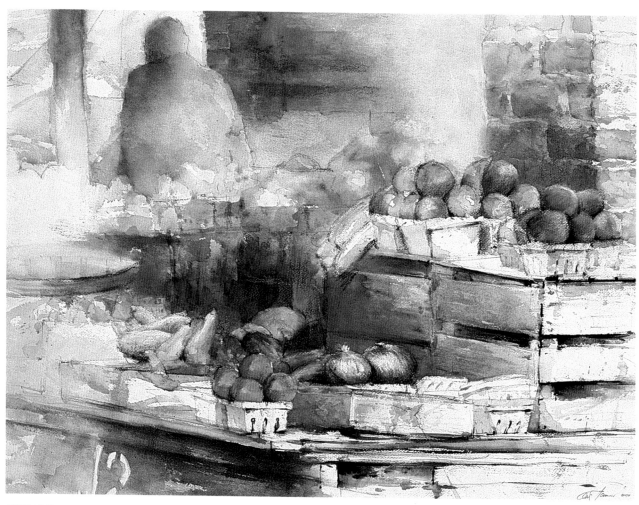

THE MARKET—CHARLESTON V, *watercolor and pastel, 22" × 30" (55.88 × 76.20 cm), 1979. Collection of Mr. and Mrs. J. Eldon Green, Columbia, SC.*

Although there are many silhouetted shapes in any value painting, the major silhouette here is the dark figure in the upper left against the background light.

I am always in a quandary concerning the background when painting a posed studio model for a workshop class. Here the silhouetted background shape (A) is a plastic dinner plate thumbtacked to the wall. The other partially silhouetted shape (B) is a large roll of binding twine. When painted semiabstractly, these strange objects work nicely with the head.

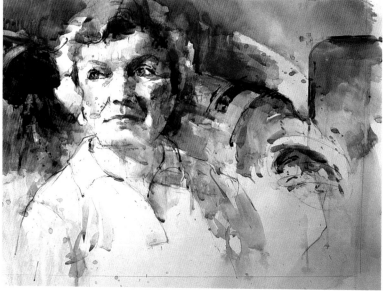

JEANNE CUMMINGS, *watercolor, 17" × 23" (43.18 × 58.42 cm), 1985. Collection of Jeanne Cummings, Noblesville, IN.*

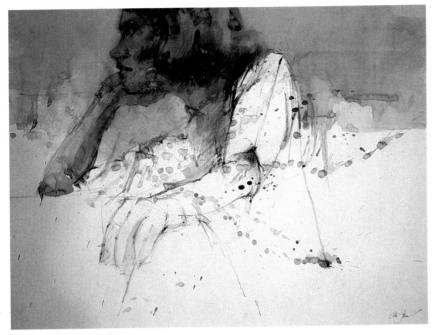

The silhouetted focal point here is the dark face (A) against the light yellow background. The paper-doll value is a secondary relationship. It is the light shoulder against the yellow, and the white paper (B) against the yellow.

JUNIOR LEAGUER, *watercolor, 17" × 23" (43.18 × 58.42 cm), 1986. Collection of the artist.*

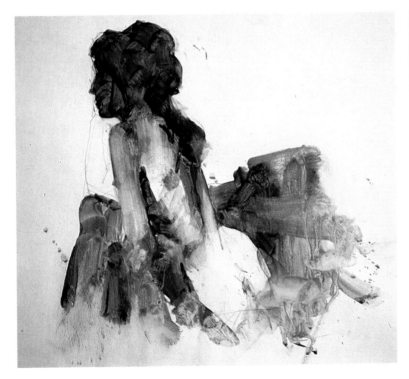

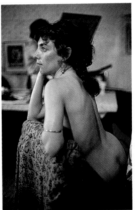

In this photograph the upper figure is light and the lower figure is dark. See how the values can be adjusted to suit the artist's purpose in the painted diagram.

The light upper part of the figure is changed to a silhouette. The shadowy lower part of the figure is left lighter than it really appears, and the lightness is enhanced by the lower background darks.

Dark Values

I have heard watercolor teachers say they could step inside any watercolor classroom and say, "darker," and it would be a valid comment. It is true that if darks are poorly painted, they can destroy an otherwise competent painting. Without dark values, half of the critical value contrast is missing. The haunting, mysterious mood that a painting conveys to the viewer is primarily supplied by dark values.

A performing artist should have the humility to prepare and the audacity to perform. Painting requires the same qualities. Once the necessity for the dark shapes has been determined intellectually, confidence and boldness are required to make them a reality. To add variety and attractiveness to the dark shapes, practice painting wet-in-wet transparent darks a la Charles Reid and dry opaque darks a la Andrew Wyeth.

Darks painted wet-into-wet are attractive to the eye because they take advantage of watercolor's inherent transparent nature. But take special care to keep darks rich in value and clearly separated from middle values.

Dark values painted dry and opaque readily retain their dark value and make contrasting middle values look even more transparent. But some artists object to them because they tend to look like oils and opaque acrylics.

Get in the habit of putting in at least one dark at the start of the painting; this will establish the value range early in the painting process. The value range indicated in the illustration at right is critical to a painting's success. When rich darks are not painted and the white paper is lost in the light shapes, contrast is not possible. For the value painter, a middle-value painting almost always fails! To succeed with a middle-value painting, you must designate bright color, strong texture, or some other dynamic design element as the focal point to replace the lack of value contrast.

Minimize the frustrations of painting by not getting involved with more than you can handle. Even though monotone (one-color) paintings can be boring, I see many more of them as unified, successful images as compared with those paintings that are dominated by color that is often fragmented. Add color emphasis to value-oriented beginnings. Remember the question we asked in the previous chapter on shape: How many paintings do you see that fail because they are too complicated? I see studios full. I see very few that fail because they are too simple. Paintings with a dominance of value contrast are simpler than color-struck images, for the colorists' paintings usually contain a full range of values as well as color complications. Practice value paintings in their purest sense—monotones.

We have discussed monotone paintings here. The silhouette and the paper doll are monotone (one-color) paintings. In fact, the design elements—*shape, value, space, edges, texture,* and *line*—and the design principles—*dominance* and *movement*—are all discussed in terms of monotone painting. It is for this reason that I have ordered the elements and principles so that color is not discussed until the seventh section on design.

Monotone paintings can easily be transformed into value paintings containing color passages of secondary importance. We will discuss color later as the dominant design element. For now, decorate the light, middle, and dark shapes with color but retain the value dominance.

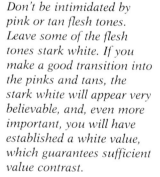

Don't be intimidated by pink or tan flesh tones. Leave some of the flesh tones stark white. If you make a good transition into the pinks and tans, the stark white will appear very believable, and, even more important, you will have established a white value, which guarantees sufficient value contrast.

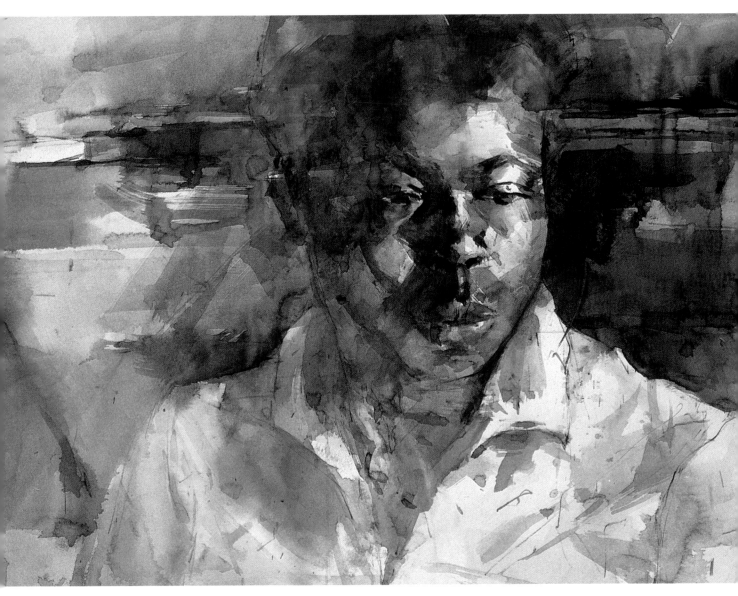

SEA VIEW WAITRESS, *watercolor, 17″ × 23″ (43.18 × 58.42 cm), 1982. Private collection.*

I would not have painted the darks as opaque as I did here if there were not sufficient middle values near the darks to make a good transition to the light values. The value painter must have both the lights and the darks. The middle value holds them together.

Space
The Traditional and Contemporary Look

Imagine being at an outdoor art show and walking in front of the painters' displays. One of the first things that the eye records at a glance is each artist's use of space. Some artists retain the predictable use of three-dimensional space; others combine depth and flatness.

Prior to Paul Cézanne, the French post-impressionist painter, much of art history reveals paintings filled with spatial illusions of depth that re-created nature's three-dimensionality. The invention of the camera and the evolution of aesthetic thought diminished this expectation. So, today, we find there is the challenge to retain the integrity of the surface of the canvas or paper. Many artists today combine traditional three-dimensional space with the flatness of modern imagery, creating an exciting combination that acknowledges the past while paying heed to the discoveries of modern aesthetics.

My interest in both traditional and contemporary art clearly shows itself in my use of space. I love to model three-dimensional shapes—such as a portrait head—with value, color, and a variety of edges. However, I find that when the entire rectangle is handled with three-dimensional use of space, the overall impression is mannered, unexciting.

What intrigues me much more is combining flatness with the illusion of depth in the same painting. I enjoy the emphasis of the patterned divisions of two-dimensional flat space in the rectangle. But one has to beware of carrying this to the extreme and painting flat shapes that look cartoony or unsophisticated.

In these pages, I have established the importance of simplifying and making priority judgments, especially regarding value and color. It may seem that I am now complicating the use of space by including the use of both two- and three-dimensional space, but after considering the following discussion, you will see that there is actually substantial simplification.

While Joe was waiting for me to get my watercolor supplies ready for painting, he was facing me and looking down. I probably would not have posed him that way. Models usually take the most interesting and natural poses without being posed by the artist. How many times have I started a painting and noticed the model, during a rest break, in a much more interesting position than the one that I was painting?

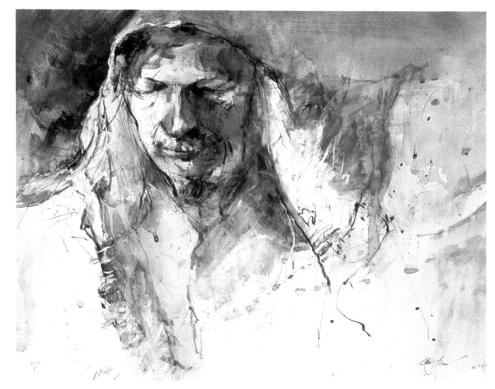

JOE WITH A HOOD, *watercolor, pastel, and charcoal, 18″ × 24″ (45.72 × 60.96 cm), 1986. Collection of Marge and Joe Ross, Columbia, SC.*

Space and the Focal Point

The paper-doll and the silhouette value relationship in space are simplified flattened shapes, but their contrasts of value separate them in space, creating the illusion of depth. The white shape of the paper doll comes forward as the dark shape pushes back. The dark shape of the silhouette comes forward in front of its light background. The flat shapes combined with the push-pull between them create a focal point that uses both two- and three-dimensional space.

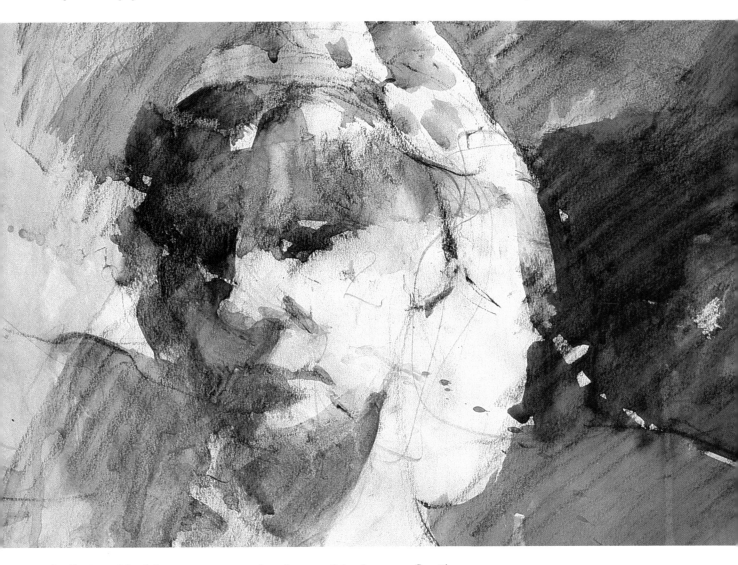

The illusion of depth here is strong even though most of the shapes are flat. The large white shape—which includes the hair and the light side of the face—appears to be flat. In the background the dark shape is seen as flat also. But because of their value contrast, the two shapes separate in space and create a three-dimensional space between them. Notice that the details of the face all occur at the left edge of the flat white shape.

The Vignette

The vignette is a way of retaining the integrity of the original surface and the paper's two-dimensionality. The idea of "leaving out" or leaving unfinished areas in a painting is not appealing to some artists. However, at the risk of sounding elementary, I have to admit that making painting easier is a constant consideration for me, and I find that the vignette is a great way to accomplish this goal.

If your eye enjoys the interaction of the finished and the unfinished, vignetted images can be both simple and sophisticated. In *John-John* I contrasted the flatness of the huge, vignetted lower light area with the three-dimensional upper portion. The lack of definition at the bottom invites the viewer to get involved in the image, using the painted areas to vivify the lower emaciated areas.

The extreme vignette of the white shirt at the bottom contrasts with the three-dimensional realism of the head and shoulders. To unify this contrast, a believable transition—the shirt below the shoulders—was needed. The shadows of the shirt move down into the vignetted areas, and some of the white values of the vignette climb upward into the area of the three-dimensional head and shoulders.

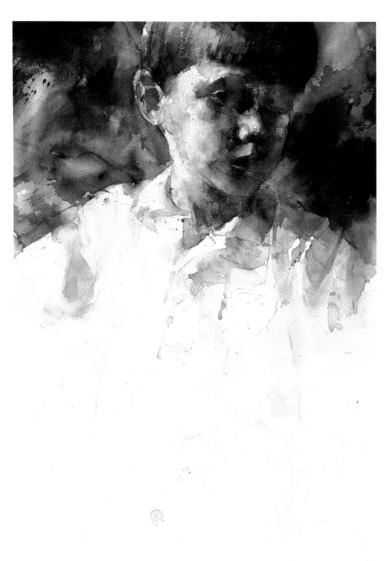

JOHN-JOHN, *watercolor, 30" × 22" (76.20 × 55.88 cm), 1981. Collection of Cecilia and George Mims, Myrtle Beach, SC.*

Spatial Divisions in Paintings

Although there is some difference of opinion on the matter, I believe that the viewer's eye enters a painting from the bottom. Therefore, it is appropriate to place the climaxing focal point toward the top of the rectangle, in the upper horizontal band of space. In *Seated Nude*, the vignetted lower band is two-dimensional and contrasts with the three-dimensional upper band. A transitional middle band unifies these contrasting uses of space; it has some of the push-pull of the upper band *and* some of the white-paper flatness of the lower band.

How often have you seen traditional artists use the design in *Pawley's Dune* on page 54? The major division of space here is the horizontal bar of the cruciform shape, which is placed three-quarters of the way up the page. There will be a push-pull of value contrasts between the shapes above the line because it is here that the greatest three-dimensionality occurs. Below this line, the painting is set up for a contrasting simpler use of space. When the eye enters the rectangle at the

bottom of the painting, it begins to move toward the attention-getting upper band of space.

Abstract artists often use the same spatial scheme. The cruciform pattern has a dominating horizontal thrust high in the rectangle and a contrapuntal but weaker tilted vertical. This tried-and-true division of the rectangle's space may be overused, but it is one that should be mastered.

Imagine the shapes on a glass picture plane being broken or shattered. The artist's job is then to rearrange the shards of reality. Predictable linear and aerial perspective may dominate *if* the artist wishes; shapes are allowed to recede into space at the artist's command. Other shapes may be fixed on the flat picture plane, establishing a contrasting two-dimensionality.

Beaufort Abstraction on page 54 shows one possible rearrangement of the shattered shapes and space. Each artist will arrange shapes and space differently, depending on his own personal vision and creativity.

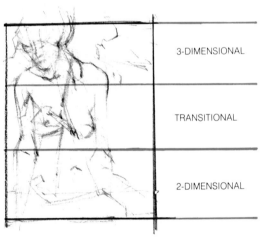

3-DIMENSIONAL

TRANSITIONAL

2-DIMENSIONAL

If the viewer's eye enters a painting through the bottom of the painting, as I believe it does, then there is a very gentle entry into this painting. As the eye moves upward into the middle horizontal band, some value contrast, color, lines, and selected sharp edges begin to appear. Toward the top, the big contrast of the shoulder and the large dark area in the upper left create the climaxing focal point.

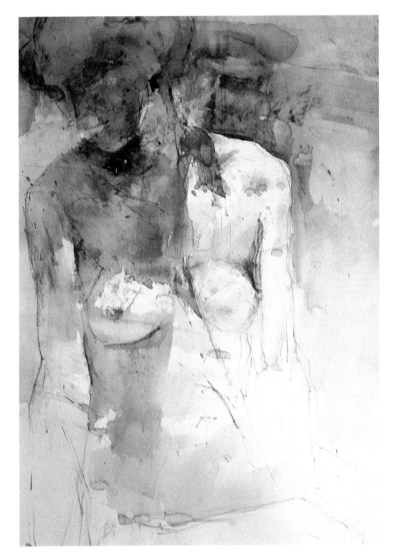

SEATED NUDE, *watercolor, 23" × 17" (58.42 × 43.18 cm), 1984. Collection of the artist.*

The fact that artists so often use this placement—a high horizon line—confirms my belief that the eye enters a painting through the bottom. Placing the major contrasting values or colors high in the painting gives the artist time to tell his story before the climaxing final chapter.

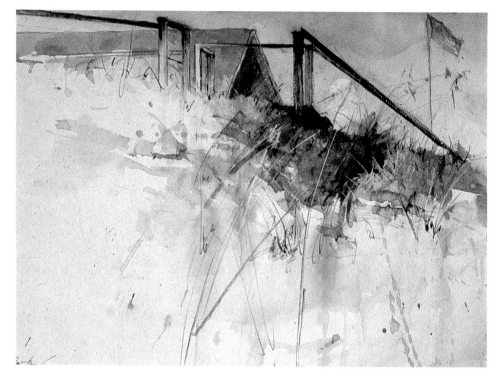

PAWLEY'S DUNE, *watercolor and graphite, 18" × 24" (45.72 × 60.96 cm), 1982. Collection of Mr. and Mrs. John Foushee, Chapel Hill, NC.*

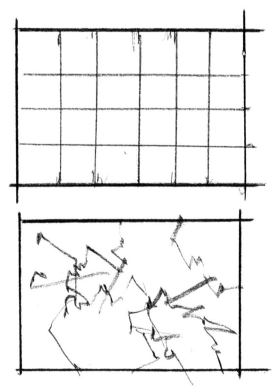

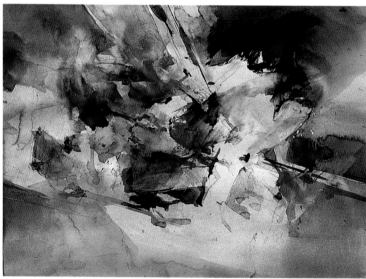

BEAUFORT ABSTRACTION, *watercolor and pastel, 18" × 24" (45.72 × 60.96 cm), 1982. Collection of Beverly and Bob Achurch, Arlington, VA.*

This is one possible arrangement of the arbitrarily shattered shapes. It emphasizes flat rather than deep space.

The space in a painting may be deep three-dimensional space or flat two-dimensional space.

The Perspective Trap

I teach linear and aerial perspective to beginning art students. Lines converging at the horizon line and distant shapes becoming hazy and light in value as they recede into the tabletop space of the landscape are realities of perspective.

Immediately upon completion of this lesson, I talk to the students of "the perspective trap." Linear and aerial perspective can be a design trap in that the eye is led to the distant space. The obvious way to prevent falling into this trap is to choose subjects with little or no linear or aerial perspective. The railroad track or street receding into space are examples of linear perspective. They are not very interesting shape arrangements to me. And they are very difficult to deal with if you wish the viewer's eye to travel in a movement other than toward these linear perspective vanishing points (the end of the railroad track or street).

An excessive use of aerial perspective is equally boring to me because the darker shapes are in the foreground and the shapes get progressively lighter as they recede into the distant space. Flip through the paintings in this book. There are no panoramic scenes here. I do some landscape paintings—two are shown on these two pages—but very rarely a painting with recession into deep space. The artist as shape maker and space maker is in charge of leading the viewer's eye through the design. Don't let the eye go into space unless that is intended.

Thinking creatively about using space to express your personal vision is important. As watercolorist Frank Webb says: "Created virtual space is the primary illusion of the graphic arts and is the very basis of make-believe. The way you conceive and design space is the single most distinguishing characteristic of your work."

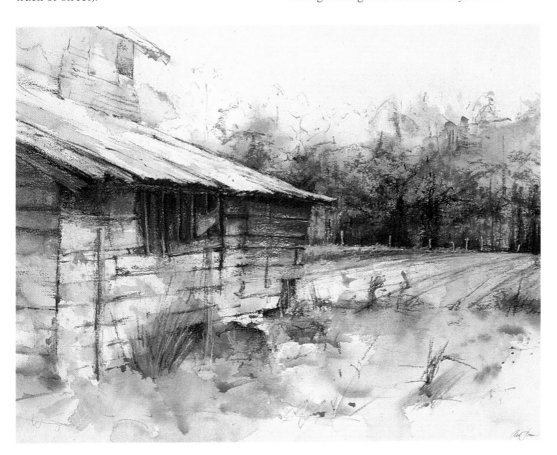

BARN SIDE, *watercolor and pastel, 22″ × 30″ (55.88 × 76.20 cm), 1979. Collection of R. J. Reynolds Corp., Winston-Salem, NC.*

Linear perspective dominates this painting. The lines of the barn side and the distant field move the viewer's eye rapidly to the distant dark trees. Since I was painting the relationship between the barn side and the distant trees, it is appropriate to allow the parallel lines to create the movement, even though I am suspicious of such a straight and rapid movement through a painting. When designing a painting, make sure that the perspective lines move the eye in the desired direction and that the trip is an interesting one.

Dominance
Choosing What Is Most Important

Dominance as a design principle refers to the most characteristic visual impression of a painting or a group of paintings. The choice of a dominant element, its contrast and unity, and the subsequent de-emphasis of other design elements are the principal decisions facing the artist as he begins to structure his painting.

Value is my dominant design element. Contrast, the visual attention-getter that is a function of dominance, is particularly evident in my work because my watercolors immediately convey the impression of contrasts of light and dark.

Color, texture, shape, line, or any other design element can be dominant. The artist's choice of dominant element determines his style. Once the dominant element has been chosen, the artist's main work is to create a unified painting.

The painting *Looking Out* has some bright red color at the neckline (A) and a splattered surface texture, especially noticeable at B, but the dominant element is value. The extreme dark at C with the small lights on the face and the vignetted white paper in the lower right are value-oriented relationships.

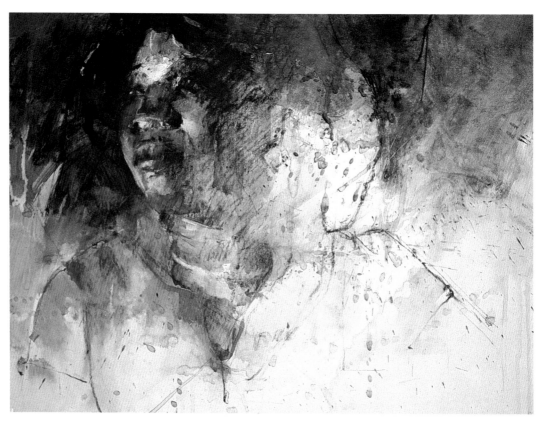

LOOKING OUT, *watercolor, charcoal, and pastel, 18" × 24" (45.72 × 60.96 cm), 1986. Collection of the artist.*

Is the dominant visual element in this painting color, texture, line, or value? It is simply what your eye sees as dominant. I think that in this painting, it is value. Color, texture, and line are used in a more limited way than value. The focal point, the face, is almost exclusively about light and dark values.

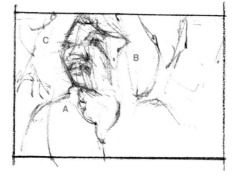

What Is the Dominant Element in Your Work?

We recognize dominant characteristics at a glance; they are what is most important in a painting. Learn to relate your visual impression of the painted image to the following design elements: shape, value, space, edges, color, texture, and line.

What has been dominant in your recent work? Spread out about ten of your recent paintings. Which of the seven design elements above seems to best characterize your paintings? After deciding which element is dominant, see how it measures up against the following criteria:

1. Does the dominant element allow for your unique way of seeing?

2. Does it work well with your choice of painting medium and technique?

3. Does it contribute to the feeling and mood you wish your paintings to evoke?

This is how I answered those questions:

1. Does my dominant element—value—allow for my unique way of seeing? I see a yellow daisy as a light shape asking for a contrasting dark background as readily as I see it to be light yellow. The glimmering highlights on a black man's face or a shocking white boat in front of dark trees are value-oriented visions.

2. Does my dominant element—value—work well with my choice of painting medium and technique? I am not a watercolorist in the traditional sense. Every brushstroke of the traditional English landscape watercolorist, for example, was fluid and transparent and seldom included large rich dark values. I love watercolor's transparency, its mysterious darks, and the liveliness of contrasting white paper—all of which are common in today's revitalized watercolor imagery. Current watercolor technique lends itself perfectly to light and dark dominance.

3. Does value contribute to the feeling and mood I wish my paintings to evoke? I have great admiration for the French Impressionist painters, but I do not see the world as composed of gay colors, fluffy clouds, and intricate purple shadows. I see the world as the contented solitude and strength depicted by Andrew Wyeth, Edward Hopper, and Richard Diebenkorn. Value is their hallmark.

Choosing your dominant element is critical. Make the decision and paint accordingly. As you paint, make design judgments. Do not mindlessly copy subject matter. Subject matter is made up of shape, value, space, edges, color, texture, and line. Make decisions relating to design as you paint, and you will find that the realistic subject matter will seem to emerge from another level of consciousness.

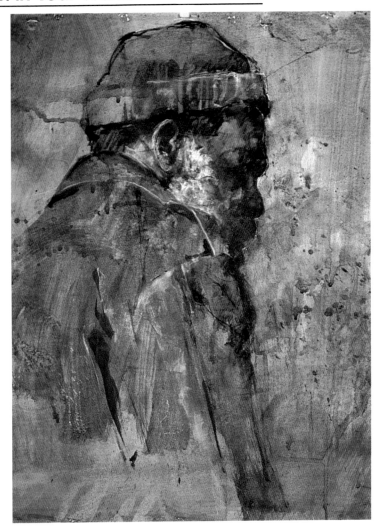

BEARDED BLACK MAN, *watercolor, charcoal, and white pastel on toned paper, 23" × 17" (58.42 × 43.18 cm), 1985. Collection of Sybil Mitchell, Fort Mill, SC.*

There is no confusion in this painting regarding the dominant element. It is value. The primary light and dark value relationships here are all involved with the foreground space. The lights on the side of the face and arm play against darks that are also part of the figure. Consequently, the background is left as the middle value of the toned paper. The front of the face is placed as a dark silhouette against the background, but its main function is to contrast with the lights of the beard.

Edges
Lost and Found—An Important Design Element

Edges are not usually included in a list of fundamental design elements. I have included them because I emphasize their use; they can be a major visual factor in a painting. Two high-contrast shapes with a razor-sharp found edge between them look and act very different from two similar shapes with a blurred lost edge linking them. Shapes with sharp edges and high contrast establish a focal area. Blurred edges set up movement through the rectangle and take advantage of watercolor's inherent wet-into-wet nature.

The sharpest edge here is the light-struck front of the figure against the dark building. To prevent the shadow plane on the rest of the figure from being too large and monotonous, I introduced some lights for variety. Study the intermittent lost (blurred) edges as well as the found (sharp) edges.

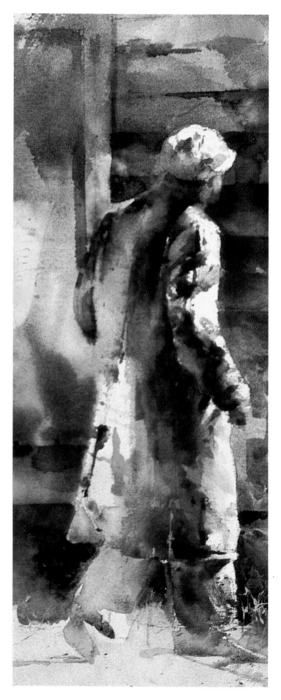

WALKING BY (detail), *water-color, 22" × 30" (55.88 × 76.20 cm), 1980. Collection of Tom Polen, Myrtle Beach, SC.*

Soft-Edge Effects

It has been suggested that oil painters would have to stay up all night to duplicate the blurred edges that watercolorists can achieve with two brushstrokes. Watercolor is a perfect medium to use for creating edge variety. It lends itself naturally to the painting of blurred edges; you need only wet the paper. Since I prefer to paint on dry paper—primarily because of my graphic and textural interests—I use a plastic spray-bottle filled with water to blur edges. I set the nozzle for a wide spray and pull the trigger on monotonous sharp edges. If this seems overly risky, let me assure you that you can soon learn to control the water spray-bottle just as you do a brush. Use the water spray to blur the entire continuous edge of a shape, to break a continuous line, or to wet a section of the paper.

The painting *Lou Whitaker's Home Run Swing* still bears evidence of the use of the water spray-bottle. The red at the top was painted on dry paper, which yields sharp edges. Before the cadmium red dried, I sprayed the paint so that the white paper would show through the blurred edges. I often spray edges while painting.

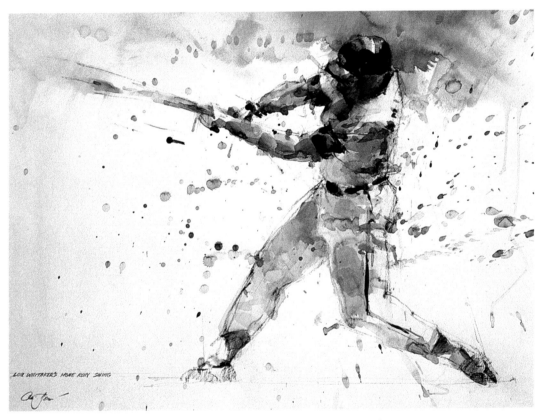

LOU WHITAKER'S HOME RUN SWING, *watercolor, 18" × 24" (45.72 × 60.96 cm), 1986. Collection of the artist.*

I sprayed the edges of the red area at the top of the painting with the water spray bottle to soften the contrast into the white paper. I used the water spray bottle through the middle of the same red area to loosen it up and give a change of value.

The Coloring Book Syndrome

Children's early years in art classes are sometimes dominated by well-meaning teachers who instruct the students to color within the lines. The results are often dull as compared to what they might have produced without strictures, following their own imaginations.

Unpredictable groupings of shapes can occur by painting across edges. See, for example, *Side-* *line Soccer—Henry II*, in which the edges of the dark head are lost into the dark background. As a result, the small highlights on the face and the light shoulder became more interesting. Since the lower part of the figure was not needed, the edges dissolved, light shape into light shape. To lead the eye along a certain path, I maximized the sharp edges from the head to the soccer ball.

Notice how the use of edges drastically changes this figure. Edges are lost dark into dark at the head and edges are lost light into light lower in the figure.

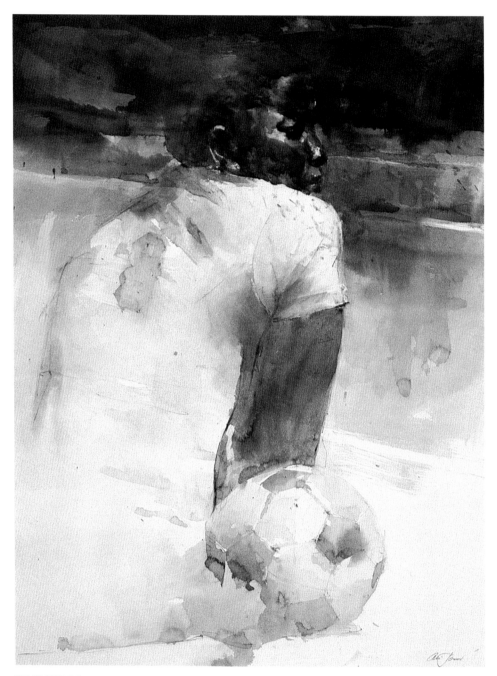

SIDELINE SOCCER—HENRY II, *watercolor, 30" × 20" (76.20 × 55.88 cm), 1982. Collection of Paula and Sam Parker, Mars Hill, NC.*

Edges and Movement

If a shape has four sharp edges, the eye is boxed in, or "put into jail." One or more blurred edges will alleviate this problem by beginning a movement beyond the shape through the remainder of the rectangle. In *Portrait in Blue and Yellow* the blurred edge of the head at A contrasts with the sharp edge at B, luring the eye from the hair toward the background. Similarly, the lack of a sharp edge at C allows the connecting white paper to move in the direction of D.

If you prefer imagery to be lively but serene rather than busy and jumpy, watch out for too many sharp edges. Almost any shape you paint will appear to have sharp edges when the eye is forced to focus on it. The decision about which edges to lose and which to keep is best resolved by taking the entire rectangle into consideration, since the choice of edges should be consistent with the overall design plan.

In the next section we will learn one approach to leading the eye through the rectangle. Edges, to a large extent, determine this movement.

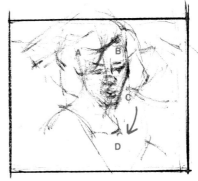

One of the most significant problems with paintings by beginning and intermediate art students is the inclusion of far too many sharp edges. Allow lost and found edges to dance the viewer's eye along the contours of form.

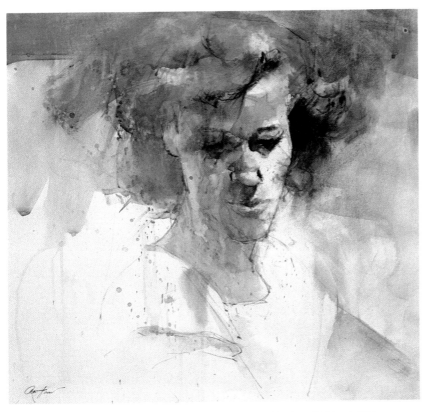

PORTRAIT IN BLUE AND YELLOW, *watercolor, 21" × 21" (53.34 × 53.34 cm), 1984.*
Collection of the artist.

Movement
The Rhythm of the Rectangle

Often overlooked by inexperienced painters, movement is the heartbeat of a design. The rhythm of the rectangle is to visual art what tempo is to music.

When I began taking art classes, I gave no thought to the rhythm of the rectangle. I painted as if I were working on a jigsaw puzzle, one piece at a time. Suffering from the fatal hypnotism of reality, I did not consider placing shapes in the entire rectangle before finishing individual shapes. Without movement, there is no transition from shape to shape. Without movement, there is no order or rhythm to the design.

I have already discussed placing shape relationships in the "sweet spots" in the rectangle and creating a focal point with these shapes by using value contrast. I talked of placing the focal point in the upper horizontal band of space. It is from this point that the movement through the rectangle begins.

Beginning the Movement

In the chapter on edges, we have already discussed the problem of boxing in, or putting the eye into jail, by using all sharp edges. But at least one sharp edge of the paper-doll white shape (A) in *Melba* is necessary against the dark background to create the focal point. A connecting light shape (B) is required to begin the light movement through the rectangle.

In *The Dishwasher*, the focal point is the light on the left side of the face (A), which is located in quadrant 1. Rather than forcing light shapes across the face to quadrant 2, I used the shoulder and chest (B) to continue the light movement. The light in these shapes are the obvious links to the light on the face. The movement of light shapes travels from quadrant 1 at A to quadrant 3 at B. The S movement, which basic design finds desirable, becomes an S turned on its side, as in the illustration on page 63, or more often, a simplified U, as in the adjacent illustration.

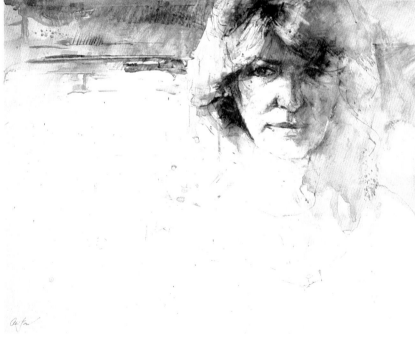

An important part of this painting is the light shape on the side of the face. As Melba posed, there was a strong shadow under her jawline (C) just below the light on the face. After I painted this shadow, I realized that I had trapped the light on the face. To provide an outlet, I lifted off the shadow. This allowed the light to move downward and circulate through the remainder of the painting.

MELBA, *watercolor and charcoal, 23" × 29" (58.42 × 73.66 cm), 1984. Collection of Melba Hayden, Myrtle Beach, SC.*

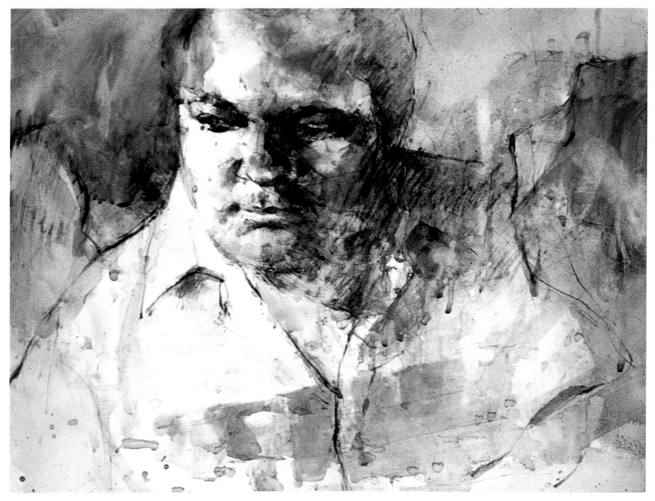

THE DISHWASHER, *watercolor and charcoal, 18" × 24"*
(45.72 × 60.96 cm), 1986. Private collection, Columbia, SC.

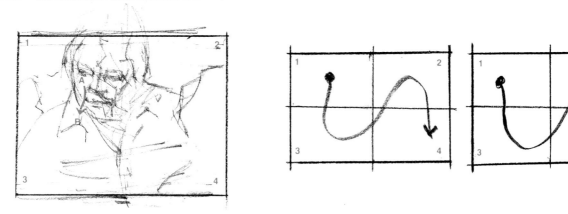

*Here the movement of light is from the face to the shoulder,
across the chest, continuing toward the background light
in the upper right. This movement makes a sideways* S- *or
a* U-*shaped movement.*

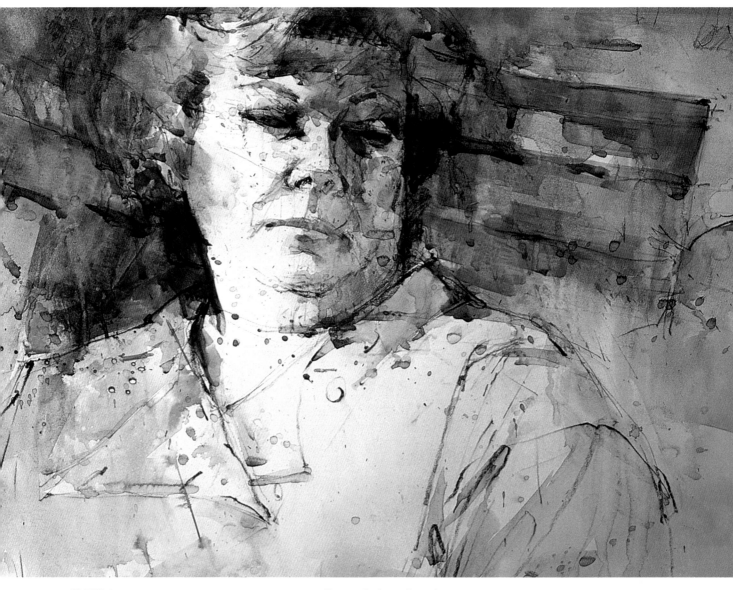

GLENDA, *watercolor, 17″ × 23″ (43.18 × 58.42 cm), 1985. Collection of Helen Bixler, Anderson, IN.*

This painting is an example of movement in a U shape. The focal-point light shapes in quadrant 1 move to quadrant 3, then to 4 and finally to the background light shapes in quadrant 2, completing the U shape.

Movement from Foreground to Background

The use of space is integrated into movement through the rectangle by connecting the foreground light of the paper doll to the background light of the silhouette. If the paper doll is in quadrant 1 and the silhouette is placed in quadrant 4, the movement makes the shape of an S turned on its side. A vignette is created by placing the silhouette in quadrant 2 rather than quadrant 4. Study the passage of light in *Southport Model*. Also, notice the rest area created by the background light of the silhouette.

Have you observed my inclination to turn the watercolor sheet horizontally rather than vertically, even when the model is in a vertical pose? This prevents the vertical pose from being echoed too loudly by the vertical format of the paper. A diagonal and horizontal movement counteracts the vertical format and brings the background space into play, offering the possibility of movement into the background. Otherwise, situating a vertical figure in a vertical rectangle can result in a thoughtless rendering of the figure, since the background space is marginal and makes no artistic demands.

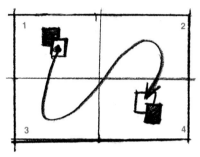

If the silhouette relationship of values is placed in quadrant 4, a sideways S movement is traveled when the white shape of the paper doll is connected to the background light of the silhouette.

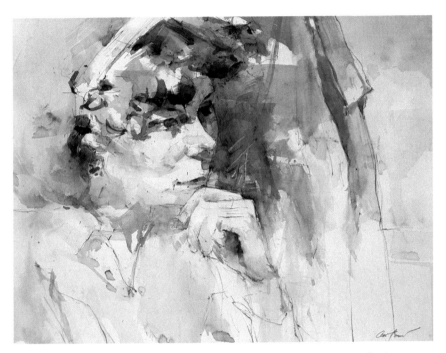

SOUTHPORT MODEL, *watercolor, 18" × 24" (45.72 × 60.96 cm), 1983. Private collection.*

Again, the focal-point light shape is the side of the face. The outlet for this light shape is the hand. The light movement connects to the vignette at the bottom of the painting and moves up to the background light behind the vague image of the silhouetted hanging jacket.

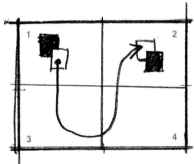

When the silhouette is moved up to quadrant 2, a U-shaped movement is made, leaving quadrants 3 and 4 as vignettes.

Movement of Darks

Any of the fundamental elements may be used to move the eye through the rectangle. But it is consistent with my emphasis on light and dark values that light and dark shapes should be my choice. I use space, color, edges, texture, and line in supporting roles.

If you look at the two abstract illustrations below, your eye follows the movement of dark shapes through the one rectangle and the movement of light shapes through the other. The illustration at left retains more white paper than painted areas. The eye could not possibly follow the movement of lights through this illustration because the light shapes are everywhere. The eye follows the movement of darks. To use the rhythmical movement of darks through a design, the remainder of the paper must be white paper or a very simplified painted area.

When moving dark shapes through a painting, do you think it is more appropriate for the focal point to be a paper doll (see below, right) or a silhouette (see below, left)? It would not be appropriate to pull a light shape forward in space, as the paper doll does, and then attempt to move dark shapes through the rectangle. For a movement of dark shapes (as in the illustration below, left), use the silhouette as the focal point; this brings the dark shape forward in space and then allows the connection of dark shapes through the remaining quadrants of the rectangle. *Victorian Dance III* is an example. Although this painting was painted some time ago, before I understood the movement of darks, the dancer comes forward in space as a sort of silhouette. The eye travels through the high leg kick to the connecting darks at the Victorian porch.

In this abstract sketch, the viewer's eye clearly follows the movement of *darks. Since the dark shapes move through the painting, it makes sense to make the dark shape the focal point and bring it forward in space (the silhouette) to begin this movement.*

In this abstract sketch, with more painted areas than white paper areas, the eye sees the movement of *light shapes.*

The paper-doll relationship of values in space.

The silhouette relationship of values in space.

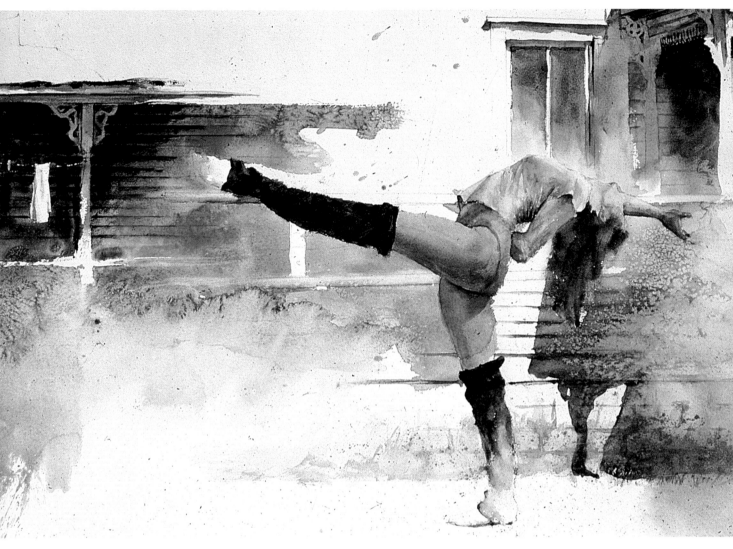

VICTORIAN DANCE III, *watercolor, 20½″ × 29¼″ (52.07 × 74.30 cm), 1978. Collection of Kincheloe and Roger Hard, Charlotte, NC.*

The "high kick" leg connects the painting areas on the left and right, making a movement of dark shapes.

Movement of Lights

Do most of your paintings look more like the top illustration on the left on page 66? Mine are much more like the one on the right. To paint in as abbreviated a style as in the illustration at left requires a poetic temperament that is valid but very rare.

If your paintings are more like the illustration on the right, then a movement of light shapes, which creates the rhythm, and the paper doll (bottom right) is appropriate as the focal point.

The paper-doll shape relationship brings a light shape forward in space, such as the shoulders in *Nude with Face in Shadow*. This focal-point light shape—the shoulder—is the beginning of the movement of light shapes through the rectangle.

Obviously, the first light shape that connects to the paper-doll light shape is vital. Often a deviation from the actual appearance of the model is necessary. The light falling across Melba's face in the illustration on page 62 made a rather strong shadow under the jawline at C. This shadow would have prevented the connection of light shapes A and B. Reality is most often not lost by such an omission. Does Melba seem to be deformed? Pablo Picasso is credited with having said that often it is necessary to tell a lie in order to tell the truth.

The light shoulders come forward in space as the paper-doll relationship with the dark background.

NUDE WITH
FACE IN SHADOW
*watercolor, 23" × 26"
(58.42 × 66.04 cm),
1984. Collection of
the artist.*

Color Temperature
The First Color Consideration

For the value painter, color temperature should be the first color consideration. Should the light, middle, or dark value be warm or cool?

All of the preceding pages of this book could be studied in terms of black and white (monotone) painting. Although it is almost impossible to make a painting without the elements shape, value, space, edges, and the principles dominance and movement, color can be eliminated. But many painters tire of painting in one color, and if the artist is bored, the viewer's eyes will surely shut.

Color adds excitement to the image. When painting with color, the watercolor artist must make two initial determinations. First, he has to control the value. As the watercolorist's brush is lifted from the water container, the amount of water allowed to remain on the brush determines—to a great extent—the light, middle, and dark values. Next, the artist must decide whether to choose a warm or a cool color. See the color wheel below, left, for divisions of hues.

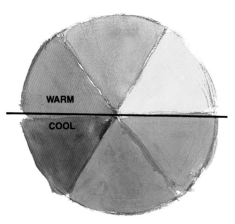

The color wheel divided into warm and cool colors.

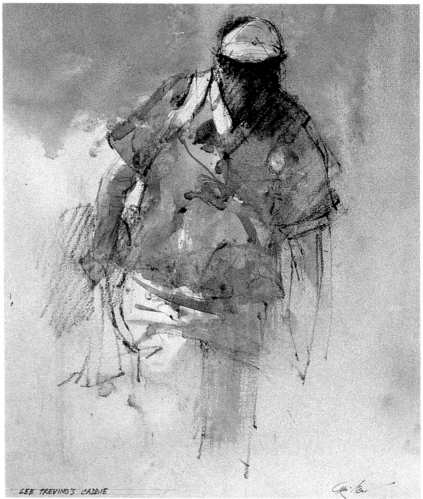

`LEE TREVINO'S CADDIE`

TREVINO'S CADDIE, *watercolor, 17" × 14" (43.18 × 35.56 cm), 1987. Collection of the artist.*

There are two main elements in this painting. One is the transition toward the vagueness at the bottom of the painting. The other is the change in color temperature between the green torso of the figure and the warm background.

Nibbling at the Focal-Point Light Shape

I usually begin a painting by nibbling at the paper-doll white shape in the foreground (A) rather than the background dark (B) as in *Chestertown Demo—Betty*. In this portrait, the paper doll's local color is the warm flesh tone of the face, which is also found in the adjacent shape. This seemingly simple placement sets up possibilities for many of the remaining warm and cool colors in the painting. If the foreground face is warm, then the background at the paper doll should be cool. This makes possible an intermixing of warm and cool colors in the foreground and background space. Just as we flipped the lights and darks of the paper doll to make a silhouette, we have to reverse the relationship of the paper doll's warms and cools at the silhouette. As the illustration below shows, this interchange of color temperature distributes warms and cools in both the foreground and background spaces. Also, because warms and cools have been established across the page, the choice of temperature in the remaining shapes is much easier.

The color temperature illusion here is one of warmth. The warm flesh color makes the neutral white of the side of the face (the foreground paper-doll shape) seem warm.

CHESTERTOWN DEMO—BETTY, *watercolor, 15″ × 22″ (38.10 × 55.88 cm), 1985. Collection of Betty and John Stafford, Jr., Chestertown, MD.*

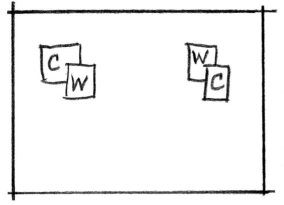

Not only are the lights and darks interchanged as the paper doll changes to the silhouette, but their associated warm (W) and cool (C) color temperatures interchange also. If the foreground light shape of the paper doll is warm, it is flipped and repeated as a warm color behind the dark silhouette. Similarly, if the foreground silhouette is cool, then the dark background of the paper doll should also be cool.

Warm or Cool Dominance

Our eyes want to see a dominance of either warm or cool color. Consider the local color of the paper doll for this dominance. The paper doll relates color to the focal point, and this is the most important relationship in the painting. In *Oyster Catch II*, the warm colors of the man's clothing are the foreground focal-point colors and become the dominant color temperature. The dark marsh grass behind the man is a cool hue. The bow of the boat and its reflection in the water are cool. The background marsh grass is warm, which completes the interchange of color temperature in the two places in space. This interchange prevents all of the foreground and background spaces from being the same color temperature.

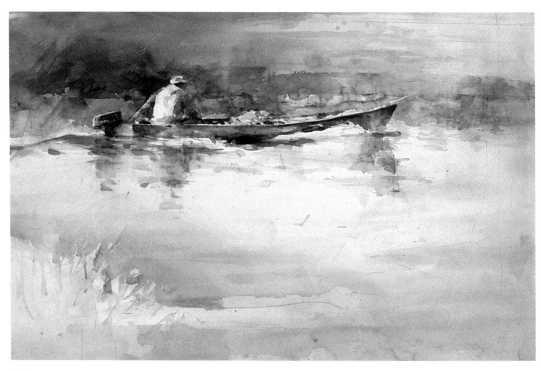

OYSTER CATCH II, *watercolor, 22″ × 30″ (55.88 × 76.20 cm), 1983. Collection of Joy and Jay Burton, Atlanta, GA.*

The foreground paper-doll shapes—the man's white coat and hat—feel warm because of the reddish tones on the right side of the man's jacket. These light warm tones are in front of cool dark tones behind the man. The bow of the boat, a cool gray, is silhouetted against the warm marsh grass behind the boat. Do you see the interchange of color temperatures here? The foreground warms of the man's coat are repeated in the warm background marsh. The cool tones of the boat's bow are repeated in the cool dark marsh behind the man.

Abstract Color Temperature Distribution

As we continue our course of imposing abstract design considerations upon realistic imagery, the opportunity is again at hand. Having determined a dominant color temperature and having distributed warms and cools in the foreground and background, we can now consider the remaining shapes in the rectangle. We are not bound to "color in" their local hues. The color temperature of these secondary shapes should be a function of the primary shapes just mentioned. All that is required is a continued distribution of warms and cools throughout the rectangle. If we keep temperature dominance and distribution in mind, we are less likely to be intimidated by the local color of objects. In this way, we could achieve an exciting representational image with the interesting difference of a solidly designed abstract color structure.

Notice the distribution of color temperatures throughout the rectangle. The eye prefers one temperature to dominate the other. Also, look at the painting to confirm that warms appear in both the foreground and the background. Do the same for the cool colors.

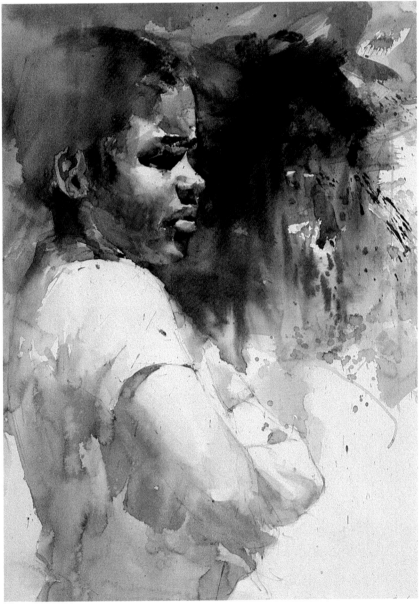

SIDELINE SOCCER—RAY, *watercolor, 30" × 22" (76.20 × 55.88 cm), 1982. Collection of Wachovia Bank, Winston-Salem, NC.*

Texture
Decorating the Rectangle

If grouping and simplifying shapes is not of interest to you, there is an alternative. That alternative is texture. Creating texture is the opposite of grouping and simplifying shapes—it makes shapes so small that they become only surface variation.

The creation of texture in a painting should be interwoven with the making of the picture; it is a choice made before or during the process, not an afterthought.

If texture is to be the dominant element in a painting, all the other elements have to be minimized. *Black Texture* is an example of textural dominance. Although there is a large front view of a face at the right and a newspaper photograph of a man on the left, shape has practically been bypassed for the sake of texture. If you choose texture as the focal point of your paintings, you will find yourself led to experimental techniques, such as the use of gesso in *Black Texture*. (See page 103 on techniques for an explanation of the use of gesso in this painting.)

There are many ways to work with texture in paintings. Applying watercolor with the usual brushes is probably not the best way. A more experimental technique-oriented approach may be required, such as the use of salt, Saran Wrap, spray paint, etc. The possibilities are almost unlimited. If texture is the dominant element of your choice, you should fill your studio space with various materials. However, be aware that experimental techniques can rule rather than serve the design. I love texture, but I like to confine it to a subsidiary role.

BLACK TEXTURE, *watercolor, charcoal, collage, and gesso, 10″ × 20″ (25.40 × 50.80 cm), 1985. Collection of Janet Powers, Myrtle Beach, SC.*

Surface texture is the dominant design element here, not light and dark contrast.

Brushwork and Splattering

In my paintings I create texture in primarily two ways: through brushwork and splattering. Lively brushwork means not closing off shapes by excessive brushing over the same spot. Lively brushwork also implies value contrast and the use of dry white paper with small seemingly choppy brushstrokes. The painting *Jody* has a lively surface quality. Very few brushstrokes of middle or dark values are continuous and monotonous. White paper provides the main rest areas. In *Dock Fishing I* I've kept the surface texture lively by not coloring in the representational shapes. Varying value and allowing accidental gatherings of paint to remain on the legs of the fisherwoman (A) lent a certain unpredictability and excitement. Notice, too, the changes in values in the dock piling (B) and the fusing of the piling with background shapes. I wanted to avoid the monotony of an all-dark value.

Because of the necessity of painting around light shapes, a transparent medium such as watercolor usually demands that you indicate small shapes first and then large shapes. This procedure—painting from the small to the large—with its choppy open brushwork often reads as rough texture. One reason I switched from cold-pressed (medium-texture) paper to hot-pressed (smooth) and high-surface Bristol paper is so that every brushstroke would be crisper and every touch of the paint on the paper would be retained. It is curious, but one can achieve more texture on a smooth paper than a rough one.

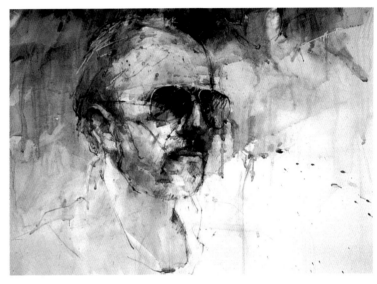

JODY, *watercolor, white pastel, and charcoal, 23" × 29" (58.42 × 73.66 cm), 1984. Collection of the artist.*

The short, somewhat choppy brushwork gives the feeling of texture in this painting. But the abbreviated nature of the work prevents the small choppy shapes from being overused.

If the artist chooses not to overcontrol or strangle the painting medium, excitedly unpredictable shapes and textures are always at hand.

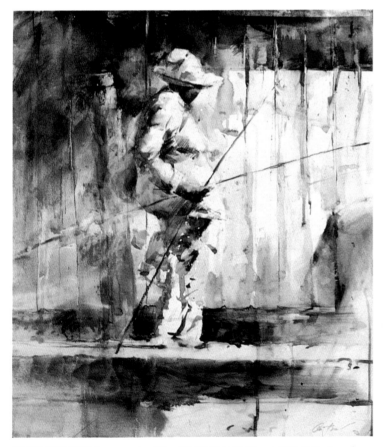

DOCK FISHING I, *watercolor, 19" × 21" (48.26 × 53.34 cm), 1981. Collection of Geraldine and Franklin Burroughs, Conway, SC.*

One of my goals with each new painting is to take myself out of the pretty-picture business and see if I have anything left. Often, I will splatter paint across the page at the very beginning of a painting. This random splattering with a brushful of paint also keeps me from presenting the actual texture of objects. Texture, like the other design elements, has to be thoughtfully distributed in the rectangle. Following nature seldom leads to a pleasing textural mosaic in the painting. The splattered textures in *Derelict* occur both on the upper figure and on the background window frames.

Texture can be a fascinating embellishment of the image. Use it in a less than predictable way and distribute it throughout the rectangle. If you paint landscapes, you might add splatters or other textures to an otherwise flat sky. For figure painters, it might be interesting to decorate a model's smooth skin with texture, as in *Raleigh Model*. Texture has its virtues, but for me it remains mainly a decoration.

Don't always be predictable with the use of texture. It may be necessary to use texture on the model's skin, for example, to repeat other textures in the painting. I would long since have quit painting if these creative alterations were not possible.

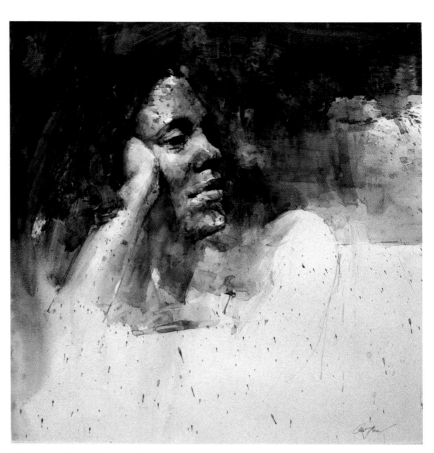

RALEIGH MODEL, *watercolor, 17" × 17" (43.18 × 43.18 cm), 1984. Collection of the artist.*

After I have finished the drawing for a watercolor, I will often arbitrarily splatter paint across the page. This has a double purpose: It creates texture and it gives me a sense of freedom at the very start of the painting process.

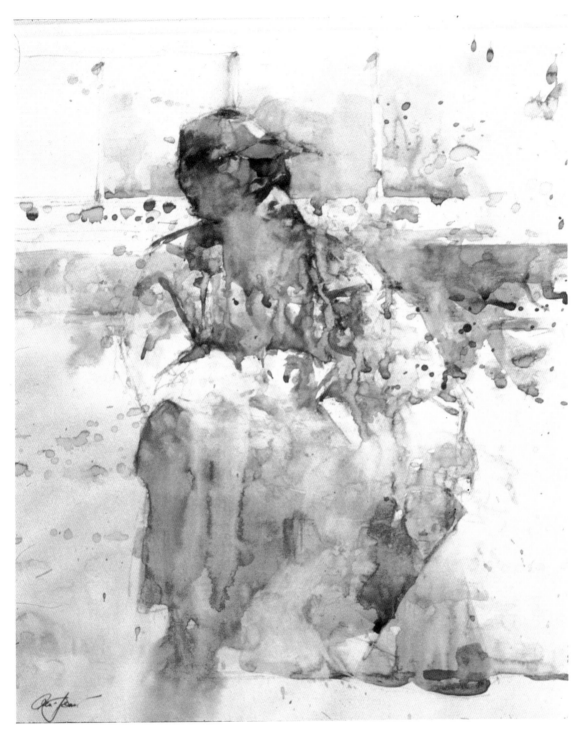

THE DERELICT, *watercolor, 18″ × 15″ (45.72 × 38.10 cm), 1985. Collection of the South Carolina National Bank, Columbia, SC.*

The textures in the figure and the background shapes are not as they appeared in the actual subject. I have distributed them abstractly in the rectangle.

Line
The Graphic Unifier

Since I have already indicated my partiality toward drawing and the graphic arts, my interest in line is apparent. In a sense, my entire output of painting is a sketchbook of watercolor and line.

Line has many forms. Its extreme uses range from preliminary thumbnail design studies to the graphic unifying element for the entire composition.

Eddie has very dark hair, and it is strange to see his hair white. If I had darkened his hair, there would have been that monotonous horseshoe shape of dark around the head, which I did not want. And since line is more important here than shape and value, I did not want to get involved in any large shapes or dark values. I wanted to get at the essence of my friend Eddie in a simple, poetic way. (This small drawing was cropped from an attempt at a 4' × 8' design that did not work. Notice the footprints at the upper left, which occurred while I was working on it as a 4' × 8' section of a roll of watercolor paper.)

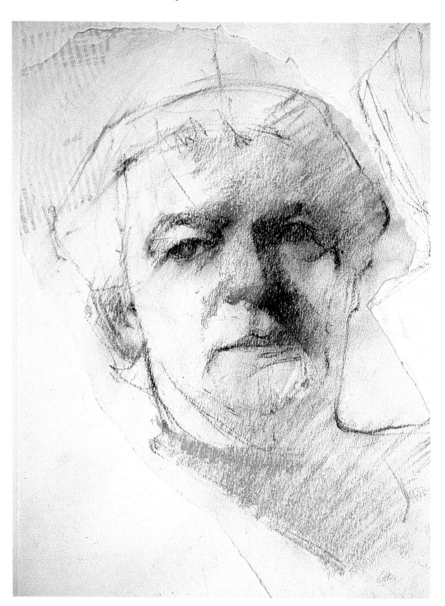

EASY EDDIE, *charcoal, pastel, and collage, 14" × 10" (35.56 × 25.40 cm), 1988. Collection of the artist.*

Sketching

Years ago I learned that I could do a painting in the same time and with about the same effort that sketching required. Now I do not keep a sketchbook, and I seldom sketch objects in nature for practice, simply because, as I see it, paintings are in reality designed sketches. Before I begin to paint, I sketch the model and adjacent shapes. In fact, I usually draw more shapes than I need for the painting, but I have learned not to paint everything that I draw. Since I impose an abstract structure on reality, having more than twelve shapes from which to choose gives me more flexibility. In the process of painting I select those shape relationships that I wish to retain.

Having come to grips with my temperament in 1972, I switched from painting in oils to watercolor. Some of my worst times as a painter were struggling over the same oil painting every day for a week or more. Although watercolor lends itself to a more spontaneous treatment, I achieve the balance I need by working with a careful approach to design. This is the bare bones of my seemingly casual treatment of subject matter.

I sketch mainly with compressed charcoal. For almost all the drawing I do, I use a 6B charcoal pencil. This is the same charcoal that is available in stick form. It has an oil binder and is not as fragile as vine or other soft charcoal sticks. I always use the 6B grade, which is darker than a 6B graphite pencil. It can make a delicate light line or a rich dark line.

In *Kinchloe*, the vague image of the head is placed low in the rectangle and the hair is an abbreviated white. Minimal use of watercolor allows the charcoal to become the dominant medium. The drawing *Golf* (page 80) was drawn with a 6B charcoal pencil. In *Studies of the Swing Plane* (page 80), the golfer on the right is drawn with varying lines: delicate in the lower body, where the figure merges into the toned paper, and strong at the top. At various stages while painting, I use the charcoal pencil.

Because watercolor tends to completely overpower a drawing, it may be necessary to keep the use of watercolor to a minimum. Here, to strengthen the drawing, I made some solid dark charcoal shapes at the upper left of the face and used watercolor only to add the vague brownish tones. By continuing the line A from the side of the face at B, I was able to describe the top of the head without fully completing the shape. Such is the suggestive power of line.

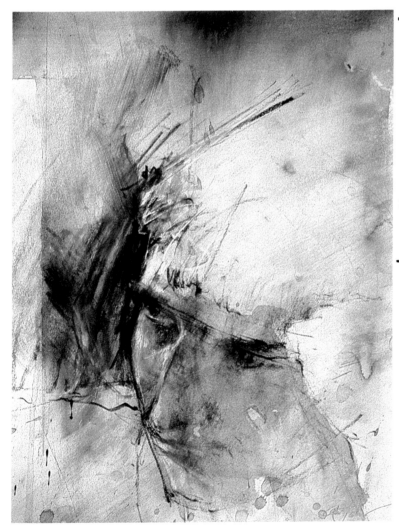

KINCHELOE, *charcoal, white pastel, and watercolor, 17" × 14" (43.18 × 35.56 cm), 1985. Collection of Dot Porter, Tullhoma, TN.*

There are no dark lines in this very abbreviated drawing. There is considerable variety in the medium and light lines. The line from the knee to the foot describes the direction more than the contour of the front of the golfer pant leg. Also, this overlapping of the golf club with the horizontal line of the putting green, unites the vertical golfer and the green.

GOLF, *charcoal, 18" × 24" (45.72 × 60.96 cm), 1986. Collection of the artist.*

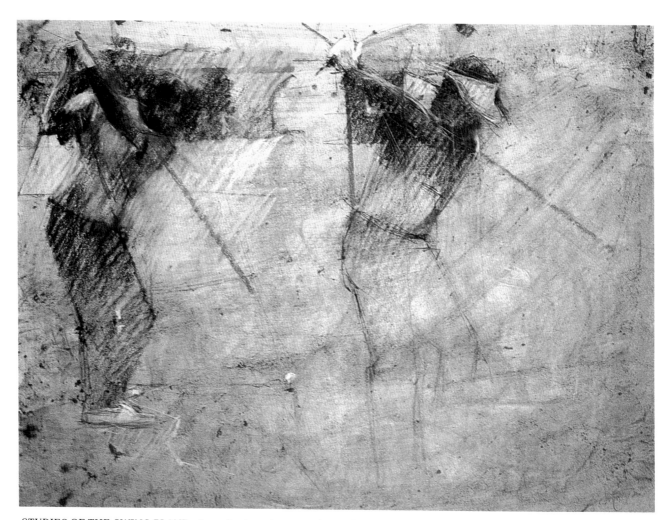

STUDIES OF THE SWING PLANE, *charcoal and pastel on watercolor-toned paper, 17" × 23" (43.18 × 58.42 cm), 1988. Collection of the artist.*

As an artist's interests change, his images for painting can change with them. Subject matter can arise from anywhere. Here it is not just golf that inspired the drawing but a study of the technique of the golf swing. The two diagonal red lines indicate two swing planes. The golfer on the left has a more upright swing plane, meaning the diagonal red line is more vertical. The golfer on the right has a flatter swing plane—the red line is less vertical.

Line and Design

If you love to draw and consequently love line as I do, then you want drawing and line to show in the completed watercolor. To prevent watercolor from overpowering line to the degree that line all but disappears, stop your painting at intervals and draw into the painting. If the paper is wet, a Stabilo pencil will make a rich line on it.

I always stop at intervals during the painting to study what needs to be changed and what needs to be added. By the time I go back to the easel, the watercolor has dried and I can draw into the watercolor with charcoal pencil. The charcoal may then become as dominant as the watercolor. With this strength, line has the capability of becoming a major design factor. The current change in my work is that drawing and line are becoming as important or more important than watercolor and shape in the design.

It is primarily in the way I have used line in these two paintings—*Street Singer—New Orleans I* and *The Laborer*—that qualifies line as the graphic unifier of the design. The upper three-dimensional painted area is fused with the lower two-dimensional unpainted band with the simplest of means—line.

Look at *Street Singer—New Orleans I*. The single line, the extension of the line of the clothing of the neck, unifies the entire upper painted area with the huge vignetted white paper at the bottom. That is a lot of mileage to gain from one line.

In *The Laborer* the transition from the three-dimensionally painted upper area to the lightly toned vignette at the bottom is made with watercolor lines instead of charcoal lines.

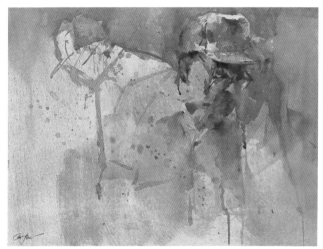

THE LABORER, *watercolor on watercolor-toned paper, 18" × 24" (45.72 × 60.96 cm), 1985. Collection of the artist.*

Watercolor lines, instead of charcoal lines, are used as the graphic unifier here.

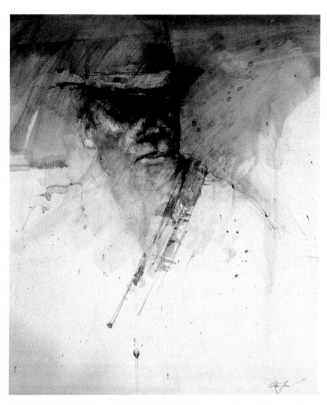

STREET SINGER—NEW ORLEANS I, *watercolor and charcoal, 23" × 20" (58.42 × 50.80 cm), 1985. Private collection, Columbia, SC.*

Here, a single line unifies the painted area with vignetted white paper.

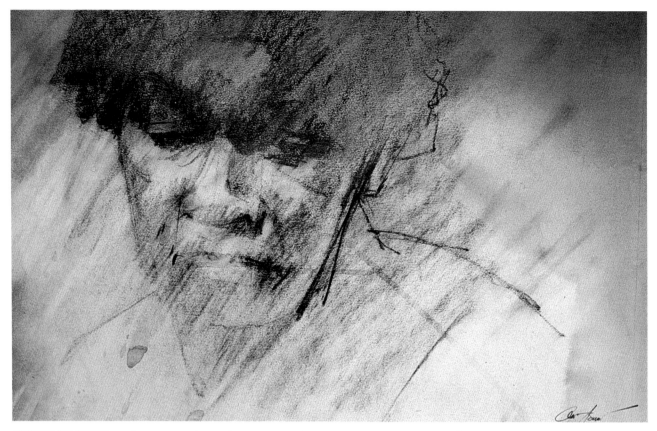

NETTIE DRAWING, *graphite on watercolor-toned paper, 10″ × 17″ (25.40 × 43.18 cm), 1988. Collection of the artist.*

*This is the only drawing or mixed-media painting that I can remember doing—
in the last ten or fifteen years—with graphite instead of charcoal. Although I
like the drawing, I will not use graphite soon again. I pressed down as hard as I
could here, and the darks are not as dark as they would have been with
compressed charcoal, even though the graphite I used was a 6B grade, very soft.
To save this drawing, I took a kneaded eraser and vigorously erased the lower
face into the lower-left background and shoulder. I also smeared some dark
graphite diagonally toward the upper right. Erasing left the upper head dark and
the lower face light and kept the head and background from being too different.*

Color Hue
Local and Arbitrary Color

The word *color* is often interchanged with the word *hue*. *Hue* actually refers to spectrum classification of color: red, yellow, blue, etc. Hue is the third of the four characteristics of color: value, temperature, hue, and intensity.

If you are a value painter, value is what your painting is about. This being the case, a more arbitrary, intuitive use of hue is in order. Color to the value painter is a decoration of light, middle, and dark value shapes. The colorist, on the other hand, is interested in another effect. For the colorist, the painting's dominance hinges on the use of color, and values are secondary, serving simply to decorate the hues.

"Good Color"

The layman, when looking at a painting, often says that it has "good color." He either has a profound response to color or does not know exactly what to say, and a positive remark on color seems safe and sensible. Maitland Graves, author of the standard design text, *The Art of Color and Design* lists the following four possibilities as typifying good color:

1. It pleases the artist.
2. It is appropriate for its purpose.
3. It has variety.
4. It has unity.

For me, color is pleasing (criterion 1) when it is there for the eye to enjoy but does not prevent shapes from being defined with value. The appropriateness (criterion 2) of color for the commercial artist may be very specific. For use in the fine arts, the aesthetics of the individual artist is the consideration. Good advice for the value painter is to get the value right and the color close, not the other way around. Color variety (criterion 3) has been partially discussed in terms of using warm and cool temperatures. Our focus here pertains to warm and cool hues and their unity (criterion 4). Compare your use of color to these four criteria.

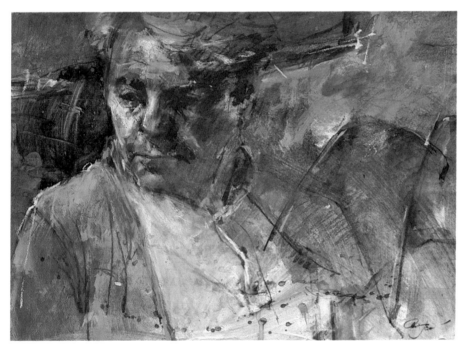

My overwhelming feelings when looking at this class demonstration painting are ones of frustration. I really struggled with it. It was only after a year or so that I began to see any virtue in it. One of the most difficult jobs of the artist is to coldly and unemotionally judge his own work after the work is finished. Try to look at your paintings as if they were painted by someone else. Sometimes it is necessary to store them away for weeks or months in order to see them objectively.

ED RAINSFORD, *watercolor, gouache, charcoal, and pastel on toned paper, 18" × 24" (45.72 × 60.96 cm), 1986. Collection of Merri Wooley, Reading, PA.*

Using Local Color and Arbitrary Color

Local color refers to the actual color of nature—the grass is green, the sky is blue. When a rectangle is clipped out of nature for a painting, the possibility that it will be properly designed is almost nil. Changes to local hues of objects are inevitable for any chance of good color dominance and distribution.

Using local color to identify subject matter can be valuable when it is not overdone. For example, many passages of pinky local-color flesh tones become tiresomely predictable in a nude figure painting. Although a wildly arbitrary green for the same painting might seem preposterous, a more intuitive selection of arbitrary hues could add the ingredients needed for visual excitement. Making creative use of both local and arbitrary hues can enliven the painting.

Letting one's intuition determine arbitrary hues while maintaining the subject matter's identity is a sensible approach. We have already begun the use of arbitrary hues with the use of the paper doll and the silhouette. They are arbitrary hues in that they are not colored-in copies of nature's given colors. Our discussion in the section on color temperature concerning distribution, not duplication, of warm and cool colors is a continuation of the use of arbitrary hues. In *Portrait of Elizabeth Mims* (below) the distribution of three hues—brown, yellow, and blue—is indicated. Notice that not only are they placed in the background and the foreground, but they are widely dispersed in the rectangle.

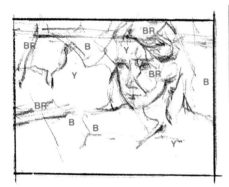

As you can see in the diagram of the painting, I have repeated the hues throughout the rectangle (BR = brown, B = blue, Y = yellow). The brown hues of the face and hair appear also in the background, far left. Behind the head and shoulder you can see the pale blue from the shoulders, face, and hair. The yellow hues add a glimmering light.

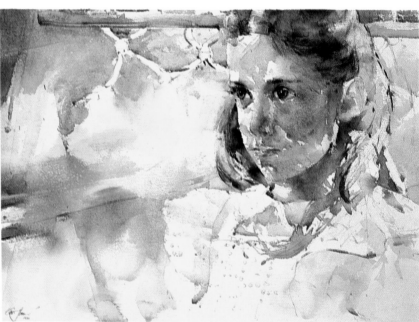

PORTRAIT OF ELIZABETH MIMS, *watercolor, 22" × 30" (55.88 × 76.20 cm), 1980. Collection of Cecilia and George Mims, Myrtle Beach, SC.*

Limit Slices of the Color Pie

In my earlier years I might return from a day's painting in the landscape with a watercolor that had

- blue sky
- white house with a rusty red roof
- green and yellow foliage

These hues are translated on the color wheel top, right. I knew there was something wrong with my painting, but I could not identify what it was until I began to notice in the art magazines the many brown watercolors traditionalists were producing. Although there was a dullness to the brown paintings owing to the lack of variety of hues, I realized how to resolve my landscape

dilemma. I decided that my landscape had too many unrelated slices of the color pie, as the color diagram for it indicates. The hues, with their four equal slices of the color pie, were competing with one another for attention.

The major hues in *Noon Day Stories—Darcy II* are brown and blue. The color wheel at the bottom indicates the placement of these complementary hues (brown and blue pieces of the pie). If you want to add more color, choose colors from the color wheel adjacent to those already dominating the color scheme. Do not include hues from the parts of the color wheel that are marked with *x*'s. This is where color harmony is lost. If you add a third hue, let it be a minor note in terms of size and intensity.

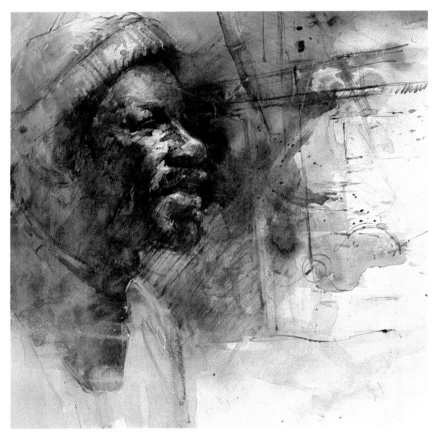

NOON DAY STORIES—DARCY II, *watercolor, charcoal, and pastel, 22" × 20" (55.88 × 50.80 cm), 1984. Private collection.*

Value painters should limit their color range. Colorists should limit their lights and darks. Here, value dominates and color is limited to brown and blue.

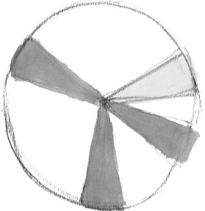

A painting whose color hues diagram like this has problems. There is no dominant hue. There is no secondary hue. All the hues are demanding equal attention.

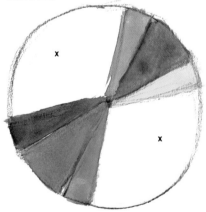

This is a diagram of color hues in Noon Day Stories—Darcy II. *The dominant hue is brown, and the secondary hue is blue. Being opposites on the color wheel, these hues give sufficient variety. If kept clearly minimal, touches of a third or fourth hue may be added.*

"Back Door" Color

I have been very specific in previous sections about the use of shape, value, space, movement, and dominance. They are major design elements for me. Because of the lesser role I let color play in my work, I prefer to be more intuitive with it. In fact, in some paintings I don't add important hues until I've almost completed the painting process. In *Sun Glasses* the large background blue and the foreground blue rims of the glasses were added as a last-minute change to an otherwise brown painting. This "impulsive" choice of color weighs favorably in the overall balance of the painting. The reds in *Study of Lou* exemplify this surprising use of color. The brown and blue painting had the red added "through the back door" as an intuitive afterthought.

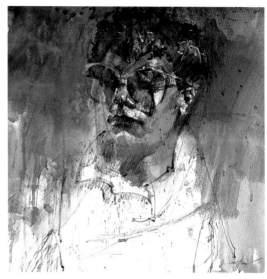

SUN GLASSES, *watercolor, charcoal, and pastel, 23″ × 20″ (58.42 × 50.80 cm), 1984. Collection of the artist.*

The dominant element in a painting should be considered before the painting is begun, during the painting process, and after it is finished. Other supporting design elements may be used more sporadically, for they are not the main unifying element. Here the brown values were constantly considered and the minor blue was added as a needed afterthought.

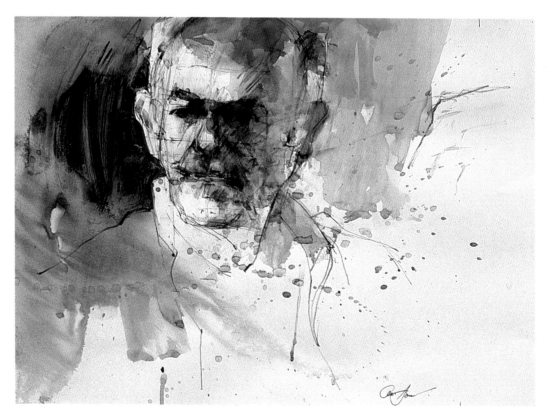

STUDY OF LOU, *watercolor and charcoal, 18″ × 24″ (45.72 × 60.96 cm), 1986. Collection of Lou Panagini, West Caldwell, N.J.*

Lou is such a character and has such an interesting head to paint that I was able to be intuitively freer in the way I handled the paint. I simplified the left side of the face, allowing it to be a good foreground light shape against the background dark. Since I had not wanted the light shape of the bald head to be the most important, I had moved it out of the middle of the upper-left quadrant toward the top of the rectangle.

Problem Colors

There are certain hues that artists find difficult to use. *Green* is one of these hues, especially for the landscape painter. The problem arises because nature provides us with such an abundance of green hues. During the summer, the problem is so acute for some artists that they consider moving from their inland environment to a coastal location where more varied colors are seen. For example, Andrew Wyeth moves from Chadds Ford, Pennsylvania (an inland community), to Cushing, Maine (a coastal town), in the summer.

Yellow is another interesting color that some artists find to be a problem. I think it is a problem because yellow does not come in a range of values. It is only light in value. How many quality paintings can you recall that have a dominance of yellow? I can think of only a very few. The solution is to paint middle and dark values of yellowish browns to fill this void.

Portrait and figure painters often have problems with *flesh tones*. In the true spirit of an artist, painting a variety of flesh tones is the solution rather than covering problem areas with clothing. Head-to-toe pink or tan flesh tones are monotonous. Arranging the light source to enlarge the shadow planes does help, but a variety of creative color hues is still necessary in the light plane. The extremities—head, arms, and legs—are generally a warm hue, while the torso can be painted a contrasting cool. A more creative and arbitrary approach than that is usually neces-

sary. Often, one reason an artist chooses a particular model or pose is because of variation of hues in clothing or skin tones. If the model or pose is chosen for other reasons, a more intuitive use of hues is needed.

Muddy colors are often an artist's lament. Too frequently the artist judges a muddy neutral gray color by looking only at that area of the painting. Winslow Homer's murky watercolor skies are well known. He would paint part of the sky after the water he was using for his watercolors was dirty and muddy. It worked because the neutral portions of the sky played nicely against the more colorful areas in the remainder of the painting.

Muddy color can be the dominant hue in an entire painting and still work. I won Best-in-Show at the 1984 Rocky Mountain National Watermedia Exhibition with a painting that had all tones of muddy brown hues. The fact that it was a value painting took the heat off the neutral hues so that the eye could focus on the value changes.

Local color can also be a special problem. My advice here is to limit local color; there is a tendency to overuse it. Be creative with excitingly intuitive hues that fit their purpose in the painting. Red is a hue. Muddy neutral gray is also a hue. Play them together in a color relationship. Enjoy the beauty and variety of color that your watercolor palette offers. Let hue be another of watercolor's joys.

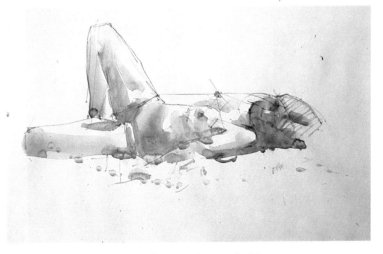

We can expand the range of the yellow hue by painting darker hues that seem to be in the yellow family.

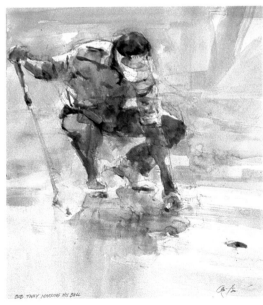

BOB TWAY MARKING HIS BALL, *watercolor, 14" × 12" (35.56 × 30.48 cm), 1986. Private collection, Atlanta, GA.*

There are cool hues at the arms and shoulders in the shirt of this clothed figure. Contrasting warms cover the chest and stomach where the warm light is reflected from the sunlit grass. Cool hues appear in the cast shadow on the ground.

We see reddish hues in our fingers when we hold them over a candle or other strong light. Similarly, when a head has strong backlighting, the ears look red because they are thin and transparent. So, too, we can paint the thin extremities of a complete figure in warm colors while we keep the thicker torso cool. What matters for the effectiveness of the painting is to avoid color hue monotony.

Color Intensity
Using Bright Color Selectively

By now you realize the interconnected nature of the design approach outlined in this book. *Value* dominance defines *shape* and relates shape to two- and three-dimensional *space*, which is unified by *line*. *Edges* enhance the focal point and set up *movement* through the rectangle. *Texture* and warm and cool *hues* relate to the subject matter but are distributed abstractly. If you use them in relation to value dominance, you can paint *intense colors* with all the excitement of their variety, but remember that ill-placed intense colors can undo a value-oriented design scheme.

Although value and color intensity are used together, they create an interesting design option. Color intensity is best used when it is painted as a middle value. Trying to use bright lights *and* darks is difficult because most hues take on their brightest chroma as middle values. Of course, contrasting muted colors can also be easily painted as middle values. Thus, color intensity can be used as an alternative to value.

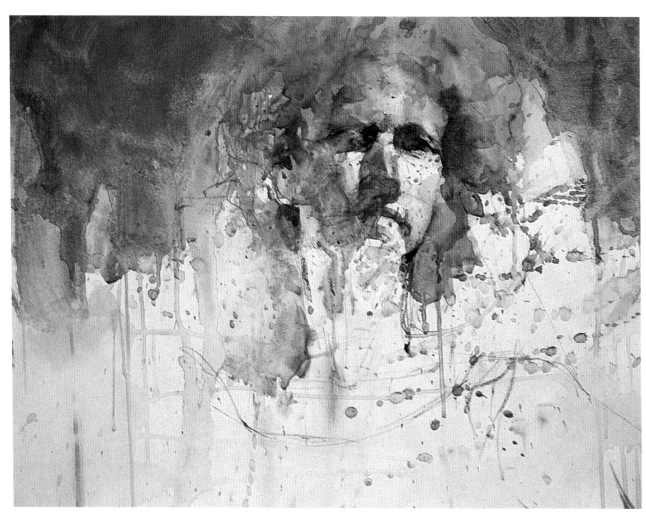

MARY BETH, *watercolor, 18″ × 24″ (45.72 × 60.96 cm), 1986. Collection of the artist.*

Even though the shapes in this painting are limited to the head and hair, there are many contrasts fighting for attention: the orange hair and face against the blue background; the dark values against the lights; the textured areas against the smooth; the clearly defined shapes against the loosely vague area. One of the conflicts should have dominated—probably the orange against the blue.

Value vs. Color Intensity

Experimenting with all of painting's possibilities—such as the inclusion of both dominant value and intense color—often prevents beginning artists from unifying their paintings. Experienced artists paint paintings with strong light-and-dark contrasts and intense colors every day. However, they do sometimes have a problem with value and bright color competing for the dominant role.

The solution to the problem lies beyond this value vs. color intensity controversy, somewhere in the realm of an even broader issue: Should artists who have advanced through the beginning/intermediate stages continue to experiment with every new technique and design approach they come into contact with? Although it is certainly a mistake to close one's eyes to any new approach, I suggest that beginning artists limit themselves until they have learned to unify the contrasting elements with which they are working. Painting is fun, but it can certainly be frustrating. Simplicity and unity will minimize frustration and create successful paintings.

When you achieve unity in a group of paintings, then and only then is it time to add new elements to your work. The same recommendation holds for the combination of value and color intensity in one painting. Use both value and color, but make the choice of which is dominant and experiment with your choice in a group of paintings. If you have not studied value, do so before emphasizing bright color. Then, if you decide to emphasize intense color, handle the design of the rectangle as you would if you were emphasizing value.

To begin a design by painting different bright colors, especially local hues, throughout the rectangle will make unifying that design an insurmountable task. Instead, look for ways to be selective. We have already discussed several of these ways: Use of the paper doll, the silhouette, and value dominance control the use of color. The abstract distribution of warm and cool hues ensures a cohesive color design. And the inclusion of arbitrary color puts the artist in charge of the local color of the subject matter.

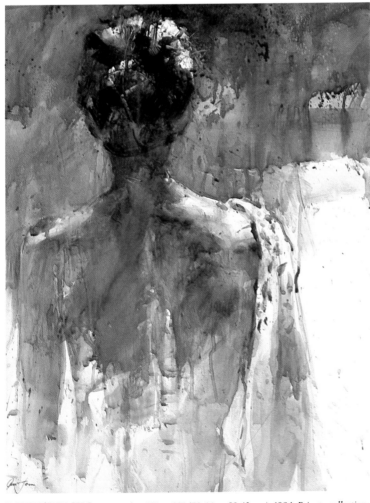

The only color used in this painting until the last two or three brushstrokes was burnt umber, making a monotone brown painting. At the very end I added some alizarin crimson in the background on each side of the head. I think that those few reddish tones make the burnt umber appear more colorful elsewhere. It is appropriate for a value painter to be restrained with the use of color, just as the colorist should not exploit a wide value range.

DONNA'S BACK I, *watercolor, 29" × 23" (73.66 × 58.42 cm), 1984. Private collection, Anderson, SC.*

Middle-Tone Intensities

As light strikes a form or object, the intense color is lost in the light plane. When the light is blocked from the form, the shadow plane's color intensity is grayed. The intense color appears in the middle-value transition area where the light plane changes to the shadow plane. In *Gena II* the local reddish color of the flesh appears at A; the light-struck paper doll (B) is almost white.

The shadow plane and the background (C) are a simplistic gray, which helps to clarify the intense middle tone. The idea is the same with a darker local color such as a black face. In *Basket Weaver—Charleston* the bright burnt sienna of the middle tone is at A, with the light plane (C) faded and the shadow plane (B) a grayed dark value.

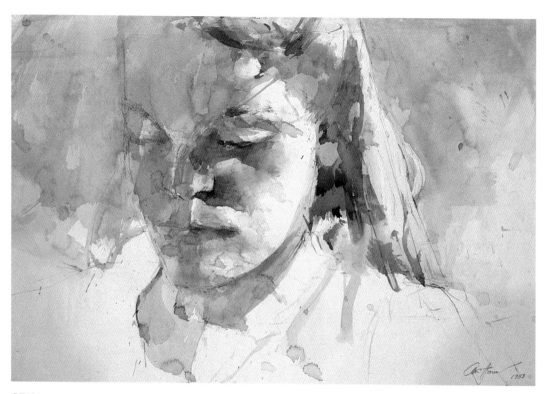

GENA, *watercolor, 14" × 20" (35.56 × 50.80 cm), 1983. Private collection.*

The brightest color of an object, such as a head, occurs between the light plane and the shadow plane. The reddish flesh tones through the middle of the face are at the point of transition between the light plane and the shadow plane.

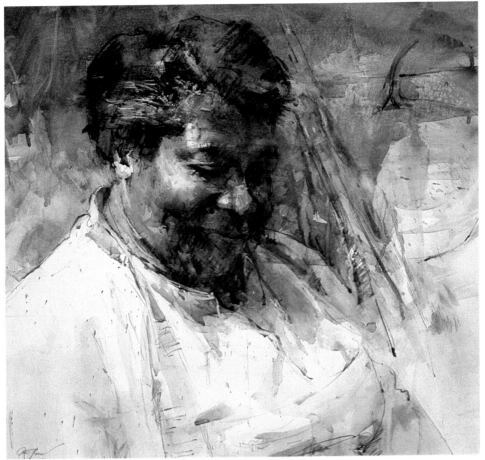

BASKET WEAVER—CHARLESTON, *watercolor and charcoal, 23" × 17" (58.42 × 43.18 cm), 1985. Collection of Sybil Mitchell, Fort Mill, SC.*

The edges between each of these pairs of color swatches are defined by a color change (green to red on the left and brown to blue on the right). The edges are not defined by a value change and then decorated with color. All four color swatches are middle value. The colorist should define edges of shapes with a color change. If the value of shapes is kept very close, a middle value for example, color is put to work to distinguish one shape from another.

Setting Up Bright Colors

Another approach to preventing too many different intense colors is to cover considerable surface area in setting up intense color. I will always remember working at my easel beside an artist whose paintings emphasized bright color. We were painting a black girl holding a bouquet of yellow flowers. The first stroke of the colorist's large brush filled half the sheet with bright yellow. By contrast, I spent two hours painting the head and background and setting up the yellow of the flowers. The colorist chopped away at his yellow, but I never could see the intended portrait because of the dazzle of the yellow flowers. Similarly, he sought in vain for more bright yellow in my painting. In *Sketchbook— Two Heads*, note the huge areas of tans and browns that set up the yellow jacket and make the yellow the focal area of the picture.

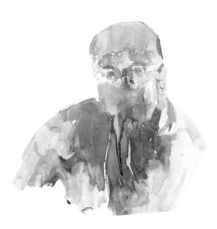

Here, a color change—red chest and green arm—is defined by a change of color, not value. The arm is separated in space from the chest by this color change.

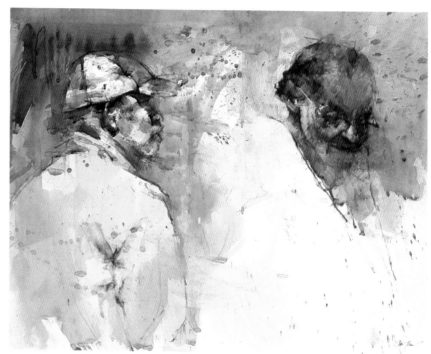

SKETCHBOOK—TWO HEADS, *watercolor and charcoal, 23" × 29" (58.42 × 73.66 cm), 1985. Collection of Pam and Allan Taylor, Conway, SC.*

The brightest hue in this painting is yellow. Look at the huge areas of tan and brown I used to set up the yellow.

Intense Color Accents

A seemingly contradictory method of being selective with bright color is to use it as an accent. The alleged contradiction is that a color accent implies that it is not set up and unified. In fact, it *is* set up, but the distribution is held to a minimum so that the accent color is somewhat startling. In *Nude with Red Scarf*, red is the intense color accent. There are no other comparable reds to set it up, but there are huge areas of brown, which is in the red family. The cool bluish-grays are small, making it a painting dominated by warm colors. The dominant color temperature should be warm if the color accent is warm. This allows the accent color to unite harmoniously with other related colors.

Study a group of your paintings or slides of your paintings. Is the value vs. color battle raging in your work? Are too many major hues fighting for attention? Calm down the use of color until your paintings consistently hold together, then you can add more color with a better understanding of the necessary interrelationships.

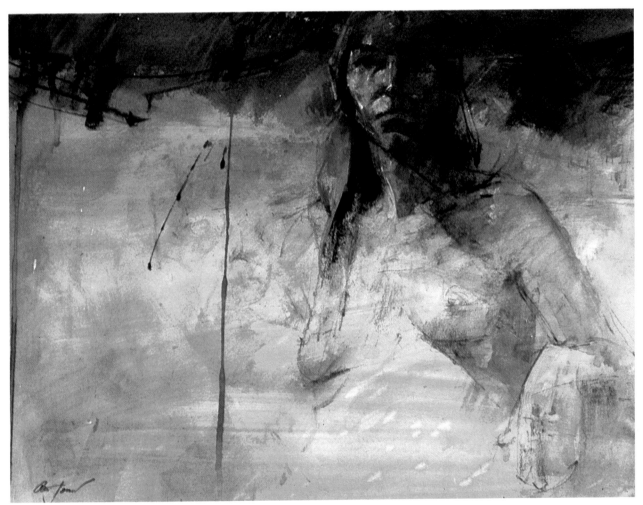

NUDE WITH RED SCARF, *watercolor, charcoal, and pastel on watercolor-toned paper,* *19" × 25" (48.26 × 63.50 cm), 1984. Collection of Anne Green, Spartanburg, SC.*

Red is the color accent in this brown painting.

Variety
Choosing Contrasts to Determine Style

Variety is essential for visual excitement. The design elements (value, shape, space, edges, color, texture, and line) create variety. The choices of contrasts are many, and to a large extent these choices determine the style of your work. They may be based on nature, the old masters, avant-garde artists, popular local artists, current art trends, or the color of a client's sofa. Most likely, your choices are based on your own unique way of seeing and your reasons for painting. We will attempt to examine these bases by exploring the tensions and conflicts in your paintings.

A study of art history can help you identify your own preferences and priorities from both traditional and contemporary imagery and aesthetics. Whatever inspiration gives you the impetus to apply paint to paper can be augmented by your awareness of the extensive variety other artists have used throughout time. This pursuit will help you to counteract dependence on subject matter that so often causes severe style problems among those who are young at art. Subject matter dominates their paintings. Their work tends to have a very different look, in terms of style, when they switch from portraits to figures to landscape to still lifes, etc. Thoughtful painting can be of benefit to them. It isn't enough for ambitious young artists to try to solve the problem by imitating another artist's technique. Although imitation of admired artists may be a necessary stage of growth, an artist must learn to identify his own individuality and express it on paper. When you can do that, your paintings will become as instantly recognizable as your signature and you'll learn about yourself as well.

Design and Style

Choosing a dominant design element is obviously a major style factor. My style is primarily a pictorialization of value as the dominant element. If one of the other elements (shape, space, edges, color, texture, or line) had been selected for emphasis, the resulting style would have been very different. It is necessary not only to make the choice of dominance but to make a priority list of the order of the remaining elements. My priority list is

1. value
2. shape
3. space
4. edges
5. color temperature
6. texture
7. line
8. color hue
9. color intensity

We have seen how light and dark values (1) were assigned to shapes (2) and arranged in the rectangle. The use of foreground and background space (3) was related to value in terms of the paper doll and the silhouette. Sharp edges (4) were used at the focal point, and blurred edges allowed movement to begin through the rectangle connecting the foreground and background shapes. Warm and cool colors (5) were added and distributed through the rectangle to alleviate the boredom of monotone painting. The rectangle was decorated with texture (6). Line (7) was used for graphic emphasis and as a unifier between the painted and the abbreviated areas. Local color hues (8) were used to identify the subject, and arbitrary hues were used for abstract distribution in the rectangle. Color intensity (9) was employed selectively for focal point emphasis and as color accents.

Another important idea to keep in mind is that too much variety can spoil your painting. We have asked this question before, but it bears repeating now: How many paintings have you seen that fail because they are too complicated? I see very few that fail because they are too simple. It is much easier to amplify a painting that is too simple than to sort through the chaos of complications. Sometimes de-emphasis can actually fine-tune your style . . . just as the barest hint of a flute can be a tantalizing element in a musical composition.

As simplicity and emphasis begin to delineate your paintings, your primary focus should be on consistency of style. Paint in one style at least long enough to do a series. If your temperament is volatile, change your emphasis and paint another series. An even better method is to follow your own promptings toward gradual growth. Refined emphasis and de-emphasis will progressively lead you toward development of your own individual style.

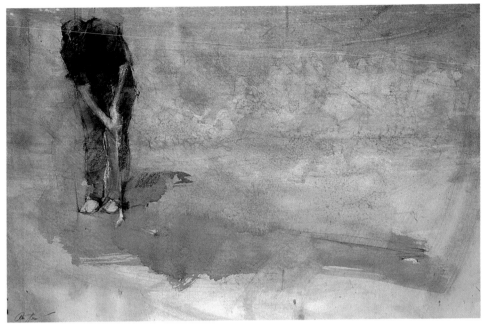

Even though I love the game of golf, a single sedate golfer putting the ball does not make a very interesting gesture for figure painting. But the lost edges in the dark head and shoulders and the green shape of the putting green between the golfer and the hole, repeating the shape of the golfer, create interest. And I like the brevity of the green shape and its lost and found edges. The vague images in the background are spectators in the gallery that were not completely obliterated when I scrubbed off the old painting (also a golf painting) as a toning for this one.

THE PUTT, *watercolor, charcoal, and chalk on watercolor-toned paper, 16" × 24" (40.64 × 60.96 cm), 1988. Collection of the artist.*

Charting Preferences

Few artists are able to do quality work while painting in more than one style. The following list can perhaps help you to pin down your preferences. Mark your choices below now, and then again at intervals every three or four months. Recognize the priorities, consistencies, and changes, and make your paintings work pictorially. Place a number in one of the two blanks indicating your preference:

> 3 = critically prefer
> 2 = prefer
> 1 = moderately prefer

EXAMPLE: _2_ transparent or opaque medium ___
The number beside "transparent" indicates my preference for transparent over opaque. The "2" indicates that I "prefer" a transparent medium. I am willing to use opaque media, so a "3" is not appropriate, but a "1" is not used because I think of myself as a watercolorist.

3 transparent or opaque medium ___
___ small or large brushes _2_
___ technique or design ___
2 paint on wet or dry paper ___
___ paint controlled or free ___
___ line or shape ___
___ color or value ___
___ paper doll or silhouette ___
___ high key (light values) or low key (dark values) ___

___ large shadow planes or large light planes ___
___ panoramic or close-up shapes ___
___ sharp or blurred edges ___
___ textured or smooth ___
___ subtle or abrupt transitions ___
___ contour or gesture lines ___
___ local or arbitrary color ___
___ warm or cool colors ___
___ bright or earth colors ___
___ abstraction or realism ___
___ semiabstraction or either abstraction or realism ___
___ abbreviated or detailed ___
___ vignette or paint corner to corner _3_
___ beautiful or character models ___
___ vertical or horizontal rectangles ___
___ oblique or right angles ___
___ static or rhythmical imagery ___
___ geometric or organic shapes ___
___ predictable or unpredictable imagery ___
___ subject matter or design ___
___ formal or informal imagery ___
___ analytical or impulsive ___
___ visual or intellectual inspiration ___
___ aesthetic based on nature or on art history ___
___ repetition or chaos ___
___ serene or busy ___
___ paint for show or sale ___
3 process or product ___

Unity
Harmonizing the Elements

Unity is built into the design. It is not achieved with the last five or six brushstrokes of a painting. The design principles of dominance, movement and variety come together into a complete whole when priorities have been set from the beginning: The conception of the painting has to be carried through construction of the image.

As stated earlier, the design elements (value, shape, space, edges, texture, line, and color) create variety and thereby visual excitement. Unity is the principle that combines these design elements into one cohesive image. Unity is an essential idea in this text.

The orientation of my design approach has always been in the direction of restraint, abbreviation, and selectivity. In fact, one very observant workshop student, after listening to my design ideas for a couple of days, suggested that my approach might be summarized by the phrase "less, bigger, darker, and faster." These references are to "less" subject, "bigger" shapes, "darker" values, and livelier paint quality by painting "faster."

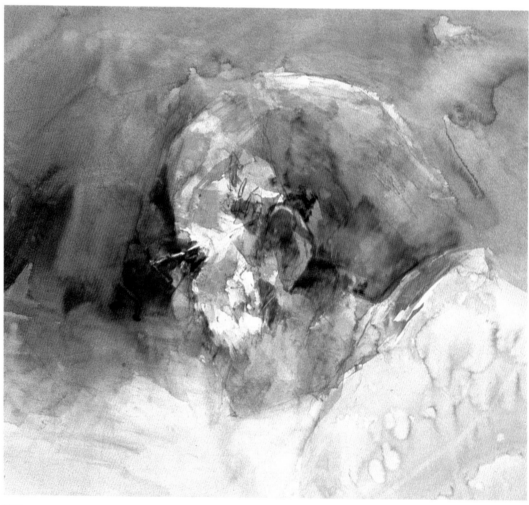

PAB, *watercolor, 18" × 21" (45.72 × 53.34 cm), 1984. Collection of Paul Stanton, Myrtle Beach, SC.*

My interest in this painting has increased since I completed it, partly because of some minor cropping I did at the bottom and right sides of the rectangle. I like the lively, fresh brushwork and the intermittent sharp and blurred edges moving from the front of the face to the back of the head.

Finding Unity Between Repetition and Chaos

Variety prevents too much repetition, and unity organizes the multiplicity of variety. The choice of the dominant design element limits the possibility of chaos. A design approach that enhances and builds upon the dominant element is the basis of unity.

Let us look at three paintings and identify their contrasts and their unifying characteristics. *Helen III* has three primary contrasts: the head, the white paper, and the abstract brushstroke located at A. The repetition of light areas toward the top of B, C, D, and E complements the lower band of white paper. Few contrasts could be greater than the highly modeled head and the wild brushstroke at A. To achieve the unity of this contrast, I coordinated the middle dark values with the connecting passage of those darks at F and G. Notice how much variety I used for the edges between the lower light band and the upper painted area; this was a way of both separating and relating sections rather than simply dividing them at H.

By flipping their values, I have given variety to the repetition of the figure and the sacks of clams in *Clam Catch* (page 98). The fisherman and the adjacent sacks (A) are lighter than the background (B). The sacks at C are darker than the background (D). By repeating this middle horizontal band (E), I introduced variety into the upper (F) and lower (G) horizontal bands of space. The distribution of light shapes unified the painting. The lower band (G) connects to the light figure and sacks at A; both are repeated in the background light (D). A serendipitous brushstroke at H animated the background and provided the necessary transition to light at D.

River Fishing I (page 98) is more of a rendering than a design. I placed the vertical figure in a vertical format, which tends to minimize the background shapes. Not repeating the darks of the face and arm in the background drew greater attention to the graphics of the figure and bucket. Although I like the lively line quality in this image, I am suspicious of making a career of renderings without abstract design distribution. Unity is primarily achieved by repeating the darks of the face and arm at A, B, C, D, and E. Just as important was the restraint of darks at F and G, which kept the face and arm from being too dark and spotty.

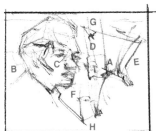

Contrast is necessary for visual excitement. Unifying the chosen contrast is painting.

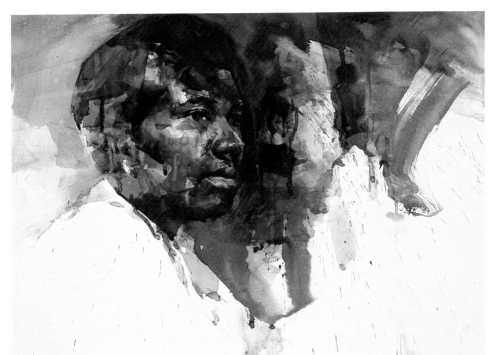

HELEN III, *watercolor, 21" × 29" (53.34 × 73.66 cm), 1982. Collection of South Carolina State Museum, Columbia, SC.*

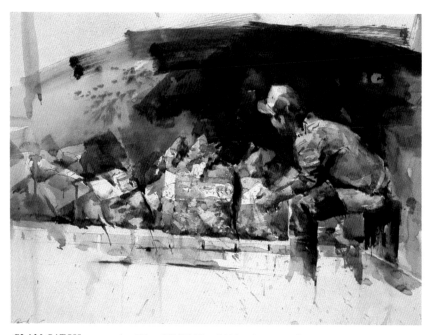

Beware of dark shapes through a painting that alienate light shapes. Connect the light shapes for a unifying movement through the design.

CLAM CATCH, *watercolor, 22" × 30" (55.88 × 76.20 cm), 1982. Collection of Floy Polen, Myrtle Beach, SC.*

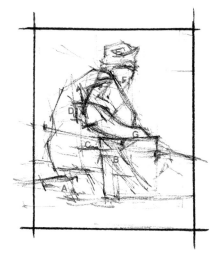

This is a poorly designed painting according to my design requirements. The vertical figure is in the middle of the vertical format and the dark shapes of the foreground figure are not repeated in the background. Its virtues lie in its line and edge quality.

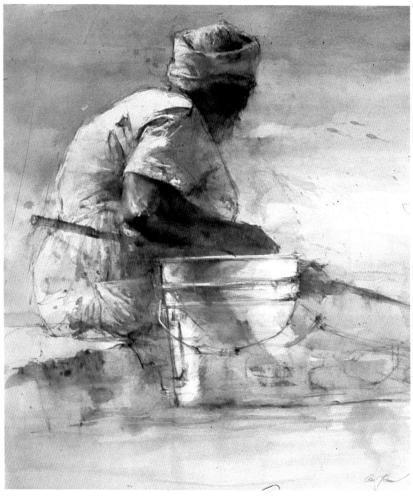

RIVER FISHING I, *watercolor and charcoal, 21" × 18" (53.34 × 45.72 cm), 1983. Collection of Joy and Jay Burton, Atlanta, GA.*

Creating Unity by Cropping

Paintings fail for many reasons: shapes too small for the size of the paper; lack of distribution of the painting's elements; too much variety; transparency of the watercolor is overworked, etc. All of us have inadvertently explored the parameters of failure. The result is knowledge from our failures and a stack of throwaway watercolors stored somewhere in our studio space.

Although I usually attempt to make every painting work as the size that it began, I have no misgivings about cropping a section from a large painting and framing it. If the shapes are too small for the size of the paper, as in *River Fishing III*, I simply zoom in closer to the focal point. In other paintings, such as *Market Vegetables*, the entire feeling of the image may be changed by cropping out the focal point and focusing on a new idea. Normally, some additional painting is required to unify the new image.

In the search for a painting within a painting, I find it works best to use two L-shaped mats. Sometimes a painting just dies, and no amount of cropping will save it. But you can save many of the paintings you were excited about but which didn't fulfill your ambitions by using this alternative way of unifying a design.

But, to repeat, if you are selective from the start, you can lessen the problem of unifying your design later. Choose the dominant design element and related elements to prevent having to salvage unity out of chaos later. You can then bring your design to a satisfying whole by having to make only minor adjustments as you complete your cohesive painted image.

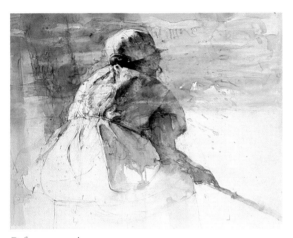

Before cropping.

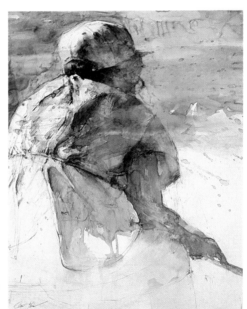

Cropping a small section of a large painting may be the answer in the search for unity. Here, cropping is rather simplistic but, I think, effective.

RIVER FISHING III, *watercolor,*
18" × 24" (45.72 × 60.96 cm),
1984. Private collection.

Before cropping.

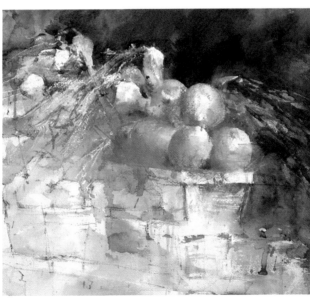

Here, the cropping is much more drastic. It completely changes the imagery and feeling of the painting.

MARKET VEGETABLES
watercolor and pastel, 10" × 10"
(25.40 × 25.40 cm), 1982.
Collection of Phyllis and Bob Boger,
Lake Forest, IL.

Part III

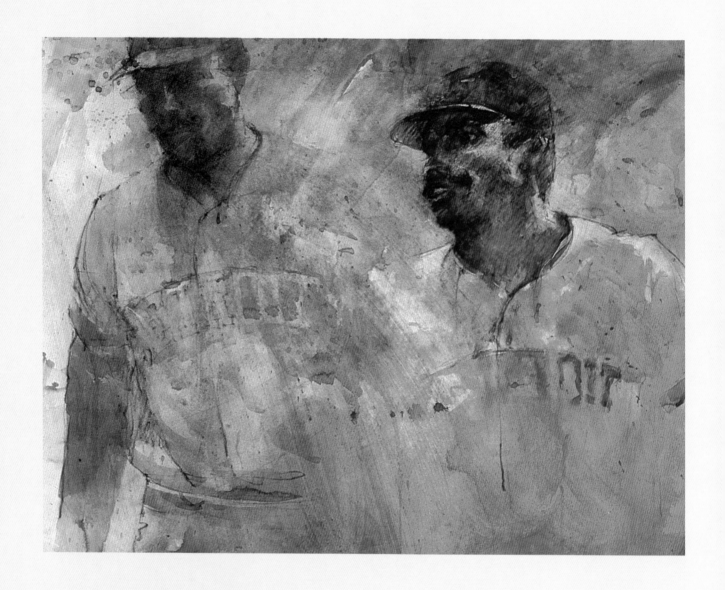

Pragmatic
Considerations

Materials

Painting materials reflect and extend design and aesthetic interests and preferences. The ones listed here reflect my interests. You should find other materials for *your* design and aesthetic preferences.

• Paper: 2-ply Strathmore high-surface Bristol

• Brushes: large! (1″ aquarelle, 2″ and 3″ mottlers)

• John Pike palette: I cut out the divider between two color sections and use it for one color so that it is wide enough for my large brushes. To cut the plastic divider, score it with a mat knife and break it off with a pair of pliers.

• Homasote/bedding board: When paper is stapled to this board, the staples can easily be removed.

• Reducing glass: The opposite of a magnifying glass, a reducing glass is used to give a distant look at a painting so that one doesn't have to constantly walk away from it.

• Plastic spray-bottle for water: Since I work on unstretched dry paper, I turn the nozzle to a fairly wide spray and pull the trigger on sharp painted edges or use the spray to wet parts of the paper.

• 6B charcoal pencil: This pencil will make a delicate line when drawing before painting and, because it is soft, a dark line when drawing after painting has begun.

• White pastel stick or small set of pastels: Since I am usually impatient with lifting color and waiting for it to dry, I usually regain lost light areas with white or light pastel chalk.

Techniques

Technique is the way an artist handles the materials of his craft. Watercolor seems to have more than its share of materials with which to work. We can't help but be fascinated when we observe watercolorists using their seemingly endless array of materials and techniques: salt or Saran Wrap textures; air-brushed stenciled grids; Maskoid, crayon, or oil-based resists; collage, etc. Since one of the tasks of a painter engaged in his art is to advance the medium he uses, these explorations can be of benefit. But artists can get caught up in such technical gimmickry and lose the thrust of their individual expressions. Demand that your techniques be consistent with your vision, and master technique. Do not let it master you.

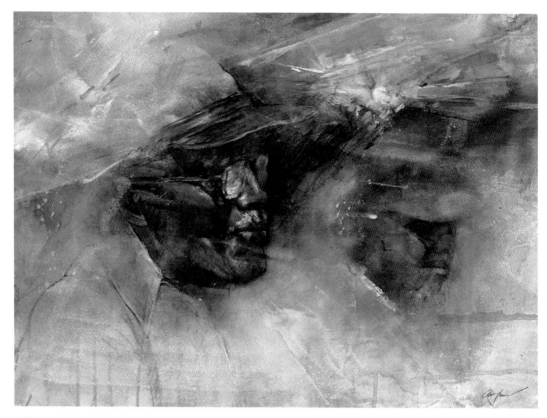

OCEAN FISHERMAN, *watercolor, charcoal, and gesso, 22" × 30" (55.88 × 76.20 cm), 1983. Collection of Long, Aldridge and Norman, Inc., Atlanta, GA.*

Huge dark areas were lightened with the floated gesso in this painting. Chinese white or white gouache are not as effective as white acrylic gesso because they do not have the opacity required to cover dark areas once water is mixed with them.

Floating Gesso Over Watercolor

When a watercolor is overworked or has large areas that need to be changed, the most obvious remedy is to take it to the sink and scrub off the color with a stiff-bristled brush. However, I have found that a good alternative is to mix one part acrylic gesso with four or five parts water and, keeping the paper flat, pour the mixture onto the troublesome areas. Leave it concentrated on the areas to be obliterated and spray the remainder of the gesso with the water spray-gun. Since the paper is flat, the gesso and water mixture will float to these wet areas and will stay away from the dry areas. If the mixture is allowed to dry undisturbed, an interesting granulated texture will result because of the opacity of the gesso. You can see this technique in *Janie Washington III*. And in *Ocean Fisherman*, large dark areas were lightened by floating gesso. One fisherman's head is clearly visible, but the floated gesso almost covered the other fisherman's head.

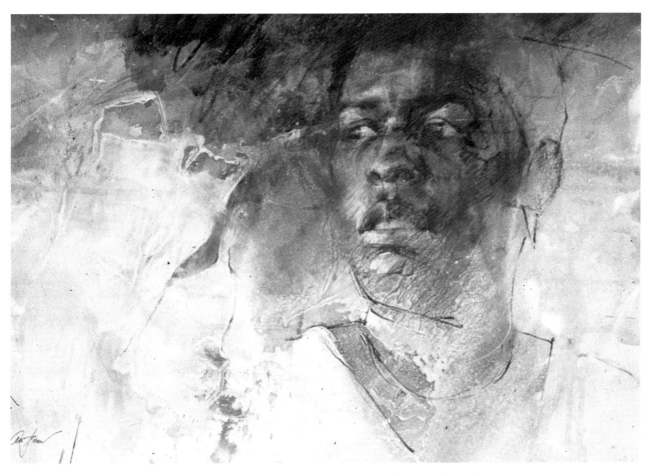

JANIE WASHINGTON III, *watercolor, gesso, charcoal, Conté, and white chalk, 18" × 24" (45.72 × 60.96 cm), 1983. Collection of Nancy and Eugene Fallon, Florence, SC.*

Here, I poured a mixture of one part acrylic gesso and four or five parts water over the undesirable areas. When the gesso dried, I worked back over parts of the painting with brown Conté crayon, charcoal, and white chalk.

Recycling Throwaway Paintings

As paintings turn into less than expected master-pieces, watercolorists quickly learn to paint on both sides of the paper. More than two water-colors may be painted on one sheet of paper by firmly scrubbing off dark and bright colors with a wet stiff-bristled kitchen scrub brush and spreading the colors over the remainder of the sheet. The wet paper becomes toned without adding additional color.

I usually stretch the toned paper, since it is already wet paper by stapling it to a Homasote/bedding board. If you are like me, you have a stack of throwaway watercolors in your studio space. Scrub off these discarded watercolors and tone many sheets at one time, using both sides of all the boards that you have available.

Opaque Gouache White

Although the choices of media to combine with watercolor are limitless, there is a natural

The top brush-stroke here had too much water mixed with the gouache white, and it dried chalky. The lower brushstroke had only a touch of water, and it re-tained its opacity.

Mix gouache white with the transparent wa-tercolors on your palette for the de-sired off-white tones and colors. Do not try to make gouache transparent by thinning it with water.

kinship between transparent watercolor and gouache, which is an opaque watercolor. I prefer gouache to Chinese white because it is more opaque. You can mix gouache white with trans-parent watercolors to make opaques of any color, or you can buy tube colors already mixed with white. I use Winsor and Newton Designers Gouache White Series 1, which is permanent.

The primary characteristic of gouache for the watercolorist to remember is that gouache is not transparent. There is a tendency to use too much water with it to try to make it transparent. When this happens, the white areas dry darker and leave a chalky, ghostly look, as you can see in the two brushstrokes at left. The solution is to antici-pate how much darker the gouache is going to dry, or if less than a pure white is desired, to mix the gouache white with other transparent water-colors for opaque off-whites. The opaque white in *Reaching Out III* (see page 105) is primarily gouache white with touches of white chalk. The toning is of a sufficient middle value to provide enough contrast with the opaque white.

Darks on Toned Paper

Toned paper offers a solution to one of water-color's greatest problems—painting dark values. Because this is a problem (which I've discussed in the section on value), artists often shy away from using darks for fear of painting them poorly. Since only darks and middle darks can be painted on paper toned to a middle value, using toned paper can help solve the problem of work-ing with the dark values. *Reaching Out III* is a good example of the toned-paper process.

The swatches lighter than the toning of the pa-per were painted opaquely. The swatches darker than the toning were painted with transparent watercolor.

Toned-Paper Vignettes

Vignettes take on a new feeling on toned paper. Here, because they are no longer made up of just white paper, they more readily unify with the remainder of the darker values in the painting. In *Reaching Out III*, notice how the lower part of the figure melts into the vignetted toning toward the bottom of the page. To create a lighter effect, I simply lifted the toning here.

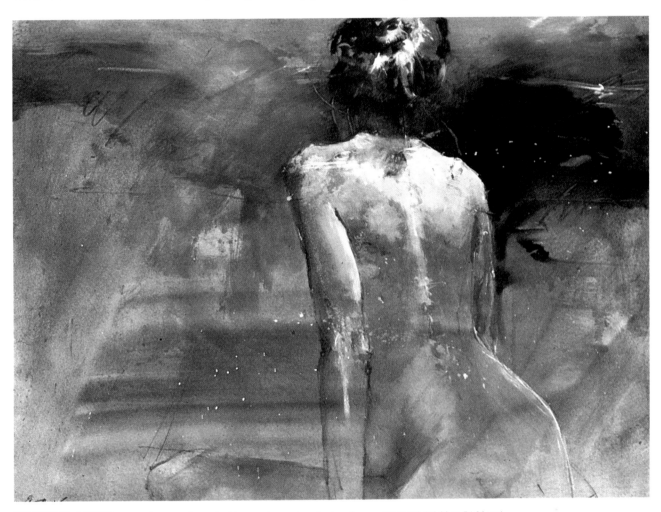

REACHING OUT III, *watercolor, gouache, and white pastel on watercolor-toned paper, 22" × 30" (55.88 × 76.20 cm), 1984. Collection of Michael Roberts, Westminster, CO.*

When painting on toned paper, be sure to leave some of the toning throughout the entire painting. Use opaque white and watercolor darker than the toning, but leave substantial areas of untouched toned paper. Here, in the lower-right corner, I lifted the toning rather than make it lighter with opaque whites.

Middle-Value Unifier

The greatest benefit of painting on toned paper is the tremendous unifying nature of the middle-value toning. This is particularly true when the toning is allowed to remain in all parts of the rectangle, not covered by transparent darks or opaque lights. In *Ernest III*, the toning reads through the design at the A's. You may be surprised to realize how little painting time you need when you use toned paper. The reason for this is that so much of the painting has already been completed by the toning!

In working with the illusive watercolor medium, I have learned to accept immediate successes: there are always plenty of time-consuming failures. It is also pleasantly surprising to discover how an unattractive toning—such as the dirty brown in *Church Man*—can take on an agreeable, even sophisticated impression when combined with the transparent darks and the opaque lights. When used properly, the middle-value toning becomes unpredictable and esoteric, although it is a great unifier of design.

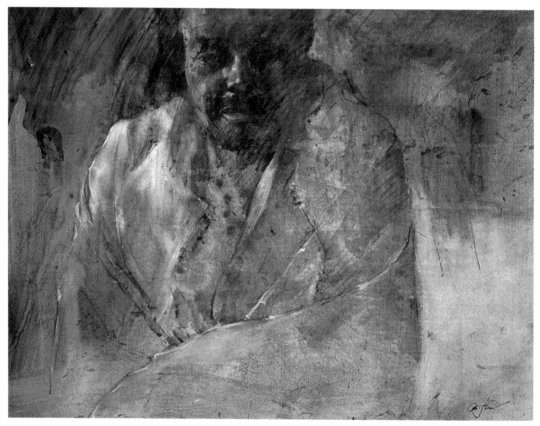

ERNEST III, *watercolor, charcoal, and white pastel on watercolor-toned paper, 23" × 29" (58.42 × 73.66 cm), 1985. Collection of Macon and Claude Epps, Jr., Myrtle Beach, SC.*

The value painter creates contrast with lights and darks. He unifies his value painting with large areas of middle value. On toned paper the large middle value areas are already there.

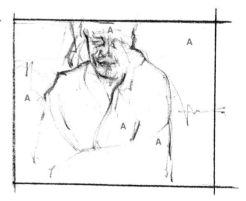

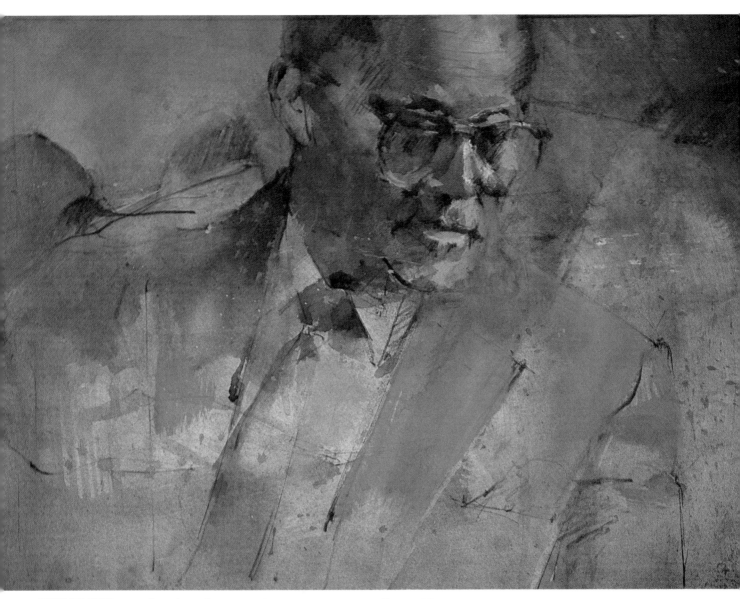

CHURCH MAN, *watercolor and gouache, 18″ × 24″ (45.72 × 60.96 cm), 1985. Collection of the artist.*

This workshop demonstration painting was done to illustrate how I work on toned paper. (See also the Psychologist and Patient *on page 117.)*

The Practical Side of Art

So many good artists lose valuable painting time when dealing with the practical side of art. Lack of organization and overdoing menial tasks often take up days that could otherwise be spent communing with the art spirit.

Efficiency in taking care of the practical matters of art can make possible a more fruitful use of yourself in all other areas important to developing your craft: learning to draw and paint the portrait head and figure, designing these shapes in the rectangle, and relating painting and design to the inner world of aesthetic thought. This section is about those pragmatic considerations: the source of subject matter, the painting routine, studio space, uninterrupted painting time, framing, photography, promotion of one's work, fame and money. Until these matters are attended to, painting remains a gleam in the artist's eye.

Studio Space

Even the landscape artist who consistently paints outdoors needs a studio. In my younger days, I would find a suitable studio space to rent and never get around to finding an apartment. Usually, I would end up with a bed in a room adjacent to the studio. The studio always came first.

I have never seen a studio that was too large. Thus, organization of the space is critical. Separate a section of the studio space, as small as possible, for supplies, framing, and photography. Leave the walls of the larger painting area free of clutter for displaying your work. Protect the large painting space from encroachments of any kind. Give yourself room to make the gestures that your paintings need, room to curse your failures and exalt your successes. Most of all, give yourself enough room to study a painting in progress from a distance. The illustration below is a diagram of my studio space.

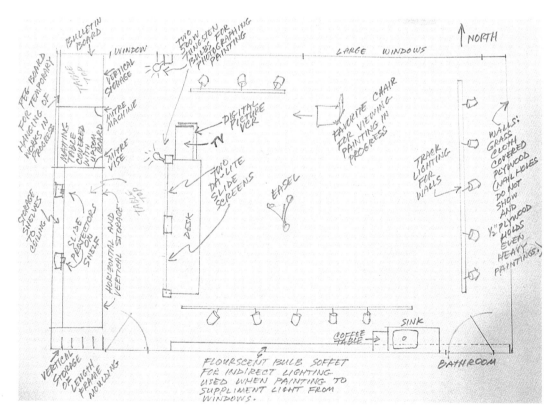

Framing and Matting

Although I have a miter machine for cutting wooden frame molding, the use of ready-made section frames is an obvious solution for artists without the space, time, or inclination for mitering and putting together frames.

It is difficult to cut mats properly without purchasing an expensive mat cutter. Mat cutting is not required if you like the look of having your watercolor floating on a backing of mat board. A linen tape is used to attach the painting to the backing board. The diagram here shows how the tape is cut and folded so that the tape is not seen above the painting. You save money by not having to cut mats, and you can use an inexpensive backing board behind the quality mat board that never touches the paintings.

Originally, the reason for using a mat with works of art on paper was to separate the painting from the glass. Since a floated painting has no mat, a frame spacer is required when the painting is framed. The frame spacer separates the painting from the glass, as shown in this illustration. It can be purchased in various lengths from framing suppliers, and since it is thin clear plastic, it can be cut with a mat knife.

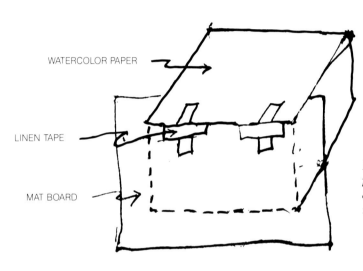

WATERCOLOR PAPER

LINEN TAPE

MAT BOARD

Floating a watercolor in front of mat board instead of cutting a window in the mat board.

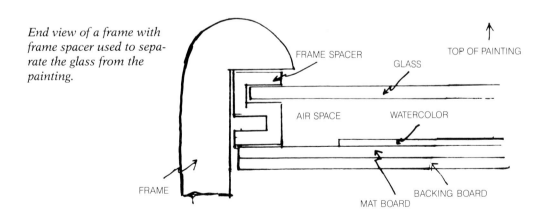

End view of a frame with frame spacer used to separate the glass from the painting.

FRAME SPACER

GLASS

TOP OF PAINTING

AIR SPACE

WATERCOLOR

FRAME

MAT BOARD

BACKING BOARD

Shrink-wrapping: Purchase No Tools

The only materials needed to shrink-wrap a matted or floated watercolor are a piece of newsprint, an iron, and a roll of shrink-wrap film, which comes in a box with a serrated edge. Cut off a piece of shrink-wrap and fold it over the floated or matted watercolor in the same way that you would wrap a gift with wrapping paper. Place the newsprint sheet over the shrink-wrap, and iron, with a middle temperature setting, first the folded backside and then the front until the sheet pulls tight. It is simple and inexpensive.

In appropriate exhibition situations, such as outdoor art shows or in my studio gallery, I often display paintings framed and shrink-wrapped rather than covered with glass. Not having glass makes them lightweight for transporting and conveniently convertible for removing from the frame for display in portfolio racks or shipping.

Shrink-wrapped watercolors are often displayed in portfolio racks. If you wish to hang them in your studio without permanent framing, use inexpensive bracquettes, which hold the painting. The bracquette is pulled tight on the back with a spring and a cord.

Slides of Paintings

Slides are a convenient documentation for paintings. They have become a necessity for sending to juried exhibitions, galleries, agents, museums, and prospective clients. Slides are also useful when you show your work to art classes and organizations and whenever you want to provide a personal pictorialization of your work.

I suggest the use of Ektachrome 50 tungsten slide film with two 500-watt tungsten photo flood bulbs. The use of corresponding slide film and floodlights eliminates the variables in photographing your paintings, thus ensuring quality. Tape the edges of the processed slide with polyester tape so that only the painted image shows.

If you have another kind of film in your camera when you need to photograph paintings, you can easily change the film and not waste the remainder of the unfinished roll. Push the film-rewind button and hold the camera to your ear while rewinding. When you hear a noise and feel the film pull off one end of the spool, stop immediately. Open the back of the camera; the film should not have been entirely rewound onto the spool. Only the leader film should be visible. Mark the film with a piece of masking tape, indicating the exposure number that the camera showed before rewinding. Later, when reloading this roll of film, advance it, with the lens cap securely attached, to the number on your tape and use the remainder of the roll as usual.

Record Keeping

I label each slide of a painting and its corresponding file card with a number. In a card tray, I file the card according to the current location of the painting: gallery, studio, etc. When and if the painting sells, I add the purchaser information to the card and file it by title in a separate card tray. I also keep a mailing list of purchasers of paintings, prospective clients, students, and prospective students for mailings of invitations to shows and classes or workshops.

A 3" × 5" file card for each completed painting, with a file number corresponding to the number on the slide mount of the same painting.

> "Nude with Red Scarf" 4-358
>
> w/c, charcoal, chalk & touches
> of gesso 19" x 25"
> Aug. '84 $500.⁰⁰
> — 1/3 = $333.³³
> Sold at Carolina S/Spartanburg Exh.
> Anne Greene
> 908 Brentwood Dr.
> Spartanburg, SC 29302

Uninterrupted Painting Time

Most people who paint are not full-time painters. Arranging your schedule to allow uninterrupted painting time is even more critical than arranging for studio space. The world is full of people who would like to paint and do not! The need to express yourself in paint does not solve the knotty problems of time and space. Make the uninterrupted painting time happen for you. Without it, you simply cannot do the work you need to do to develop as an artist.

Promotion of Your Work and Fame

Do what is necessary to get your deserved notoriety. Start at home and work out regionally and nationally. Fame in the art world comes primarily through juried exhibitions. Although the juried exhibition game is subjective, it is the only game in town. Non-juried exhibitions also abound, but beware of some of these sales-oriented opportunities, for they may lead to sales you cannot resist and thus take you away from your long-term goal of noncommercial quality work.

As North Carolina artist Russ Warren says in *Understanding Abstract Art*: "I try to make as much good art as I can; I'm preoccupied with that, at any cost. The rest will take care of itself. People who believe that you have to be a hustler to make it around the art circles, ultimately get to be known as hustlers, not artists."

Money

There are few artists who make a living selling their art. Fame does not always bring money. Teaching is certainly a viable alternative, and it often allows painting time. I think art students should also train themselves in an unrelated field. Many times this secondary training can help you support yourself during the years you need to be able to consistently produce quality fine art. Although this is not a perfect solution, I think that it is better for the artist in the long run to have training in an unrelated field that will provide steady income. Although it is tempting to try to make money using your talent for art, rather than earn a living in an area you might not enjoy as much, my observation is that this seldom works. If sufficient income is made by some form of commercial art, it complicates and takes away from the fine art being produced at the same time. Not only are the artist's clients and peers confused between the commercial and the fine art the artist is producing, but the artist too becomes confused. The commercial art *will* influence the fine art. It is almost impossible to keep them separate.

Sources of Inspiration

Style results from uniqueness of vision, choice of ideas painted, and reasons for painting. Realization of style is more than an intellectual undertaking or a technical task: It is a clarification with paint of an intuitive emotion.

Style is also a function of the approach to imagery. There are five approaches to representation, listed below from the initial concept or inspiration (left) to the completed image (right):
1. from realism to realism
2. from realism to abstraction
3. from abstraction to abstraction
4. from abstraction to realism
5. a combination

The approaches that seem to lend themselves most readily to good design are number three, from abstraction to abstraction, and number four, from abstraction to realism. Design can best be visualized in terms of abstraction. However, *any* of these approaches are valid and can lead to quality work.

My source of inspiration is usually a realistic image of people and their environments. Of the resulting paintings, column on the right, the one I prefer is the one that combines the realistic image with an abstract design structure. Thus, my approach to imagery is number 5, a combination, "from realism to a combination of realism and abstraction." The fact that my approach does not begin with abstraction, which most readily adapts to design, demands constant modification of realism into abstraction. I am willing to make the adaptations because my source of inspiration comes from realism. The two sections that follow are necessary for me in gathering inspirational source material, since my approach is based on realism and nature and its inhabitants.

Painting from Slides

I paint from life and from slides. I paint from slides rather than photographic prints because there is so much more information available in the slide when the slide is projected on a large screen. I have a permanent Da-Lite slide screen in my studio. The slide projector is placed permanently on a shelf for rear projection. I can view the three-foot by three-foot screen from the front without having to darken the room.

You can get information about portable Da-Lite screens from your photography shop. Any size can be cut from a large roll. The screen is also available in a seventeen-inch square that rolls down into a portable metal holder. You can purchase the screen film less expensively from a theater supply company.

Painting from Television

Whether an artist's inspiration derives from nature or from the artist's make-believe world will make practical demands on the artist's pre-painting routine. Since my initial inspiration for a painting is based on reality, I am constantly gathering subject matter for painting. I paint from live models and from slides of models. To give me more flexibility with this initial inspiration, I have begun painting from television.

Using a VCR videotape played through the television, I make a still image by pushing the "pause" button on the VCR. The "pause" mode on a regular VCR has poor picture quality and kicks off after five minutes. This unsatisfactory situation caused me to buy a *digital picture* VCR. The "digital pause" mode image is transferred to a computer image and then frozen on the screen. The tape is not running over the same spot on the tape, and the paused image can be left on the screen for a long period of time without fear of damage to the videotape or the tape head. An additional advantage is that the television picture in the "digital pause" mode is perfectly clear and still.

In the beginning, I painted from VCR tapes of network television programs to make sure that this method of gathering subject matter was one that I would actually use. The drawing *Tom Kite* is an example. As soon as I knew that I would use it, I purchased a videotape camera/recorder, camcorder, so that I could make my own tapes. Now I seldom paint from photographic slides. My own videotapes are much more versatile than the slides, and the video camera is much easier to use than the photographic camera. *Tiger* is an example of a painting I painted from my own videotapes.

I purchased one of the small video camcorders. It is not much larger in size than a photographic camera. It has the advantage of making the image available for use immediately after taping. As you know, this is not true of slide film, which has to be processed and often requires several days before the slides are ready. With a video camera you can immediately find out if, in fact, you did get the image on tape, which is not possible with a photographic camera.

Another plus for the video camera is that a good image of dimly lighted subjects presents no problem to the video camera, whereas the photographic camera is very sensitive to lighting. Also, the zoom lens and the wide-angle lens, which are built into the camcorder, are much better and less cumbersome than in most photographic cameras. The video camcorder costs about a thousand dollars. It has a VCR built into it, even though it is not a digital-picture VCR. The camera can be connected directly to the television. When you are on painting trips or vacation, it can be plugged into your hotel television for previewing the images taped that day.

I never thought that I would have a television in my studio, but I have one now. I find it much more versatile than slides, and even though I am not a high-tech person, I find the video equipment easy to operate. Having discovered this new method of gathering images, I have expanded my range of inspirational source material. In this way, practical reality has increased my artistic capabilities. Taking care of the practical realities of art can often facilitate the free flow of creativity that combines inspiration, technical know-how, and the materials of the craft to produce new and exciting painting.

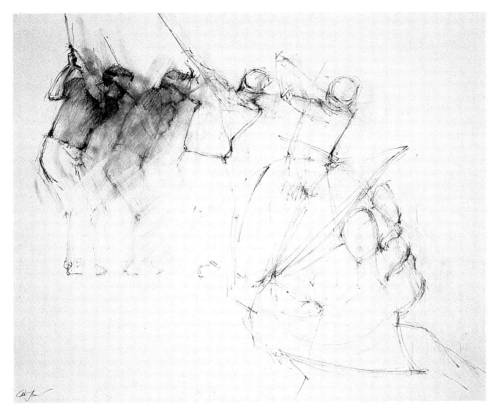

This drawing and several other paintings of golfers were made before I purchased my video camera. The versatility of video is illustrated here. I was able to stop the tape at various points during the golf swing, something the amateur photographer cannot do with a still camera.

TOM KITE, *charcoal, 22" × 28" (55.88 × 71.12 cm), 1987. Collection of Wynlakes C.C., Montgomery, AL.*

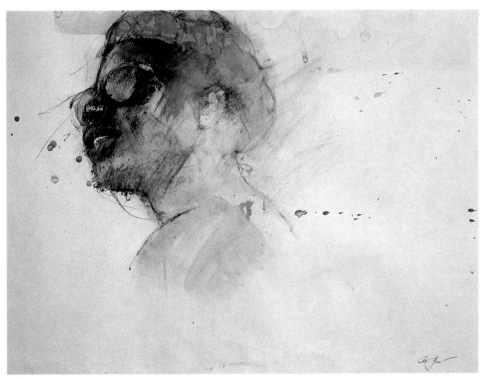

Tiger gave boat rides to tourist at our hotel in Jamaica and told interesting stories about life on that enchanting island. I did his painting on a regular VCR videotape before I bought a digital-picture VCR. The difference was that the picture quality was poor and every five minutes the picture would automatically kick off and I'd have to get it back again.

TIGER, *watercolor and charcoal, 17" × 22" (43.18 × 55.88 cm), 1987. Collection of Alby Johnson, Waterford, CT.*

Demonstrations

As a teacher, I do not have a technique-oriented approach to instruction, but I do see the value of using painting demonstrations as a program for an art meeting or as part of an art class. They are always popular with the students. The process of making a painting is revealed as well as the finished product. There are as many different processes, or painting procedures, as there are varieties of completed paintings.

Some art teachers base their teaching on demonstration paintings. Others do not use them at all because their painting procedure is not direct and fast enough or because they dislike this method of art instruction. When I use demonstrations, I schedule them toward the end of the workshop week. Also, during demonstrations I explore with the class how technique relates to design and aesthetics.

Coordinating the Head with the Background

Step 1. Before I painted the dark blue background, I defined and modeled the upper face. Even though Janie Washington, one of my favorite models, is a black woman, I left some of the light areas of the face as white paper. This creates sufficient value contrast with the dark background.

The focal point of the painting is established in the upper-left quadrant with the white face against the dark blue background. The sharp edges of this strong value contrast draw the eye to the focal point. A middle-value version of the dark blue background is carried behind the head and toward the upper right.

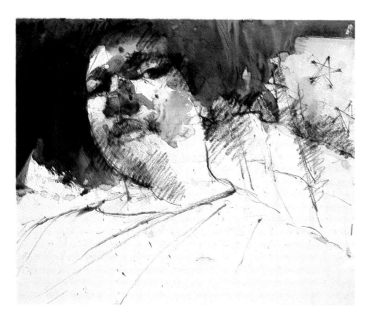

Step 2 With a 6B charcoal pencil, I drew back into the painting, after it had dried, to re-establish the drawing and to allow myself to think about the next step in the painting. I also strengthened some of the darks of the face with the charcoal pencil.

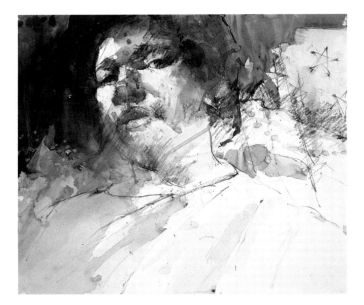

Step 3. The browns and tans of the face were repeated in the lower half of the painting. I indicated the beginning of the feeling of the stripes of the flag at middle right.

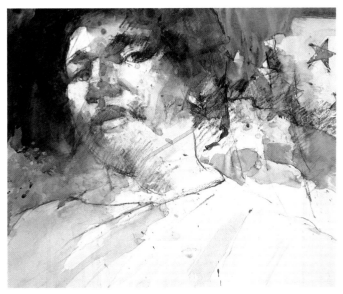

Step 4. The reddish tones added here had already been set up by the browns, which are in the same color family. I painted the stars red in the background flag to contrast with the off-white beside them. I did not want to continue the blue all the way across the top of the painting. This left the off-white to play against the stars. I added some reds to the face to bring the reds into the foreground space.

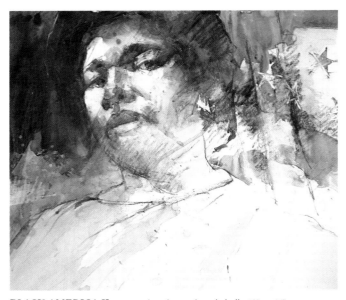

BLACK AMERICA II, *watercolor, charcoal, and chalk, 12″ × 16″ (30.48 × 40.64 cm), 1987. Collection of Elaine West, Lakeside Park, KY.*

Step 5. Although this step is one of clarifying detail, it is a step that worries me. I try to confine any detail to the transition from one shape to another. I try to stay out of the center of light, middle-value, and dark shapes.

At this point, I added a white star or two to suggest the feeling that the stars are becoming lighter in value as they move to the left, while the blue background grows darker moving toward the left.

Notice that one side of the face has a much sharper edge than the other, making clear which is the focal point. Similarly, the upper part of the face is much more defined than the lower part. This prevents the rectangle from being divided in half. Also, it sets up a transition from the clarity of the face in the upper left to the vagueness of the shoulder in the lower right. The entire central area of the painting serves to unify this contrast.

Using Transparent and Opaque Watercolors on a Toned Surface

Step 1. I scrubbed the dark values and bright colors off an old painting and added additional watercolor to complete the toning. I chose reds to complete the toning, probably because the bright colors of the old painting had been reds.

The charcoal drawing of the psychologist and the vague figure in the upper left were drawn over the dry watercolor toning.

Step 2. I began modeling the psychologist's head with transparent watercolor darker than the toning. Care was taken to leave some toning in the face. I had to anticipate where the opaque whites would be placed. It does not make sense to cover all of the toned paper with transparent watercolors darker than the toning and opaque whites and off-whites lighter than the toning.

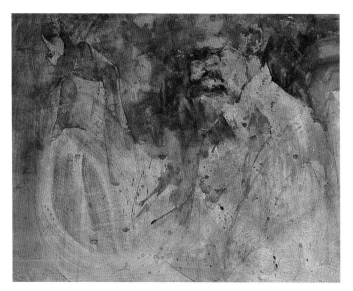

Step 3. I deepened the important dark background in the upper right, creating a focal point against the neck and shoulder. This dark background was carried behind the head at the top middle portion of the painting. The shadowy left side of the psychologist's head was lost into the background. I kept the background light in the upper left and began silhouetting the vague figure, as the dark hand against the face indicates.

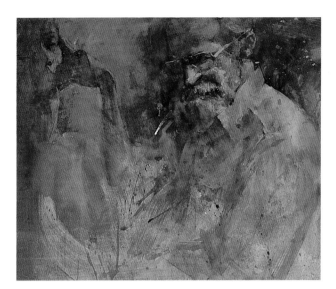

Step 4. Here I brought into play the opaque whites. In the face and the shoulder the whites complete the focal point against the dark background at the upper right. Repeating the opaque whites of the foreground figure in the background behind the figure in the upper left strengthened her silhouetted image.

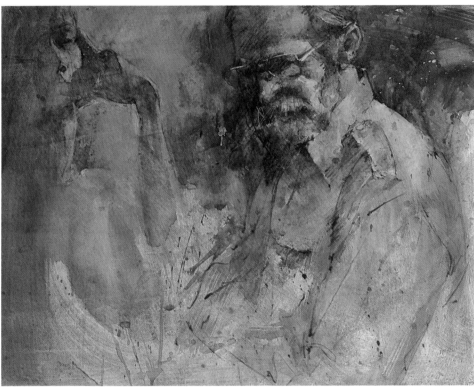

PSYCHOLOGIST AND PATIENT, *watercolor, charcoal, and gouache on watercolor-toned paper, 23" × 29" (58.42 × 73.66 cm), 1985. Collection of Audrey Wreszin, Basking Ridge, N.J.*

Step 5. I worked on some details here, primarily with the 6B charcoal pencil. When completing details, be careful to retain the integrity of the shapes that you have worked so hard to establish. Do not destroy those shapes with random embellishments.

Designing with Color Temperature as Well as Value

Step 1. At this stage it is important to begin with the head and get a feeling for painting it. Leaving it in a simplified, almost caricatured stage of incompleteness was fine here, as I considered the overall design. Having established that white paper will remain on the face and in the lower-right background, I began to work out the distribution of warm and cool colors.

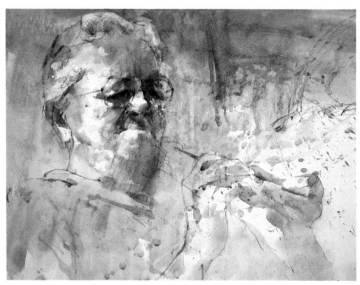

Step 2. I silhouetted the hand farthest to the right against the background white. The other hand was transitional, with some silhouetting and some lights.

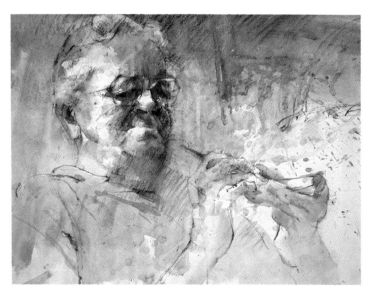

Step 3. No watercolor was used in this step. I used the 6B charcoal pencil to clarify the face and hands, but I also used it in the shoulders and the background. This painting is unusual for me in that I have not used dark shapes in it. In fact, there are really no clear shapes in the background. I think the two important white shapes and the changes from warm to cool provide sufficient distinction of shape.

OGGIE, watercolor and charcoal, 18" × 24" (45.72 × 60.96 cm), 1986. Collection of Oggie Vanover, Wise, VA.

Working Intuitively with Imagery

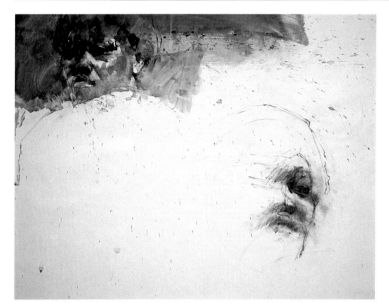

Step 1. As I began this painting, I had in mind the random placement of shapes that an artist's sketchbook might contain. I first placed the head in the upper left with the strong edge at the top of the shoulder. That edge demanded other shapes below, away from the sharp edge of the shoulder. It also caused me to group the dark head and its background as one general shape. I did the charcoal drawing of part of a head in the lower right without any idea of what was to come next. Working intuitively and reacting to imagery as it appears is probably the most fun for me as a painter. The possibility of a very personal expression is heightened when using this paint-and-react approach.

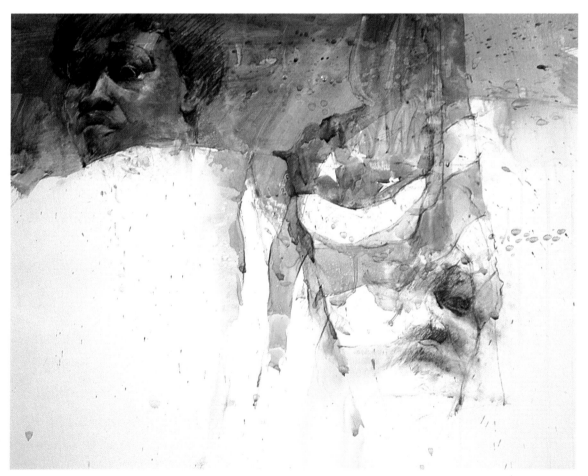

Step 2. Not only did I introduce the flag here, but I painted a large reddish wash over the top of the painting, including the head. The charcoal drawing of the head at the lower right now merges into the flag. The vertical red and white stripes of the flag make a transition into the large white shape at the left. I decided to stop this painting here. I feel that my work is best when it is most abbreviated.

BLACK AMERICA I, *watercolor and charcoal, 23" × 29" (58.42 × 73.66 cm), 1986. Collection of the artist.*

Part IV

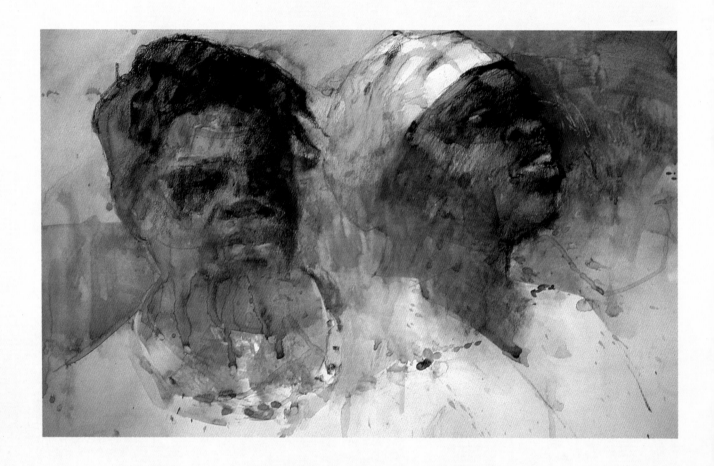

Looking
at Paintings

The Analytical and the Intuitive

Now that we have considered design in both a general and a specific way, let us look at some completed paintings. As simple and specific as I make my approach to design, the preceding design ideas are too numerous for all to be represented in any one painting. The design elements for each particular painting are thoroughly examined here. For clarity, overlay letters are used to point out areas I wish to discuss.

I do have a confession to make. This book has leaned heavily on the analytical left side of the brain. Very little has been mentioned about the powerful, intuitive right side of the brain. Yet many decisions in these paintings were made *intuitively.*

I am constantly amazed at the number of good artists who cannot analyze their own work or the work of other artists. While intuition is most important, an ability to analyze and critique is also essential.

The text of these completed paintings will include discussions of intuitive motivations as well as analytical design considerations. Thus, I hope this section will help provide some understanding of the use of both the right and left sides of the brain to create a cohesive, personal painting.

Enhancing Light with the Paper-Doll Value Relationship

I painted *Gray Nude* in a sketch class in three or four twenty-minute poses. The figure was drawn on toned paper, which remains visible at the bottom of the painting. The values darker than the toning were painted first. The lower part of the figure was left unfinished, except for the charcoal line drawing, so that the figure would melt into the background. The top of the figure was separated three-dimensionally from the background to create contrast with the lower two-dimensional vignetted area. The large light area of the model's upper back (A) was painted with gouache white and played against the adjacent dark background (B), creating a focal point.

The light on the model's hat was a large light area, which I did not paint so that I could keep the emphasis on the model's upper back. Painting the large light areas on the hat would have directed the eye out of the top of the painting and given undue attention to the odd element—the hat—rather than the total pose of the nude form.

Opaque gouache white areas were repeated in the background in the upper-left quadrant (C), creating a secondary focal point. The lower two quadrants were left simple, establishing a contrasting two-dimensionality. Touches of red chalk were used in the upper contrast areas to enliven the dirty gray toning.

Normally, I like to repeat the specific shapes from the figure somewhere in the background, but in this painting I was most inspired by and interested in the paper-doll relationship between the beautiful light of the model's upper back and the dark background. I made adjustments to the remaining shapes, values, and edges in order to retain and enhance this focal point.

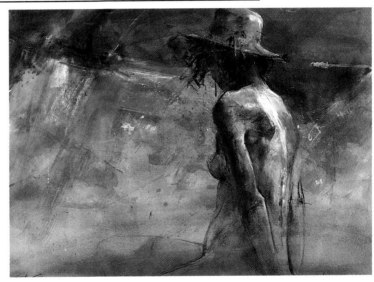

GRAY NUDE, *watercolor, gouache, charcoal, and red chalk on watercolor-toned paper, 22" × 30" (55.88 × 76.20 cm), 1984. Collection of Nancy and Eugene Fallon, Florence, SC.*

Using Change of Value to Emphasize Light Effects

My initial excitement about this pose was with the lively lights on the face. I wanted to paint almost everything else very dark so that these lights would sparkle by contrast. But when I completed the darks—in the lower background (A) and the shirt (B)—I thought that there was not enough change of value in them and that the light of the face needed to be repeated in the background. So I took the painting to the studio sink and scrubbed off the lower darks with a kitchen scrub brush. I added the vague red hori-zontal line (C) at the top of the scrubbed-off light area to give some transition in the background and to provide color unity with the reddish browns of the face (D). In the hair and in the shadowed side of the face, I repeated the cool darks from the background.

For this image to work as I envisioned it, the initial inspiration of the lively lights had to hold up as the focal point. I had to have the design savvy to make those lights work as the bright keynote in an otherwise dark, moody painting.

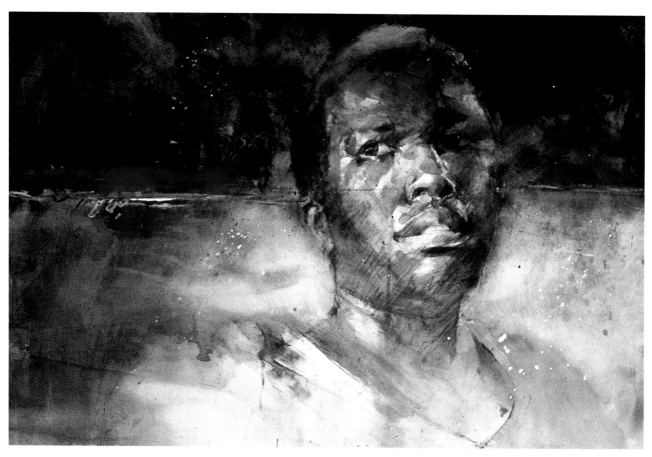

JANIE WASHINGTON II, *watercolor and charcoal, 22″ × 30″ (55.88 × 76.20 cm), 1983. Collection of Seibels, Bruce Co., Columbia, SC.*

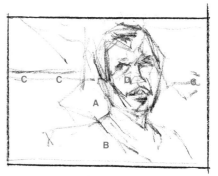

Making Small Light Areas Carry the Painting

As in the painting *Janie Washington II*, my excitement here was with the light areas of the upper face. To contrast with the exciting lights around the eye (A), I made the eye socket (B) and the shadow cast from the toboggan (C) very dark. To make the light nose stand out, I used a black background at D and connected it to the eye socket. I made the background dark (D) large before changing its value at E. Notice, also, that I extended this background dark upward rather than downward to allow the light background at F to play against the silhouettes of the lower face

(G) and the front of the jacket (H). I minimized the lights and details of the toboggan to maximize the special lights of the upper face.

I like the grouping of shapes of the jacket at H and I and the placement of the calligraphy of the collar, which occurs at the transition of shapes at G and I. But the placement of the front of the face in the center of the page and not in one of the four "sweet spots" in the rectangle (as explained in the section on shape) divided the painting in half and did not give me room to create interesting shapes in the background.

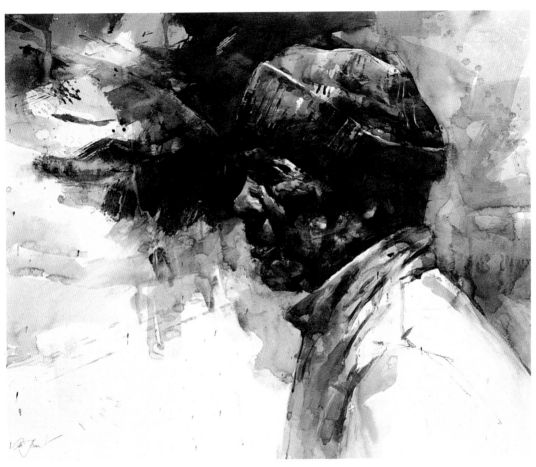

INLET MAN I, *watercolor, 22" × 30" (55.88 × 76.20 cm), 1982. Collection of G. W. Davis, Jr., New Canaan, CT.*

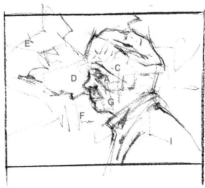

Painting the Sketchbook-like Rendering

I painted this image on Strathmore 400 drawing paper rather than on watercolor paper. Sometimes when I paint on watercolor paper I feel as if I am doing a "finished" painting to be framed. If this feeling disturbs my approach to painting, I take it seriously and give myself the freedom to fail that inexpensive paper allows. For just that reason, when I do use something other than drawing paper, I paint on two-ply Strathmore high-surface Bristol paper rather than the more expensive four-ply or watercolor boards. In this case, I opted for the drawing paper because it gave me an even greater sense of freedom—as one feels when sketching.

In this painting I wanted to be very abbreviated. My goal was a sketchbook-like rendering. I was not particularly interested in the cowboy hat that the bearded man was wearing. I simplified its very busy shape in order to emphasize the man's face and his red shirt.

The right side of the face (A) has a sharp edge against the dark background (B), which creates the focal point. The left side of the head has blurred edges and little contrast. The remainder of the painting is decorated with splatters and drips that further the poetic sketchbook style.

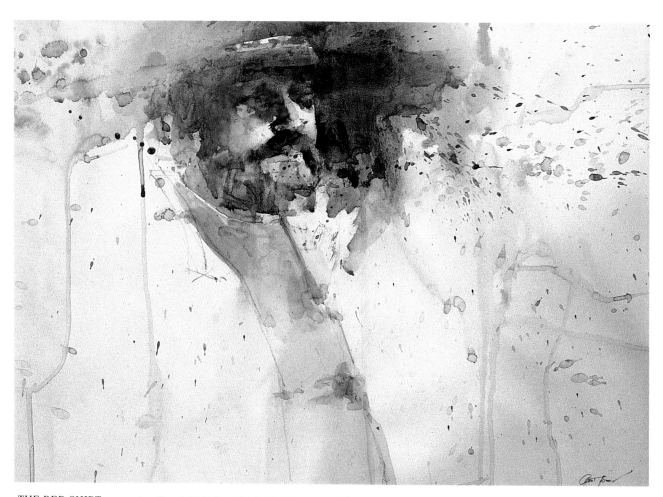

THE RED SHIRT, *watercolor, 18" × 24" (45.72 × 60.96 cm), 1985. Private collection, Toronto, Canada.*

Figure Painting with Small Focal-Point Figures

As an alternative to figure painting, in which the figure is always a large focal-point shape, this painting has two or three small focal-point figures at A. Because the close-up sacks of tobacco are very large shapes contrasting with the small figures, I was conscious of playing intermediate-size shapes between the foreground and the background to make the transition more fluid between the extremes of size. I reserved the light and dark value contrast for the small figures so that they would not be completely lost in the rectangle. To prevent shape B from overpowering the figures, I painted it with a blurred edge at C, and I did not make it white. Beyond this value control, the calligraphy of the sacks dominates the remainder of the painting; their lines create a movement through the rectangle leading to the distant figures.

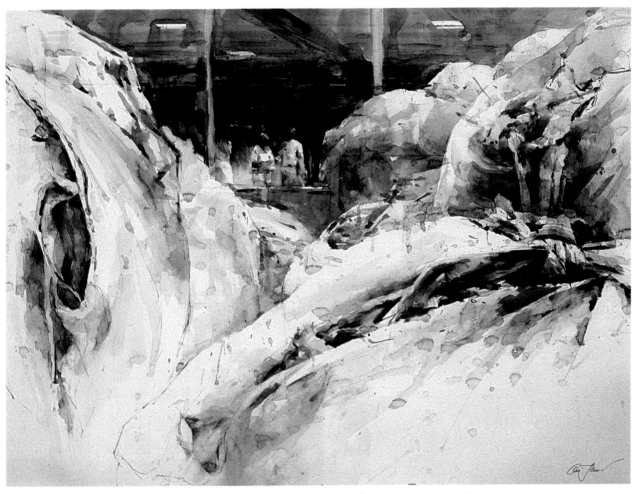

TOBACCO AUCTION, *watercolor, 22″ × 30″ (55.88 × 76.20 cm), 1981. Collection of Bebe and Lorin Mason, Florence, SC.*

Contrasting Two- and Three-Dimensional Space

The primary impetus for this painting was the special light on the hand and the cheek. To emphasize the special lights, I exaggerated the lights and darks of the hand and the dark of the adjacent neck (A) and intensified the extreme dark of the eye sockets. The front of the face and hat are blurred middle values so that they will not compete with the focal point.

This focal point and the use of the background at B and C establish a clear three-dimensional horizontal band (D). I created a contrasting two-dimensional use of space at the bottom of the painting (E) as a complement to my focus. A transitional horizontal band of space (F) unified the spatial transition from D to E. Horizontal band D has the look of being complete, whereas E is mostly vignetted white paper. Notice how line is used as the unifying element between contrasting horizontal bands D and E. At the upper portion of band F, line is a continuation of shape. In the vignetted white paper (E), the charcoal lines are more abbreviated.

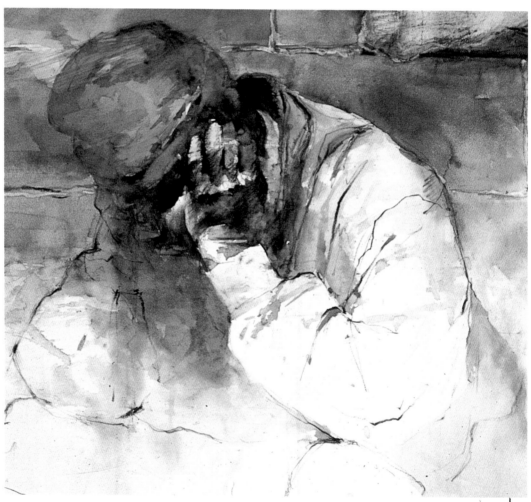

DOWN AND OUT, *watercolor, charcoal, and crayon, 22" × 22" (55.88 × 55.88 cm), 1982. Private collection, Lexington, KY.*

Painting the Figure as a Secondary Image

So often I tend to paint the figure as a focal point—a light shape coming forward in space against a dark background. But in *Fish Sale I*, the figure is a secondary silhouetted image. The eye moves from the top of the foreground light shape—the wooden stand for weighing fish—downward to the light behind the silhouetted fisherman (see diagram). The light path down the stand is basically straight, but the weighing scales and the hanging shirt provide some variety. Although the movement seems cramped into the center and left portions of the rectangle, I preferred to center the wooden stand in the rectangle rather than centering the dark background shape.

To create variety at A, I used the water spray bottle to lift some dark color from the background at the top, which was too large and had no value change. I used some separation of val-

ues in the fisherman but retained the silhouette look against the large, light background.

I think this painting unifies nicely. Squint your eyes to see that the grouping of the silhouetted shape of the fisherman has not been lost. Notice the interchange of lights and darks in the foreground and background. The inclusion of the paper-doll shapes (relationship B and C) and the silhouette shapes (relationship D and E) ensured a beginning of this interchange. To keep the edges of the dark background shape from getting too much attention, I darkened the light shape at F and blurred the edges at G, H, I, and J.

The inclusion of some interesting shapes in addition to the shapes of the figure create an environment and interest that is seldom possible with models posing in the studio. Sketching and photographing on location are a welcomed change from painting posed models indoors.

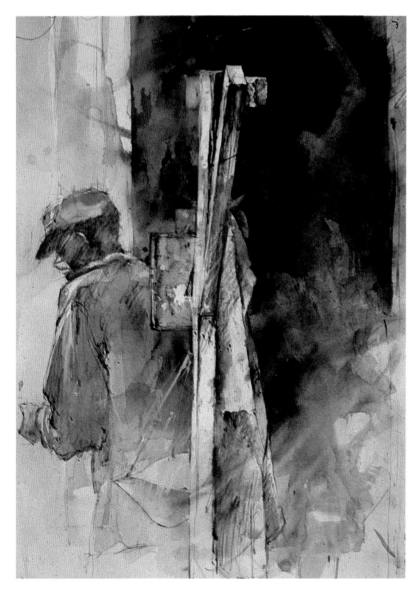

FISH SALE I, *watercolor, char-cc ' chalk, and crayon, 30" × 22" (76.20 × 55.88 cm), 1982. Collection of Jane and Harry Charles, Myrtle Beach, SC.*

Making the Image Work with Lively Brushwork

I painted this workshop demonstration painting with the model, Roosevelt, posing outside. My attention was centered on him rather than the images in the nearby landscape. The shapes of the cowboy hat, the mustache, and the lights and darks of the face and bandanna were exciting enough to absorb my interest.

In this simple painting, the large grouped lights and darks of the figure are repeated in the large background shapes. The lively handling of the paint carries the image. Although the red of the bandanna is not set up with other reddish colors as well as it should be, I think the rest of the painting is unified. Notice the distribution of cool colors in the foreground at A and B and in the background at C and D. Similarly, foreground warm colors appear at E, F, G, and H and in the background at I, J, and K.

The greatest value contrast in this portrait occurs at the middle of the face and against the front of the hat. Making the left and right sides of the face close in value to their adjacent backgrounds allowed me to keep the focus of the painting on the middle of the face and the front of the hat and prevented the possibility of competing focal points.

The lively interplay of the watercolor and charcoal and the selective placement of value contrasts in the painting create both variety and simplicity.

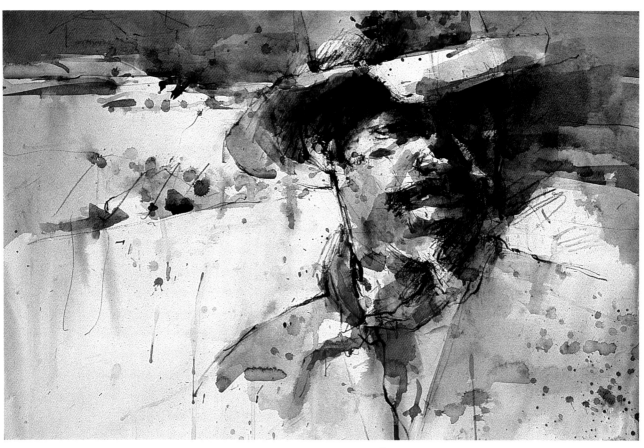

ROOSEVELT AT OLIVER'S LODGE, *watercolor and charcoal, 17″ × 23″*
(43.18 × 58.42 cm), 1985. Collection of Nancy Bulluck, Greensboro, NC.

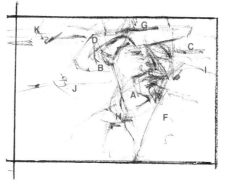

Using and Contradicting Basic Design

This is a significant painting for me. Even though it is a large painting, it has the sketchbook look, an approach in which I am very interested. In some ways, the sketchbook look is contradictory to basic design because it pays so little attention to the edges of the rectangle. The artist places images somewhat at random on the page, as if they were studies of objects and shape relationships, in the way they might be done in a sketchbook.

Actually, there are some conscious design considerations here. The placement of the focal point, silhouetted (A) against the light background (B) is in the "sweet spot" of the upper-right quadrant. In the section on movement, we discussed moving light and dark shapes through the rectangle. If a painting has more remaining white paper than painted areas, the eye sees the darks rather than the lights move through the rectangle. As the diagram shows, this is what happens in this painting. It is appropriate here that the focal point is a silhouette rather than a paper doll. A silhouette brings a dark shape forward in space and sets up the movement of dark shapes through the rectangle. It would be a bad beginning to have a paper-doll focal point, with the light shape coming forward in space, when you know that you are going to move the darks through the painting instead of the lights.

I do wish I had repeated the dark of the black woman's head in the painting, probably in the area of the flag (C). I used gesso, floated over the flag, to lighten this area, but I failed to re-establish a secondary dark after the gesso dried.

The sketchbook approach of fragmentation and unusual juxtaposition of subject matter allows a very flexible treatment of objects in space, such as the headland of trees (D), against the sky (E), which are placed adjacent to unrelated objects. It also gives painters like myself the opportunity to make creative use of the treasure of realistic imagery we continually gather as inspiration from photographs, sketches, videotape, and memory.

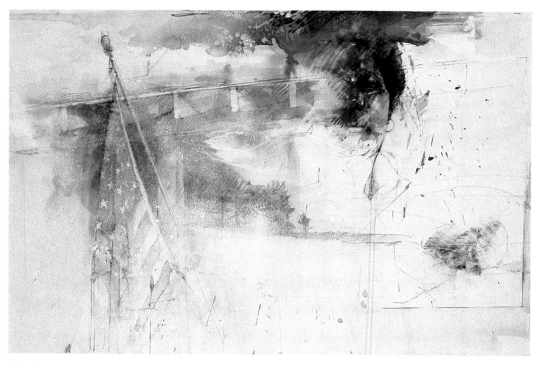

FRAGMENTS OF AMERICA, *watercolor, gesso, charcoal, and white chalk, 26" × 40" (66.04 × 101.60 cm), 1984. Collection of the artist.*

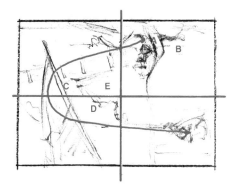

Perfect Subject Matter Can Be a Problem

When a subject for painting is extremely exciting, there is a tendency to paint the figure/subject and not to design the rectangle. This tendency is all right if the resulting painting is as exciting as the one envisioned. In fact, this is not unlike the sketchbook approach in that a sketchbook is a record of exciting, albeit incomplete visions. However, in many cases this approach is a design cop-out. Designing shapes in the rectangle in a unique way usually requires instruction and soul-searching, for it is not an easy or natural approach in the beginning for most of us.

Here I had to make a decision about the hat. Its twisted shape, bands, and feathers tended to gather too much attention. I was interested in the eye patch and bearded face. The light side of the face is painted in a very predictable realistic way, probably because of my excitement about the shapes as I saw them. Some variety was achieved by abbreviating the hat and painting across the shadow side of the face (A) into the background. Since the light spaces from the painted head to the edges of the page at B, C, D, and E are monotonous, the painted areas had to be special.

I remember in my earlier years, returning from a painting trip to Monhegan Island, Maine. The paintings that I brought back were the most photographically realistic I had done in some time. I think the subject matter was very pictorial and it seemed to need few changes. My conclusion is that subject matter that is too pictorial inhibits changes and consequently curbs creativity. Little of my individual aesthetic appeared in those Monhegan Island paintings. I have since realized that the ordinary subject matter in our immediate environment may be the best of all.

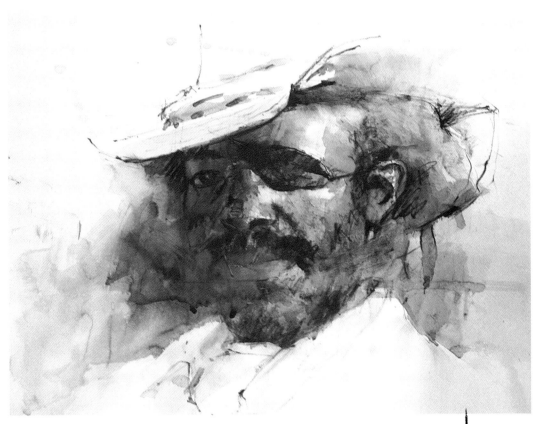

ROOSEVELT, *watercolor and charcoal, 22" × 25" (55.88 × 63.50 cm), 1984. Collection of Jane Templeton, Greenville, SC.*

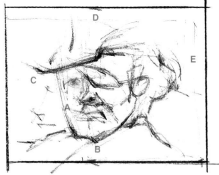

Preventing Repetitive Subject Matter from Being Monotonous

This painting of a group of heads was probably a reaction to my tendency to paint single-head studies. It represented a challenge to me. The biggest problem with any grouping of images is to make them work together as a unit and not look repetitive and scattered across the page.

The inclusion of the red at C prevented the shapes from having the look of being piled up in the middle of the page. This decision to use the large red shape in the upper left came late in the painting process. Before I added it, there was a racetrack of light running around the edges of the rectangle. Even though the head at A and the torso at B run off the page, they are so light in value that they do not interrupt the racetrack of light around the edges of the rectangle. As suggested by many art teachers, running shapes off two or three sides of the page is excellent advice.

The dark heads at D and E in the foreground were reinforced by the dark red shape in the background. And with the headland of trees (F) against the sky (G) I was able to evoke the beginning of an environment for the heads, releasing them from the confines of the studio pose.

There are many ways of handling this kind of painting and many ways to fail. I recommend preliminary sketches, actual or imagined, and changes during the painting process. Without a decision-making routine, the art of applying paint to paper becomes a technical task.

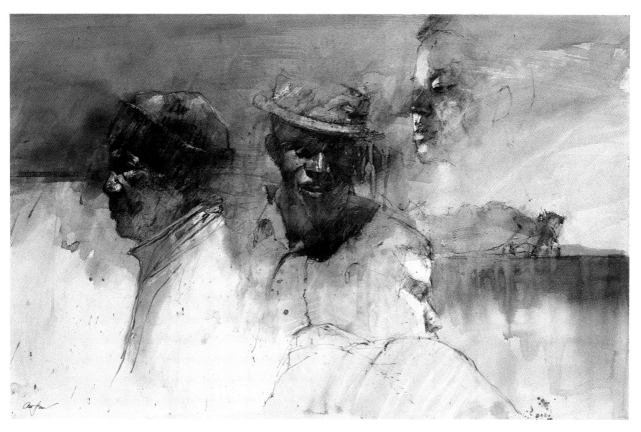

BLACK MONUMENT, *watercolor and charcoal, 26" × 40" (66.04 × 101.60 cm), 1985. Collection of Tucker Cooke, Asheville, NC.*

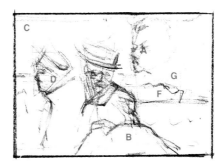

Balancing High-Value Contrasts and Color Accents

This painting is simply one of high-value contrast combined with a touch of red. Notice the variety of edges and the value control at the edges. High-contrast sharp edges are at A, B, and C. Sharp edges at D, E, and F are much closer in value. Blurred edges occur at G, H, I, and J. Transitions—light shapes lost into light shapes—are made at K and L. This much attention to edges is required of high-value contrast images.

The red apron is meant to be a color accent, which is not entirely set up and repeated, even though some of the burnt siennas of the face do relate to the red. The use of color accents rather than complicated color compositions is appropriate for the value painter. Color accents give some color to the painting but prevent color from competing with value as the painting's dominant element.

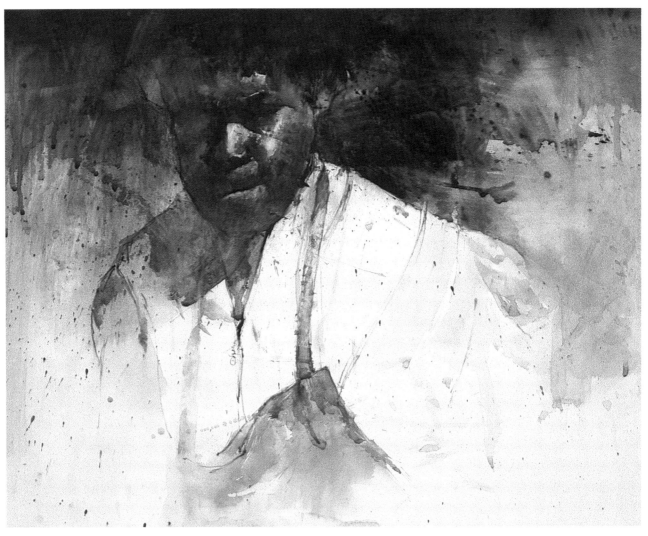

THE RED APRON, *watercolor, 23" × 29" (58.42 × 73.66 cm), 1984.
Collection of the DeLand Museum of Art, DeLand, FL.*

Emotionally Charged Paintings with Design Contradictions

The paper-doll relationship between the balloon (A) and the dark background (B) is in the upper-left quadrant. The silhouetted back of the head (C) against the light background (D) is in the upper-right quadrant. In spite of this placement and the balloon running out of the top of the page and the shapes at E running off the left side, the darks remain centered in the painting. The darks, however, are in both the foreground (F) and the background (G), which does help add a variety of shapes in space.

Study the variety of edges of the balloon. A sharp edge is between the high-contrast values A and B. The edge at H gets less attention to prevent the eye from being taken out of the top of the painting. The edge at I is lost, and at J the balloon is darker than the background. A balloon is such a large simple shape that particular attention needs to be given to its contours.

How do you give a painting emotional content? This question is difficult to answer. However, developing a painting style that expresses one's unique vision and reasons for painting is an answer. This painting's emotional content feels good to me, and for me that is everything.

It may surprise you to hear me say that design is merely a tool to be used to create form and content. Content relates to human emotion and the intellect and are the end result of the reasons for painting. Design is the means to that end.

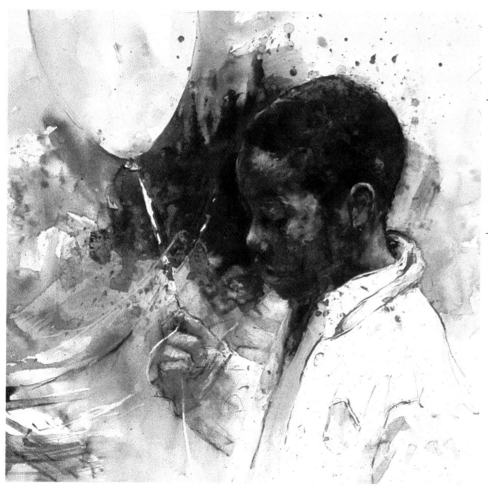

FESTIVAL BALLOON, *water-color and pastel, 22" × 26" (55.88 × 66.04 cm), 1981. Collection of Gaye and Jesse Fisher, Myrtle Beach, SC.*

Exaggerating the Simplification and Grouping of Shapes

Some viewers have trouble identifying the head and hat in this painting. The edge of the cast shadow from the hat is on the jaw at A. The front of the face is lost at B. The left (C) and right (D) sides of the hat are lost in shadow, making the hat appear small. I like the decision to simplify the form of the head and completely lose the front of the face at B by connecting the dark shadow of the face to the dark shadowy background.

If you have read the preceding text, you will understand my concern for simplifying and grouping shapes. You can then imagine my concern in painting the plaid coat in this painting. I did nibble at the plaid patterns and then paint in other areas of the rectangle and come back to nibble at the plaid some more. I wanted to be sure the plaid was related to the rest of the painting and not just paint it for its own sake.

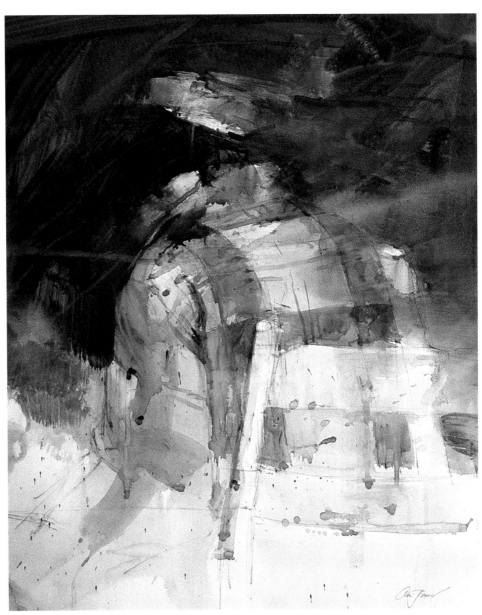

INLET MAN III, *watercolor, 23" × 21" (58.42 × 53.34 cm), 1985. Collection of T. Michael Copeland, Columbia, SC.*

Harmonizing Paint and Portrait—Form and Content

I have mixed feelings about this painting. I like the lively brushwork of the head as much as any painting that I have done. I dislike the arrangement of shapes in the square with equal intensity. The head and adjacent painted areas are in the upper-left quadrant, and there is little else in the square. The front of the face and shoulder divide the painting in half.

To mention more on the positive side: I like the combination of the open brushwork and realism of the head. It is a good balance between paint and portrait—form and content. The background at B is darker than the profile at the eyes and forehead. The background changes to a lighter value at C to allow the nose and beard to silhouette against C. The lower cheek (D) is unpredictably darker than the beard at E. The red color of the nose and cheek are repeated in the background, the color engulfing the hat, which, in reality, was not red. The back of the head is de-emphasized to allow the profile to hold its own as focal point.

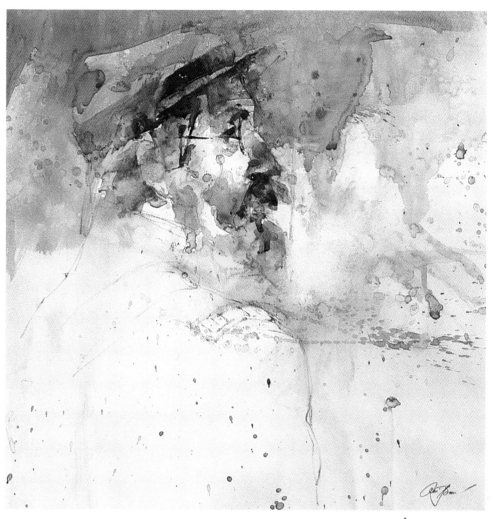

SOLDIER STUDY I, *watercolor, 17" × 17" (43.18 × 43.18 cm), 1985. Collection of Margaret and Guy Lipscomb, Columbia, SC.*

Controlling Values to Create Movement

Here I used a different painting procedure from the usual one. This may explain why I did not like the painting for a long time. After the drawing was completed, I painted the upper area blue, toward the middle green, and the lower area a tan horizontal band. I seldom begin a painting in this way: I began it on white paper and waited for the three color washes to dry. Then I worked it as I do papers that have been toned ahead of time.

The lights are all white chalk and the darks are all charcoal, with watercolor being a very minor part of the rendering of the figures. The high value contrast at the batter—Jim Rice of the Boston Red Sox—and the umpire's back create the focal point. The viewer's eye movement through the painting is directed by means of value control and the placement of the figures. The eye looks from the batter and umpire to the catcher, to the ball, and finally to the pitcher, as indicated in the diagram.

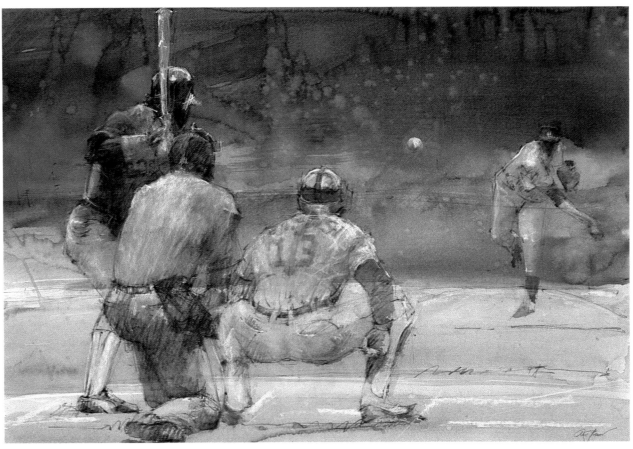

JIM RICE AT BAT, *watercolor, charcoal, and white chalk,*
23" × 29" (58.42 × 73.66 cm), 1983. Private collection, Columbia, SC.

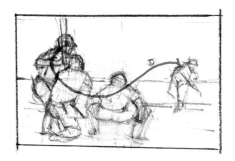

Alternating Values to Make Transitions

The high-value contrast here is limited to the upper portion of the figure of slugger Carl Yastrzemski. The solid background at A makes its transition at B, with a suggestion of the fans and the stadium in the outfield, ending at a solid light shape at C. The light at C and on Yaz's helmet and shoulders is repeated on the umpire's back, suggesting the design movement indicated in the diagram.

Notice the value control transition in the figures. Yaz has the strongest light and dark contrast. The umpire is next in importance, and the catcher and pitcher are vague figures receding into space. I wish I had subdued the light on Yaz's bat because it tends to lead the eye out of the painting at right.

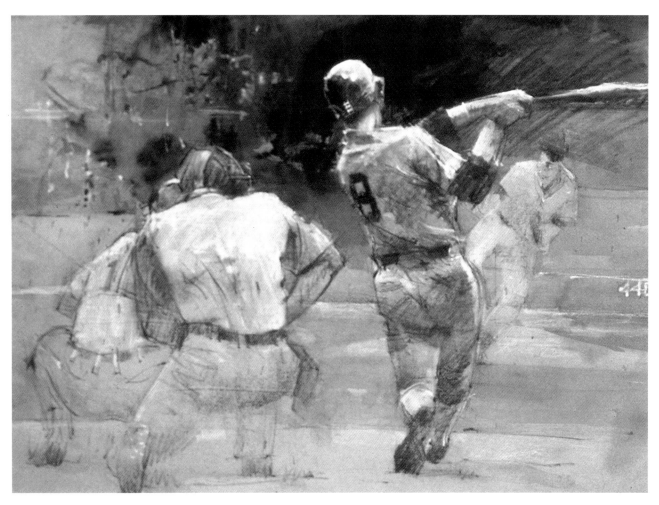

YAZ, *watercolor, charcoal, and chalk on toned paper, 23″ × 29″ (58.42 × 73.66 cm), 1983. Collection of Tom Polen, Myrtle Beach, SC.*

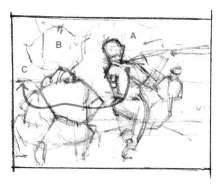

Part V

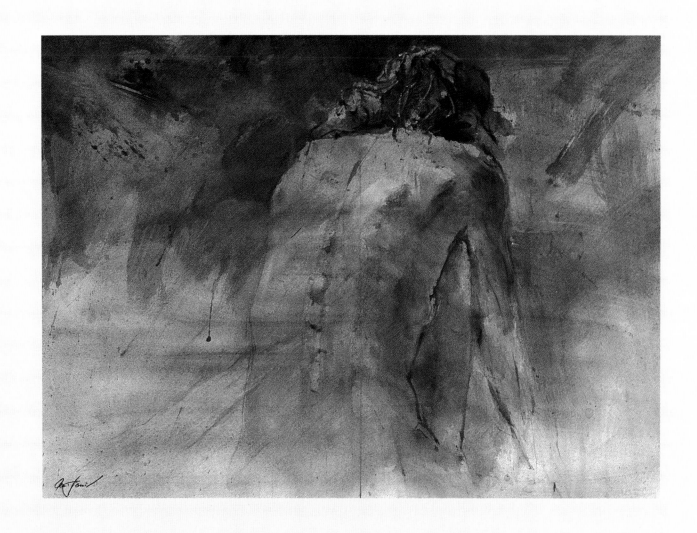

Aesthetic Considerations

Beyond Design

There is a story related by William Pachner about four men in a hospital room, only one of whom had a view out the window. It was he, of course, who described the beautiful scenery and lush vistas for the others, who all became jealous and decided to murder him so that they could take turns at the window. After they murdered him, they discovered that the window looked out on a brick wall, and they realized that they had murdered the one man among them who could create great beauty from within himself for others to enjoy. This is what the artist does.

Learning to draw, paint, frame, and sell work does not make a complete artist. The artist's world includes a thorough consideration of beauty, the emotions, the senses, and above all love. Andrew Wyeth said, "One's art goes as far and as deep as one's love goes, and there is no reason for painting but that."

But whatever the reasons for painting, knowing only the technical side of art is not enough for a full experience of what art is or what an artist is. Each artist finds his way to his own answers through his art. His answers emerge from his own growth and the relationship he has to his craft and his world. There are as many answers to "What is art?" as there are artists.

I particularly appreciate Joseph Conrad's eloquent statement from the preface to his book *Nigger of the Narcissus*: "[Art] is an attempt to find in its forms, in its colours, in its light, in its shadows, in the aspects of matter and in the fact of life what of each is enduring and essential— their one illuminating and convincing quality— the very truth of their existence. The artist, then, like the thinker or the scientist, seeks the truth and makes his appeal. . . . His appeal is made to our less obvious capabilities, to that part of our nature which, because of the warlike conditions of existence, is necessarily kept out of sight within the more resisting and hard qualities— like the vulnerable body within steel armour. His appeal is less loud, more profound, less distinct, more stirring—and sooner forgotten. Yet its effect endures forever. [The artist's] task is to make you hear, to make you feel—it is, before all, to make you see. That—and no more and it is everything."

Creativity

In his wonderful book *The Art Spirit*, Robert Henri states: "There are moments in our lives, there are moments in a day, when we seem to be beyond the usual. Such are the moments of our greatest happiness. Such are the moments of our greatest wisdom. If one could but recall his vision by some sort of sign. It was in this hope that the arts were invented. Signposts on the way to what may be. Signposts toward greater knowledge." To deny the intriguing offerings of our unconscious wisdom would be to truncate special moments that occur too seldom.

Creativity occurs both intellectually and intuitively. The major emphasis of this text has been on the intellectual, analytical, and structural, with particular attention to the learned design format. However, few if any masterpieces were ever painted without calling upon the impulsiveness of the right side of the brain. An amazing amount of quality painting can be done in brief periods of "turned-on" intuition.

To be creative in the face of nature is a task that must be conquered by the representational artist. Grouping and arranging nature's shapes in an abstract structure to express your artistic vision is a worthy goal. Copying objects in paint is a technical task, one of the basics to be learned yet surpassed by the serious artist. But to conceive a personal vision of ideas, gleaning lessons from traditional and contemporary art, is a lifelong venture that can lead you beyond to exciting new realms.

For me, expressing reactions to life with paint is the best of all possible experiences. Through it, art and life seem to become one. Whether an artist's imagery is a confirmation of life as he would like it to be or a revolt against life as it is, it is nevertheless a humanitarian contribution. As North Carolina artist Russ Warren so wisely states in *Understanding Abstract Art*: "Defining 'art' is absolutely impossible. It's like trying to prove or disprove the existence of God. It can't be done, so perhaps it's best to take it on faith. It does exist, and it exists within a very fine and long tradition of art objects which have been produced for an infinite number of reasons and can be interpreted to mean an infinite number of things. What's important is the experience and knowledge that can be gained through approaching art. 'Meaning' doesn't matter, nor does an intellectual understanding. The richness of the experience one has with art is important, and one way of nourishing this experience is to make more frequent the encounter and openly embrace works which seem difficult, or unusual, thereby making the experience more unique."

Inspiration

*"A personal aesthetic is established when the painter has in-dwelling knowledge
and is no longer wafted by every aesthetic wind."*

—Frank Webb

Without inspiration, the lifeblood of art is missing. Young artists are filled with inspiration; experienced artists sometimes fight to sustain it.

If inspiration is based upon what one sees, being in a visually exciting environment is required, even though exotic lands are not necessary. I have heard landscape painters say that the more they paint, the less they drive, meaning that visions abound in their own backyards.

If inspiration is based upon ideas, developing new ideas from already familiar ones will minimize long unproductive lapses. Good advice is to paint what you think, not what you see.

Whether inspiration is based on what one sees or on ideas, the artist's job is to react emotionally to what inspires him. Be less demanding of the source of your inspiration and give more guts to the representation of your visions and ideas.

Art Education and Growth

*"I believe that entirely too much emphasis is placed upon paintings and
drawings made in art schools. If you go to a singing teacher, he will first give
you breathing exercises, not a song."*

—Kimon Nicolaïdes

*"Growth takes place through perception, conception and execution. In simpler
language: seeing, thinking and acting."*

—Frank Webb

Quality instructors guide students beyond subject matter and technique to design and aesthetics. These instructors make sure that while students master technique, their spirits remain alive with active visions. A quality art education establishes a style of painting that fosters gradual changes and an increasing capacity for the discovery of new ideas. The search for aesthetic stimulation leads the artist in many directions. He may collect art, art books, travel to lands with new vistas, and discuss art with artists and non-artists. All of these positive cultural experiences are valid steps toward aesthetic growth. But, fundamentally, this search leads to a realization and exploration of self.

The need to grow and the difficulty in critiquing one's own work in a detached manner cause the artist to look for means of assessing his paintings in relation to the contemporary art world. Submitting work to regional and national juried exhibitions can help in this evaluation. Involvement in workshops around the country can lead you to discover knowledgeable artists, teachers, and other students who will share their experiences and goals. But remember that there is much to be explored in your own world. Take a stand in the middle of the life you wish to paint. Avoid insulated art colonies and art institutions.

The Benefits of Art Criticism

"She liked to have a show for herself before mounting a public one, as she had done in 1915 when she first decided to paint for herself. Then 'I have already settled it for myself,' she candidly stated . . ., 'so flattery and criticism go down the same drain and I am quite free.'"
—From Laurie Lisle, *Portrait of an Artist: A Biography of Georgia O'Keeffe*

Writing about art can be an arduous task, as Kimon Nicolaïdes points out in *The Natural Way to Draw*: "If you have tried it, you will realize how difficult it is to speak clearly and concisely of art. One is always very close to contradiction." And yet, despite the difficulties, there is much to be gained from quality art criticism. The art critic can be the agent who brings thoughts on art that the public might not otherwise have had. The artist too can benefit from a competent critic. Since the artist's language is paint, he sometimes finds it difficult to articulate the profound observations and insights that he might show in his work. Although the artist may be able to discuss specific designs and techniques, he may be lacking in an objective view of his own work and can be at a loss for descriptive observations about art on a larger scale. Therefore, I think it would be valuable in art class and workshop critiques of students' paintings not only to hear detailed design and technique criticism from the artist/teacher but also to hear from the competent critic, who searches for larger relationships.

As all artists know, there are self-proclaimed art critics everywhere. And yet all of us have friends and acquaintances whose opinions and insights we respect. These are the artists' valuable unofficial "critics."

Style

"I express that which I feel, rather than that which I see. I want to transform natural images into my own images and colors. Even though my work may appear to be abstract, to me it is very representational."
—Norbert Irvine

An obvious influence on the style of an artist's work is the choice between traditional realism and modern abstraction. Actually, the choice in imagery only seems obvious. Nature is seen both in realism's imagery and in abstraction. Style is not limited to an either/or aesthetic.

Andrew Wyeth, who is heralded as master by realists and recognized by modernists as an extraordinary designer, says in *Two Worlds of Andrew Wyeth: Kuerners and Olsons*: "Why not have both? Why not have abstraction and the real, too? Combine the two, bring in the new with the traditional and you can't beat it. I believe, however, that I don't want to let the one take over the other. I try for an equal balance. If somehow I can, before I leave this earth, combine my absolutely mad freedom and excitement with truth, then I will have done something. I don't know if I can do it, probably never will, but it's certainly a marvelous challenge to me. And yet pull it back at the last moment to make it readable—and tangible. I want the object to be there in my paintings, perhaps in all its smallest detail, not as a tour de force, but naturally, in such a way that I have backed into it."

Most contemporary art combines traditional and modern styles. While Winslow Homer and Thomas Eakins showed us how to translate the emotions of nature and its inhabitants onto paper, Willem de Kooning and Jackson Pollock, with their dazzling surface variations, opened our eyes to a fresh approach. It is handicapped vision that does not see, learn, and use the achievements of others.

The Artist and the Public

"For the language of visual art cannot be reduced to linear thinking and words without changing its meaning. Art, if it is to be understood, must be approached with the whole being."

—Gary Cook

". . . non-representational art (meaning nonobjective or abstract) is a way of seeing things, the result of which may seem unrealistic but is really an individual's uniqueness expressing itself."

—Clara Couch

The incredible pressure placed on young artists to discover new art and the failure of our educational institutions in exciting the aesthetic sense of students in art appreciation classes have not helped bridge the gap that exists between artists and non-artists. This lack of public understanding of contemporary art imagery has to be faced before it can be treated. Artists' audiences need not be limited only to the few who are true art lovers and those who *think* they *should* love art. The dilemma of the public's lagging appreciation of art will always be with us to some extent. However, some difficult but obvious changes would readily narrow the gap. A social structure in which teenagers and young adults learn to treasure art as much as science and economics would be a great beginning. Everyone has a natural capacity to enjoy artistic creations; this capacity can be nurtured.

Herb Jackson suggests an approach to art appreciation that the public can benefit from. He says: "It is a mistake to look at visual art for literal truth. The gift of art is the form, not the subject; that is, we are informed by experiencing the 'how' instead of the 'what.' Subject is an important element of content, just as is line or color or shape or texture or scale; but it is to be dealt with secondarily, after the initial sensory experience. If you are able to listen to Mozart or watch ballet movements without asking for identifiable meaning, allow yourself the same freedom for experiencing visual images. Imagine how barren it would be if those who would restrict the vocabulary of visual art to those images readily identifiable such as landscapes, people, barns, and so forth, would impose the same restrictions on music. We would only be able to compose with the sound of birds, wind, water, etc., which would limit our musical palette to a narrow range of possibilities."

Suggested Reading

Canaday, John. *Culture Gulch: Notes on Art and Its Public in the 1960's*. New York: Farrar, Straus and Giroux, 1969. A sensible art critic's compilation of his *New York Times* art reviews.

Carlson, John F. *Carlson's Guide to Landscape Painting*. New York: Dover Publications, Inc., 1958. An excellent text of the basics. His paintings are traditional. His thoughts in the text are more creative.

Cary, Joyce. *The Horse's Mouth*. New York: Harper and Row, Publishers, Inc., 1965. A fascinating and funny novel about an artist.

Glenn, Constance W. *Jim Dine Figure Drawings 1975–1979*. New York: Harper and Row, Publishers, Inc., 1979. An interesting combination of traditional and contemporary/funky figure images.

Goodrich, Lloyd. *Edward Hopper*. New York: Harry N. Abrams, Inc., Publishers, 1985. The strong but quiet imagery of Edward Hopper is the essence of American art.

———. *Edwin Dickinson*. New York: Whitney Museum of American Art, 1965. A powerful traditional American oil painter.

Graves, Maitland. *The Art of Color and Design*. New York: McGraw-Hill Book Co., 1951. A standard and thorough study of general design characteristics.

Hale, Robert Beverly, and Nike Hale. *The Art of Balcomb Greene*. New York: Horizon Press, 1977. A personal alternative to traditional figure painting.

Hawthorne, Mrs. Charles W. (collected by). *Hawthorne on Painting*. New York: Dover Publications, 1960. Collected notes on Hawthorne's excellent ideas on color, etc. Two of my teachers, Eliot McMurrough and Henry Hensche, were students of Hawthorne.

Henri, Robert. *The Art Spirit*. New York: Lippincott Co., 1939. One of the best art books ever written.

Hunter, Sam. *Larry Rivers*. New York: Harry N. Abrams, Inc., Publishers, 1969. If you like to draw, you will like Larry Rivers's work.

Katchen, Carol. *Painting Faces and Figures*. New York: Watson-Guptill Publications, 1986. I am included in this book in a five-page section, along with seventeen other portrait and figure painters.

Knobler, Nathan. *The Visual Dialogue, An Introduction to the Appreciation of Art*. New York: Holt, Rinehart and Winston, Inc., 1980. A basic reference text on design and art appreciation.

Lisle, Laurie. *Portrait of an Artist, A Biography of Georgia O'Keeffe*. New York: Washington Square Press, 1980. A fascinatingly independent American woman artist.

May, Rollo. *The Courage to Create*. New York: Bantam Books, 1980. An interesting study of creativity, a subject that is difficult to write about.

Nicolaïdes, Kimon. *The Natural Way to Draw*. Boston: Houghton Mifflin Co., 1941. Maybe the best book on drawing ever written, it can be used as a one-year course on drawing.

Nordland, Gerald. *Richard Diebenkorn*. New York: Rizzoli, 1987. The Edward Hopper of American abstract painting. A great painter!

Paintings and Drawings by David Levine and Aaron Shikler. New York: Brooklyn Museum, 1971. David Levine is the watercolorist. His work is everything good that traditional art has to offer.

Read, Herbert. *The Meaning of Art*. Baltimore: Penguin Books, 1931. A philosophical look at art.

Reid, Charles. *Figure Painting in Watercolor*. New York: Watson-Guptill Publications, 1974.

———. *Portrait Painting in Watercolor*. New York: Watson-Guptill Publications, 1973. His loose realism has been a strong influence on my work.

Webb, Frank. *Watercolor Energies*. Fairfield, Conn.: North Light Publishers, 1983. Thoughtful ideas for the watercolorist, especially the chapter on the design element space.

BOOKS ON ANDREW WYETH

Wilmerding, John. *Andrew Wyeth; The Helga Pictures*. New York: Harry N. Abrams, Inc., Publishers, 1987. Quality large reproductions of paintings.

Two Worlds of Andrew Wyeth: Kuerners and Olsons. New York: The Metropolitan Museum of Art, 1976. A five-day interview with Andrew Wyeth. Text is excellent!

Wyeth, Betsy. *Wyeth at Kuerners*. Boston: Houghton Mifflin Co., 1976. Quality large reproductions of paintings.

———. *Christina's World*. Boston: Houghton Mifflin Co., 1982. Quality large reproductions of paintings.

CATALOGS

Also consult catalogs of juried watercolor exhibitions, such as the ones below, and those of various regional and state watercolor societies. The addresses of the watercolor societies may be obtained in various issues of *American Artist* magazine (see the Bulletin Board listing of exhibitions).

The Rocky Mountain National Watermedia Exhibition. Foothills Art Center, Golden, CO.
The American Watercolor Society, New York, NY.
The National Watercolor Society, Los Angeles, CA.
Watercolor U.S.A., Springfield, MO.

Index